IMAGES
of Rail

OIL CREEK AND
TITUSVILLE RAILROAD

Richard Roth, the Titusville area manager of the Oil Creek and Titusville Lines, is at the Petroleum Centre station on November 19, 2010, talking with engineer Chris Dingman on locomotive No. 75. The Oil Creek and Titusville Railroad runs the passenger service. However, Oil Creek and Titusville Lines operates the freight service and is the purveyor of service for the Oil Creek and Titusville Railroad. (Photograph by Kenneth C. Springirth.)

ON THE COVER: Pennsylvania Railroad steam locomotive No. 5746 is preparing to leave Titusville for the last regularly scheduled passenger train, No. 980 from Oil City via Titusville to Corry, on June 9, 1953. The train consisted of a mail baggage express car, a combination car, and a passenger coach. The conductor was J.A. McCoy, the engineer was E.J. Metzinger, the fireman was Wayne Acklin, and the baggage man was Ira Miller. (Oil Creek and Titusville Railroad collection.)

IMAGES
of Rail

OIL CREEK AND
TITUSVILLE RAILROAD

Kenneth C. Springirth
and David L. Weber

ARCADIA
PUBLISHING

Published by Arcadia Publishing
Charleston, South Carolina

Library of Congress Control Number: 2011922956

For all general information, please contact Arcadia Publishing:
Telephone 843-853-2070
Fax 843-853-0044
E-mail sales@arcadiapublishing.com
For customer service and orders:
Toll-Free 1-888-313-2665

Visit us on the Internet at www.arcadiapublishing.com

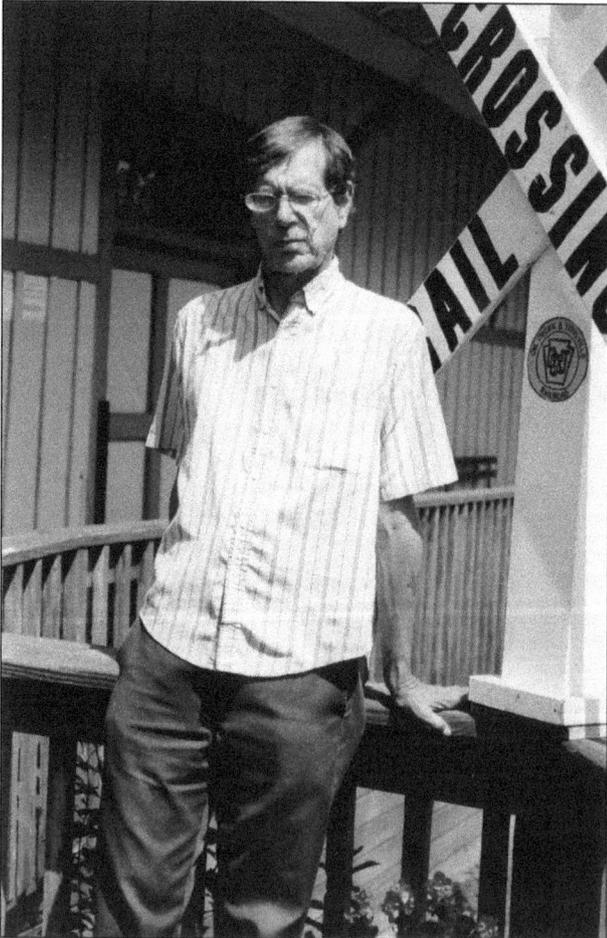

This book is dedicated to longtime *Titusville Herald* reporter Tom Boyle (shown at the Perry Street station of the Oil Creek and Titusville Railroad on August 14, 2010) and Michael Sample, publisher of the *Titusville Herald*. Their help and cooperation made this book possible. (Photograph by Kenneth C. Springirth.)

CONTENTS

ACKNOWLEDGMENTS

Thanks to the *Titusville Herald* for the use of its historic picture collection and the work of its reporter Tom Boyle in locating material. Thanks to Betty Squire of the Oil Creek and Titusville Railroad for providing pictures. Thanks to the Oil Creek Railway Historical Society for saving the railroad. Train boarding for the Oil Creek and Titusville Railroad is at 409 South Perry Street, Titusville, Pennsylvania (telephone number 814-676-1733).

One *Titusville Herald* photograph showed 23 students (the class of 1963) from St. Joseph Academy High School alongside railroad passenger car No. 912 *Pithole Valley* before a class trip that left May 1, 1963, from Corry to New York City via the Erie-Lackawanna Railroad. *Pithole Valley* was used a clubhouse owned by James Stevenson, William Stevenson, and Joseph Fleming and was so called because James Stevenson had owned the site of the former boomtown of Pithole from 1957 to 1963. Tom Boyle used the picture in a story asking if anyone could identify those students. Joseph Fadden identified the names, and Chester Barker brought in the 1963 St. Joseph Academy High School yearbook showing the students. Claron Rosman, a student in that picture, achieved 1960s rock-and-roll stardom as a pianist-organist with Tommy James and the Shondells. St. Joseph Academy High School, located at 512 West Main Street in Titusville, closed in June 1969. Thanks to Joseph Fadden and Chester Barker, two of the students in that picture, for getting everyone identified.

Copies of the *Titusville Morning Herald*, which on February 26, 1913, became the *Titusville Herald*, were viewed on microfilm at the Benson Memorial Library. Lois Parsons of the Titusville Historical Society provided information and pictures. Jim Watson, John Dunn, Jane Hayes, Cathy Coffaro, and Donald Kaverman provided pictures. Michael Dowling, a Rosewood Real Estate sales associate in Titusville, provided industrial contact information. Richard Roth of Oil Creek and Titusville Lines provided information so the freight trains could be photographed for this book. Jim and Charlene Morvay, who own Fairmont Rail Car model MT19-A with Tomah cab No. 7821 (about 30 of these cabs were built by the Milwaukee Road Railroad to handle cold winters), provided speeder car information. Information was also provided by Raymond E. Grabowski Jr. (president of the Lake Shore Railway Historical Society, Inc.), Richard Senges, and Paul Schneider.

Unless otherwise noted, all images are from Kenneth C. Springirth's collection.

INTRODUCTION

At a meeting of the stockholders of the Pennsylvania Rock Oil Company in 1858, former railroad conductor Edwin L. Drake was chosen by default to go to Titusville to search for oil; he was the only one present who had a railroad pass and would not cost the company any expenses for transportation. Drake supervised the drilling of the first successful oil well by William A. Smith on August 27, 1859. This opened the door to tapping the subterranean deposits of oil beneath the Oil Creek Valley. Development came overnight and, with it, the need for railroads. The Oil Creek Railroad was chartered on August 17, 1860, to construct a railroad from any point on the Philadelphia and Erie Railroad to Titusville. Corry was selected as the northern terminus because it could connect with the Philadelphia and Erie Railroad and the Atlantic and Great Western Railroad.

In October 1862, a total of 27 miles of the broad-gauge (six feet) Oil Creek Railroad was completed from Corry to Titusville, reaching Miller Farm during 1863 and Shaffer Farm on the west bank of Oil Creek by July 1864. A dual-gauge track (third rail) was added in May 1865 so that the broad-gauge line could also accommodate standard-gauge (four feet eight and a half inches) cars of the Pennsylvania Railroad at Corry. Track gauge, the distance between rails, is measured at right angles to the rails from the inside face of the rail to the inside face of the opposite rail five-eighths of an inch from the top of the rails. In September 1865, the Oil Creek Railroad came under control of the Philadelphia and Erie Railroad.

The six-and-a-half-mile Oil City and Pithole Railway was built along Pithole Creek from Oleopolis and began service on December 18, 1865. The Farmers Railroad, incorporated on October 8, 1863, completed a line from Petroleum Centre to Oil City in November 1866. In 1866, the Oil Creek Railroad connected to the Farmers Railroad at Petroleum Centre, thereby allowing oil to move from the oil regions to either Corry in the north or to Oil City in the south. The Buffalo and Oil Creek Cross Cut Railroad opened a 14-mile line from Brocton to Mayville in New York State on May 20, 1867, with construction continuing to Corry, where the line connected with the Oil Creek Railroad. This became the Buffalo, Corry, and Pittsburg Railway, which was later sold at foreclosure and on May 3, 1879, became the Buffalo, Chautauqua Lake, and Pittsburg Railway. The Atlantic and Great Western Railroad opened to Corry on May 27, 1861, and Meadville on November 10, 1862. The line from Meadville to Oil City opened in March 1865.

The Oil Creek Railroad was purchased by the Warren and Franklin Railway, which was consolidated with the Farmers Railroad and the Oil City and Pithole Railway into the Oil Creek and Allegheny River Railway on February 26, 1868. With the Oil Creek Railroad having more business than it could handle, the June 29, 1865, *Titusville Morning Herald* noted, "the Oil Creek road, crowded with passengers and blockaded with freight is undeniably inadequate to the wants of the public and the necessities of trade and travel." The *Titusville Morning Herald* of February 6, 1871, reported that the Union and Titusville Railroad was completed, noting on Saturday, February 4, 1871, "The locomotive [identified as] Shoo Fly hauled 12 carloads of oil from the refinery of Porter, Moreland & Co., the only firm in the business who are yet accommodated with a switch." A banquet was held on February 15, 1871, at the Petroleum House in Union Mills to

celebrate the completion of the broad-gauge railroad. The Union and Titusville Railroad was built to provide competition for the Oil Creek Railroad, because oil shippers were reportedly charged high prices to move their oil via the Oil Creek Railroad to Corry. On July 26, 1871, the Union and Titusville Railroad was leased by the Oil Creek and Allegheny River Railway, ending any competition. The Union and Titusville Railroad was abandoned from Union City to Canadohta Lake by 1890, and the remainder closed by 1926.

On September 14, 1871, US president Ulysses S. Grant arrived at Titusville on a special train, and following an elaborate breakfast at the Parshall House, he remarked, "Fellow citizens, I feel very grateful to you for this kind of reception. This is my first visit to the oil regions. I am aware that this section of the country furnished its full share of men and means for the suppression of the rebellion, and your efforts in the discovery and production of petroleum aided materially in supplying the sinews of war, as a medium of foreign exchange, taking the place of cotton." President Grant and his family then travelled by train to Petroleum Centre, Oil City, Franklin, and Pittsburgh.

The *Titusville Morning Herald* of April 30, 1874, reported the Allegheny Valley Railroad "had completely passed under control of the Pennsylvania Railroad." On May 1, 1874, the Oil Creek and Allegheny River Railway defaulted in payment of the interest due on consolidated mortgage bonds, and on July 12, 1874, a receiver was appointed. It was sold at foreclosure on December 29, 1875, and was acquired by the Pittsburg, Titusville, and Buffalo Railway on February 8, 1876. A joint meeting of stockholders of the Pittsburg, Titusville, and Buffalo Railway with the Buffalo, Chautauqua Lake, and Pittsburg Railway in Philadelphia on February 17, 1880, resulted in the merger into the Pittsburg, Titusville, and Buffalo Railway operating from Oil City to Brocton, New York. The Titusville and Oil City Railroad was built on the east bank of Oil Creek (with an annual train run over this track used largely for freight car storage) and, along with the Pittsburg, Titusville, and Buffalo Railway on the west bank of Oil Creek, became part of the Buffalo, Pittsburg, and Western Railroad on January 22, 1881. On February 14, 1883, it became the Buffalo, New York, and Philadelphia Railroad, which on November 28, 1887, became the Western New York and Pennsylvania Railroad. On Saturday, June 4, 1892, at 6 p.m., heavy showers caused Oil Creek to rapidly rise, and by 11 p.m., portions of Titusville were under water. The dam at Spartansburg broke, and a tidal wave of water hit Titusville. Fire broke out, and there was extensive damage to homes and industries and washout of considerable amount of railroad track. The June 9, 1892, *Titusville Morning Herald* reported that the Western New York and Pennsylvania Railroad had 3,000 men repairing track between Oil City and Corry. According to the *Titusville Morning Herald* of October 7, 1892, the Western New York and Pennsylvania Railroad began constructing a new freight house at the foot of Perry Street in Titusville. By 1893, the Western New York and Pennsylvania Railroad went into receivership, and it was reorganized in 1895 as the Western New York and Pennsylvania Railway.

The Pennsylvania Railroad took over the Western New York and Pennsylvania Railway on July 31, 1900, making it the major railroad in the Oil Creek valley. The east-bank railroad tracks were rebuilt, and new bridges were constructed during 1913–1915. On September 13, 1928, the *Titusville Herald* announced "J tower to be closed" and noted, "Only the northbound tracks of the double tracks between J tower and Oil City will be used from Pioneer north to Titusville." Removal of track on the west side of Oil Creek from Titusville to Pioneer occurred between 1929 and 1933. Beginning February 6, 1935, shipments of freight on the Pennsylvania Railroad between Pittsburgh and Oil City that were less than carload were handled on passenger trains. The *Titusville Herald* of February 6, 1935, reported, "Starting today freight in less than carload lots from Pittsburgh will leave that point in a car attached to passenger train No. 913, which will make the shipments available for delivery in Oil City at 7:00 a.m. and in Titusville between 9:00 and 9:30 a.m." Less-than-carload lots of freight for Pittsburgh would be taken on "train No. 912, leaving Titusville at 2:42 a.m. arriving in Pittsburgh at 7:20 a.m. for delivery early in the forenoon." When major washouts occurred on the Pennsylvania Railroad mainline near Johnstown on March 20, 1936, nine passenger trains had to be rerouted using the Pennsylvania Railroad via Titusville

to Buffalo and the New York Central Railroad from Buffalo to New York City.

A headline from the October 19, 1950, *Titusville Herald* read, "5,000 Greet Penna. Week Special Here," to announce the 11-car Pennsylvania Railroad train that arrived at the South Perry Street freight station in Titusville from Warren at 4:20 p.m. on October 18, 1950, for Pennsylvania Week. The article noted, "Persons aboard the train were astonished at the size of the crowd here. They termed it the largest and most enthusiastic in all their stops of the day." Ezra Stone, famous for his radio role as Henry Aldrich, was master of ceremonies. At 5:10 p.m., the train headed south for Oil City. The train was on a six-day, 1,248-mile tour through Pennsylvania.

On Friday October 10, 1952, vice presidential candidate Sen. Richard M. Nixon travelled via Erie Railroad to Oil City and then on the Pennsylvania Railroad, leaving Oil City at 2:31 p.m. and arriving in Titusville at 3:16 p.m. From the rear platform of his campaign train at South Monroe Street, he spoke to an estimated crowd of 2,000. Senator Nixon's train had stopped in New Castle, Sharon, Meadville, and Oil City, with the next stop in Corry.

On May 15, 1953, the Pennsylvania Public Utility Commission granted permission to the Pennsylvania Railroad to discontinue the last passenger trains running from Corry via Titusville to Oil City in the morning and returning to Corry in the evening. At 6:45 p.m. on June 9, 1953, the last Pennsylvania Railroad passenger train, No. 980 northbound for Corry, stopped at Titusville, where 40 passengers boarded. A few passengers got off at Centerville. At Spartansburg, a few got off, and five boarded the train. As the train pulled into Corry, torpedoes placed on the track erupted into a loud noise. The area was now without railroad passenger service for the first time in 90 years; the station agent was transferred to the freight station on June 10, 1953. On May 1, 1962, the Pennsylvania Railroad closed its freight station at Centerville and transferred all freight activities through Titusville. Centerville had had railroad freight service for almost 100 years since the completion of the Oil Creek Railroad between Corry and Titusville in October 1862.

The Dunkirk, Allegheny Valley, and Pittsburgh Railroad connected Titusville with Dunkirk, New York, and later became the Valley branch of the New York Central Railroad. On December 31, 1872, passenger service began on this line. Two passenger trains travelled in each direction between Titusville and Dunkirk until June 26, 1932, after which service was reduced to one train in each direction. The New York State Public Service Commission conducted a hearing at Dunkirk, New York, on January 27, 1937, on the New York Central Railroad's proposal to discontinue the final round-trip Dunkirk-to-Titusville passenger train. Concern was expressed at the hearing that public interest would be seriously affected by the abandonment of passenger service; however, railroad officials testified that losses had been increasing over the last three years.

At the Pennsylvania Public Utility Commission hearing in Erie on February 25, 1937, it was noted that 35 school children used the train, and a grocery storeowner testified that 10 of his customers depended to a large extent on the trains. A railroad official noted that on school days, ridership averaged 50 passengers per train, and it averaged 10 per train on Saturdays. The Pennsylvania Public Utility Commission conducted another hearing on March 11, 1937, in Warren, where petitions from the communities of Youngsville, Warren, and Grand Valley were presented in opposition to the discontinuance of passenger train service. While many came to the hearing by train, it was revealed that most of the attendees had not ridden the train in years. Permission was granted, and the last passenger train operated on this line on June 12, 1937. The *Titusville Herald* of Monday, June 14, 1937, noted, "On Saturday, June 12, not much interest was created, and fewer than half a dozen persons were at the station in the evening when the doodlebug train pulled in on its last run at 5:25 p.m." Freight service from Titusville to Warren ended on August 19, 1967, except for the two-and-a-half-mile Fieldmore branch from Titusville to East Titusville.

The Titusville Electric Traction Company, chartered under the laws of the State of Pennsylvania in 1897, opened for service on June 1, 1898. The trolley company's powerhouse on the east side of Pine Creek near East Titusville furnished electricity. The powerhouse also contained a carbarn that housed six trolley cars and a combination work-freight car known as *Dewey*. The *Titusville Herald* of August 5, 1915, noted, "The Titusville Traction Company watches its lines very carefully and makes needed improvements from time to time in its roadbed and its service." Declining

ridership forced the company to end trolley service on December 31, 1924. The *Titusville Herald* of Friday, January 2, 1925, reported, "The last car was operated from Hydetown through the city to the car barns at about 11 o'clock Wednesday night, and the last passenger to pay a fare and ride over this part of the line was Harry Fleek of North Brown Street, who was the sole passenger from Hydetown to the city." The article continued, "While the patronage on the street cars for several years has been negligible, excepting on certain days when something special summoned people from the rural communities at either side of the city, the fact that the cars have been in daily operation for more than 26 years had made them and their service a real part of the community life of Titusville."

In 1981, Consolidated Rail Corporation announced it was planning to abandon 16 miles of track from Titusville to Rouseville because it was no longer profitable. Local people in Titusville and Oil City formed the Oil Creek Railway Historical Society and purchased the right-of-way for $286,000. The Titusville Industrial Fund, Inc., provided $100,000 to assist with the funding of the Oil Creek and Titusville Railroad and contributed $75,000 toward the reconstruction of the Perry Street station. The Oil Creek Railway Historical Society hired a designated operator, which operates the freight service under Oil Creek and Titusville Lines. The operator also provides the locomotive, operating personnel, track maintenance, and other services for the Oil Creek and Titusville Railroad, which operates the passenger rail service. Passenger excursion service on the Oil Creek and Titusville Railroad began on July 18, 1986, operating through the valley where oil was discovered and literally changed the world. A headline from the *Titusville Herald* of October 25, 1986, read, "30,000th OC&T Passenger." The article honored Jason Hartmann, a student at Maplewood Elementary School, for being the 30,000th passenger to ride the Oil Creek and Titusville Railroad.

On May 27, 1988, the rehabilitated Perry Street station in Titusville was officially opened. The project involved a new roof, outside repair and repainting, interior finishing for ticket sales, restrooms, a gift shop, a refreshment area, and a museum. The Petroleum Centre train station was dedicated on August 26, 1988, with the invocation given by Rev. David Hampson, pastor of the Rouseville United Methodist Church; Boy Scout Troop 14 from Oil City provided the flag salute.

The Oil Creek and Titusville Railroad has built boarding facilities at Drake Well Park and Rynd Farm. At the Perry Street station, an industrial switcher, boxcar, three-dome tank car, and caboose are on display. Across from the Perry Street station, the railroad operates Caboose Motel, Inc., consisting of 21 cabooses.

The Oil Creek and Titusville has lengthened the Rynd Farm siding at the interchange with the Western New York and Pennsylvania Railroad and has constructed 1,500 feet of track for car storage at the north end of the line at Titusville north of Pennsylvania Highway 27. In 2008, ties were replaced on the Columbia Bridge north of Rynd Farm. During 2009, significant work was done on the Black Bridge in Titusville, the Jersey Bridge near Drake Well Park, and the Allen Street railroad overpass in Titusville. In 2010, the Warren truss bridge north of Petroleum Centre was rehabilitated. The Oil Creek and Titusville line has an ongoing tie replacement program and has continued to add facilities to meet customer needs.

Titusville was known as the Queen City of the oil region because it was a financial and cultural center, including a number of musical and literary societies during the 1860s and 1870s. The center of oil production moved to the Bradford region of northern Pennsylvania after 1880. The community survived because of its churches, public school system, and determined entrepreneurs who fostered new industrial growth. Titusville witnessed boom periods and hard times and has had the resilience to weather changes that will poise the community to meet future challenges. In addition, preserving its rail service has made a vital contribution to Titusville's industrial renaissance. The Oil Creek and Titusville Railroad is now part of Titusville's pioneering, progressive, and proud heritage. Titusville indeed has a promising future.

One

EARLY HISTORY

Thomas Struthers from Warren joined with others to form the Oil Creek Railroad on August 17, 1860. Originally built as a six-foot, broad-gauge railroad to match the Erie Railroad, it was completed from Corry to Titusville during October 1862. Miller Farm was reached in 1863, and Shaffer Farm was reached in 1864. Both of these locations became important loading stations. The June 29, 1865, *Titusville Morning Herald* noted that a charter had been obtained to build a 23-mile railroad from Titusville to Union Mills (Union City).

Six persons were killed and nine seriously injured on the Oil Creek Railroad one mile west of Titusville on August 24, 1865, when an express train rounding a curve had a head-on collision with a freight train. A number of newspapers expressed concern over the accident and previous passenger overcrowding issues on the Oil Creek Railroad, with the *Erie Observer* commenting on the necessity of building the proposed railroad from Union Mills to Titusville.

On February 19, 1866, construction began at Union Mills for the Union and Titusville Railroad. The Oil Creek and Allegheny River Railway planned a new passenger station in Titusville on the north side of the tracks, just west of Franklin Street. According to the July 13, 1870, *Titusville Morning Herald*, in June of that year, 9,000 passengers used the train at Titusville, with the most popular destinations listed as Buffalo, Erie, Dunkirk, Rochester, and Philadelphia. Ground was broken for the new station in September 1870, and the brick structure with ornamental Ohio sandstone opened on February 20, 1871. On December 21, 1870, at the Common Pleas Court at Meadville, a motion was made to restrain the Oil Creek and Allegheny River Railway from interfering with the crossing of its railroad by the Union and Titusville Railroad. The January 23, 1871, *Titusville Morning Herald* noted, "The crossing of the U&TRR with the OC&ARR in Titusville was practically effected yesterday." Principal stations on the Union and Titusville Railroad were at Titusville, Hydetown, Tryonville, Centerville, Riceville, Lincolnville, and Union Mills.

BUFFALO, CORRY AND PITTSBURG RAILWAY

Trains Leave				May 1870	Trains Arrive		
Mail	Exc.	Acc.	Miles	Stations	Exc.	Mail	Acc.
A.M.	P.M.	P.M.			Noon	P.M.	P.M.
8:55	2:35	7:00	0	...**Brocton**...	12:00	5:00	7:00
9:55	3:25	8:00	14	...Mayville...	11:15	4:10	6:00
10:20	3:45	8:30	20	...Summit...	10:55	3:45	5:35
10:40	4:00	8:45	24	...Sherman...	10:40	3:25	5:20
11:05	4:20	9:05	32	...Panama...	10:20	3:00	4:55
11:22	4:35	9:25	35	...Clymer...	10:05	2:40	4:35
11:55	5:05	10:00	43	...**Corry**...	9:30	2:00	3:55

Connects at Brocton with Buffalo and Erie; at Mayville with steamboats on Chautauqua Lake for Jamestown and Randolph; at Corry with Atlantic and Great Western, Philadelphia and Erie, and Oil Creek and Allegheny River Railways.

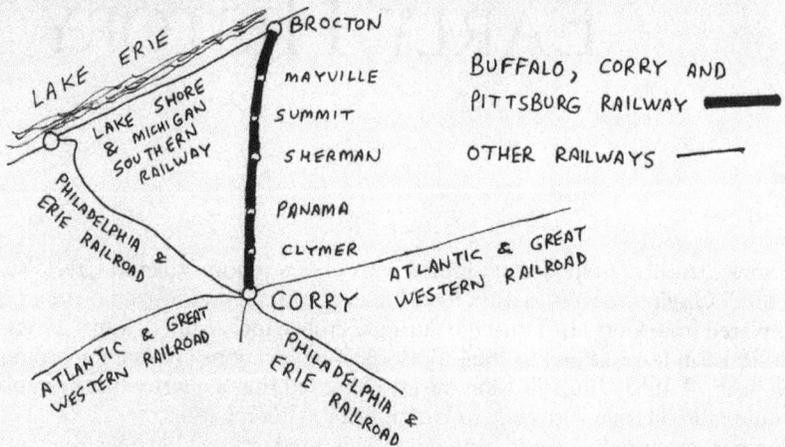

OIL CITY AND PITHOLE RAILWAY
November 16, 1869

Trains leave Pithole for Prather's Mills, Wood's Mills, Bennett's Mills, and Oleopolis, 8:00 a.m. and 2:30 P.M. Returning, leave Oleopolis 10:05 a.m. and 4:05 p.m. Distance 7 miles.

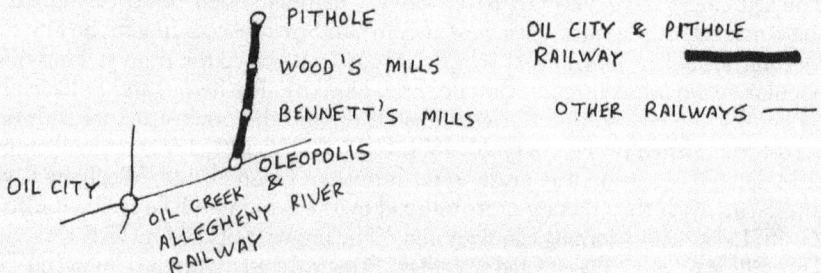

The May 1870 schedule of the Buffalo, Corry, and Pittsburg Railway shows three passenger trains in each direction on the Corry to Brocton, New York, line. At the Brocton, New York, and Corry, Pennsylvania, terminus points, passenger train connections could be made to other parts of the United States. The Oil City and Pithole Railway schedule from November 16, 1869, shows two passenger trains in each direction on the Oleopolis to Pithole line. Oleopolis was a connection point for passenger trains on the Oil Creek and Allegheny River Railway.

Shown are 10 locomotives awaiting the next assignment at the roundhouse in Oil City in 1870. This was the Oil Creek and Allegheny River Railway, later becoming the Western New York and Pennsylvania Railroad, which was acquired by the Pennsylvania Railroad. For many years, the Pennsylvania Railroad operated two Oil City roundhouses. (*Titusville Herald* collection.)

Pictured is the Dunkirk, Allegheny Valley, and Pittsburgh Railroad trestle at Youngsville in Warren County around 1873. The trestle crossed Brokenstraw Creek and the Philadelphia and Erie Railroad tracks. Warren and Titusville had similar industrial facilities, such as oil refineries, tanneries, furniture factories, lumber mills, and boiler and heavy forge shops, for many years thanks in large to the direct railroad connections between the two municipalities. (*Titusville Herald* collection.)

OIL CREEK AND ALLEGHENY RIVER RAILWAY
(Warren and Franklin, Farmers, & Oil Creek Railroads consolidated)
November 15, 1869

Trains Leave					Trains Arrive		
Acc.	Mail	Pas.	Miles	Stations	Mail	Exs.	Acc.
A.M.	P.M.	P.M.			Noon	P.M.	P.M.
	+12:05	+7:15	0	**Irvineton**	+11:40	+5:10	
	•••	7:25	2	Dunn's Eddy	11:32	•••	
	12:17	•••	4	Penn's House	•••	4:56	
	12:25	7:38	5	Thompson's	11:21	4:48	
	12:34	7:47	9	Cobham	11:13	4:40	
	12:40	7:54	11	Magee's	11:06	4:33	
	12:53	8:08	15	Tidioute	10:56	4:21	
	1:00	8:26	20	White Oaks	10:38	4:02	
	1:20	8:37	23	East Hickory	10:28	3:52	
	1:30	•••	26	Dawson	10:18	•••	
	1:35	8:54	28	Jamison	10:14	3:36	
	1:40	9:01	30	Tionesta	10:07	3:31	
	•••	9:11	33	Hunter	•••	3:21	
	1:55	9:18	35	Stewart	9:50	3:13	
	2:03	9:24	37	President	9:43	3:07	
	2:07	9:29	38	Eagle Rock	9:40	3:03	
	2:12	9:34	39	Henry's Bend	9:34	2:58	
	2:17	9:40	41	Oleopolis	9:27	2:52	
	2:23	9:47	43	Walnut Bend	9:21	2:45	
	2:35	9:57	47	Rockwood	9:11	2:35	
A.M.	2:50	10:10	50	Arr **Oil City** Lve	8:59	2:22	P.M.
*7:00	2:57	10:20	50	Lve **Oil City** Arr	8:53	2:15	*9:30
•••	3:11	10:34	53	McClintock	8:40	2:02	•••
7:18	3:14	10:37	54	Rouseville	8:36	1:59	9:02
7:24	3:19	10:43	55	Rynd Farm	8:31	1:53	8:56
7:30	3:25	10:49	56	Tarr Farm	8:25	1:48	8:50
7:34	3:39	10:53	56	Columbia	8:21	1:45	8:45
7:40	3:34	11:00	57	Arr **Pet. Centre** Lve	8:14	1:40	8:38
7:43	3:36	11:05	57	Lve **Pet. Centre** Arr	8:12	1:38	8:36
7:50	3:43	11:13	59	Pioneer	8:05	1:32	8:28
7:59	3:50	•••	61	Shaffer	7:59	•••	•••
8:05	3:55	11:30	62	Miller Farm	7:55	1:18	8:12
8:30	4:20	11:59	68	Titusville	7:35	12:59	7:50
8:42	4:30	12.11	71	Hydetown	7:21	12:43	7:29
8:59	4:44	12:29	76	Tryonville	7:07	12:29	7:14
9:09	•••	12:40	79	Centerville	•••	12:17	7:03
9:21	•••	12:50	82	Glynden	•••	12:06	6:52
9:35	5:16	1:05	86	Spartansburg	6:39	11:52	6:38
10:10	5:45	1:40	95	**Corry**	6:10	11:30	6:05

Connects at Irvineton with the Philadelphia and Erie Railroad; at Oil City with the Franklin branch of the Atlantic and Great Western Railroad; at Corry with the Philadelphia and Erie Railroad, and the Atlantic and Great Western Railroad. *Daily +Daily except Sunday

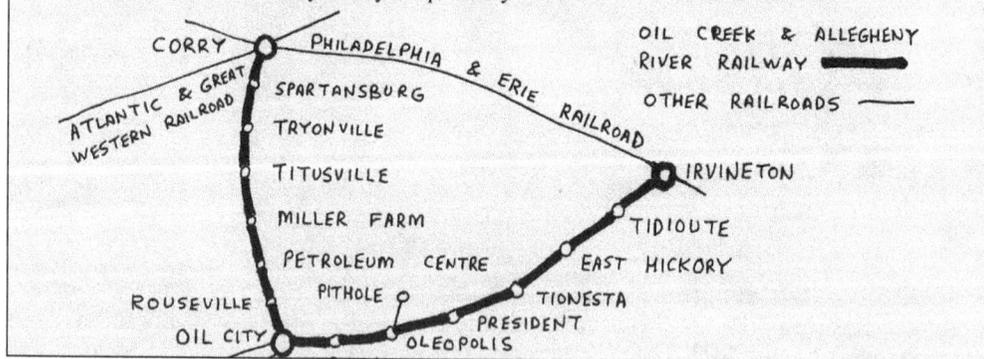

The November 15, 1869, Oil Creek and Allegheny River Railway schedule shows two trips in each direction daily except Sunday on the Irvineton–via–Oil City–and–Titusville–to–Corry line. A daily roundtrip from Oil City via Titusville to Corry ran as well. Oil City, Corry, and Irvineton provided passenger train connections to many parts of the United States.

Western New York and Pennsylvania Railroad engine No. 37 with a 4-4-0 wheel arrangement is shown in Oil Creek valley during 1880. This railroad reorganized into the Western New York and Pennsylvania Railway in 1895. Most of the original Western New York and Pennsylvania Railway has been abandoned except for the section from Rynd Farm to Titusville, which is now operated by the Oil Creek and Titusville Railroad. (*Titusville Herald* collection.)

A northbound Western New York and Pennsylvania Railroad passenger train is at the Petroleum Centre depot around 1880. Most of the town had been destroyed by fire or had been demolished by this time. The Oil Creek State Park and the Oil Creek and Titusville Railroad Petroleum Centre Visitors Center stand on this site today. (*Titusville Herald* collection.)

Bradford around 1880 is the scene for this Buffalo, New York, and Philadelphia Railroad passenger train. This railroad became part of the Western New York and Pennsylvania Railroad in 1887. Titusville had a connection to Bradford using the Pennsylvania Railroad from Warren via Kinzua to Riverside Junction, New York. (*Titusville Herald* collection.)

Western New York and Pennsylvania Railroad locomotive No. 91 is west of the passenger station and slightly west of Perry Street after the fire and flood of June 5, 1892. On the far left was the wreckage of a railroad car. The damaged Acme Refinery (later Pennsylvania Paraffine Works refinery) is to the right of the locomotive. (*Titusville Herald* collection.)

This is the railroad yard at South Perry Street in Titusville after the fire and flood of June 5, 1892. Some of the freight cars were burned to the wheels. Boxcar No. 1242 was lettered AVRR for the Allegheny Valley Railroad. Boxcar No. 6604 was lettered WNY&P for the Western New York and Pennsylvania Railroad. (Oil Creek and Titusville Railroad collection.)

The remains of burned freight cars are shown at Titusville following the great fire and flood of June 5, 1892, in this view looking east from Perry Street. The disaster occurred when the earth-and-wood Spartansburg dam broke, leaving 130 dead, approximately 300 injured, and 1,500 homeless in Titusville and Oil City. Fire started when tanks full of gasoline and naphtha collapsed and then ignited. (*Titusville Herald* collection.)

This is the Oil Creek Railroad/Western New York and Pennsylvania Railroad bridge at South Martin Street in Titusville. The photograph was taken shortly after the June 5, 1892, fire and flood, which the bridge survived. Later that year, the bridge was rebuilt as an iron truss bridge. During 1914–1915, the bridge currently used by the Oil Creek and Titusville Railroad replaced the iron truss bridge. (*Titusville Herald* collection.)

This is the South Martin Street bridge over Oil Creek in Titusville in 1893. Famous football coach John William Heisman, whose name graces the esteemed Heisman Trophy of college football, graduated from Titusville High School; he lived in the residential area on Bank Street at the far right of the picture. (*Titusville Herald* collection.)

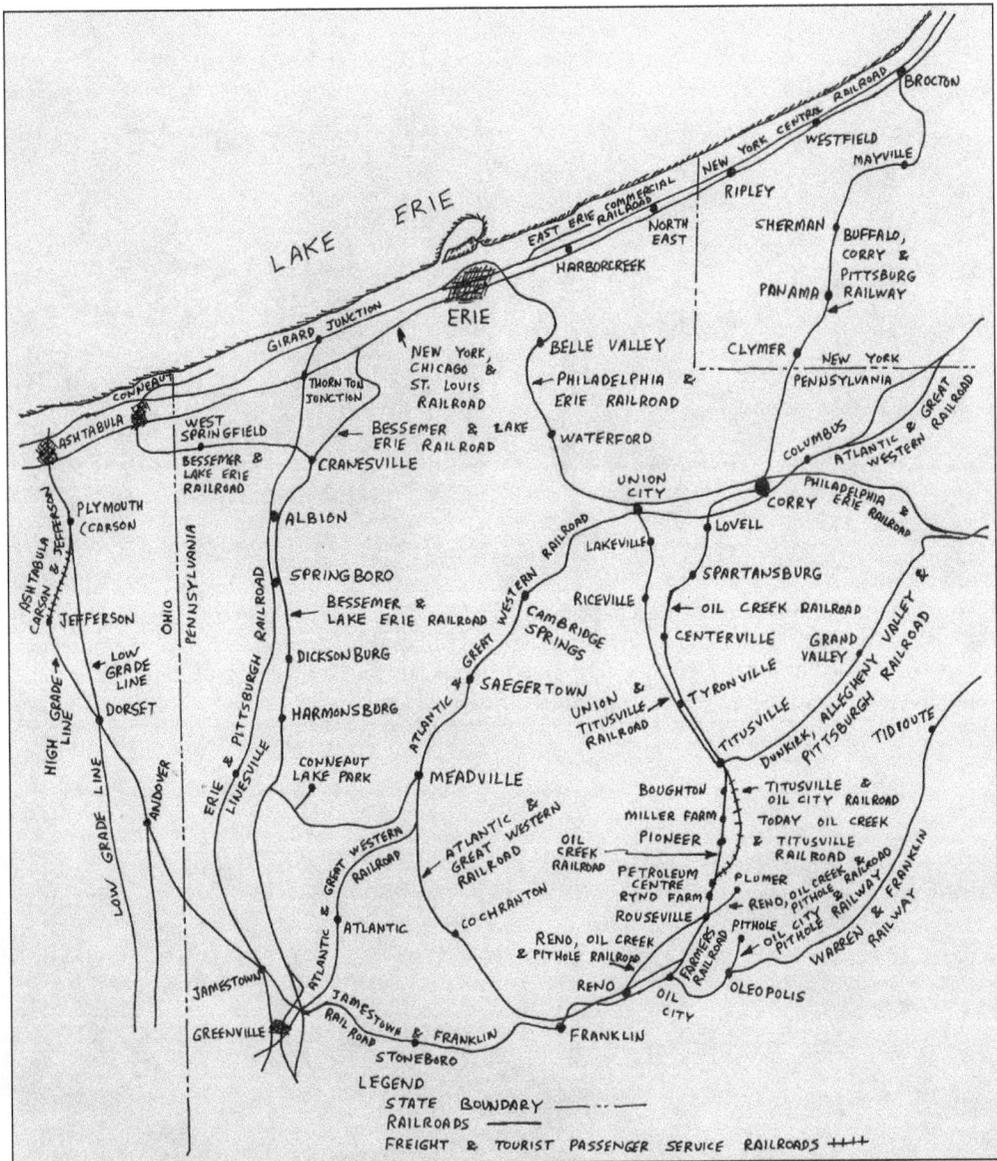

Northwestern Pennsylvania Railroad lines are shown at their peak in this map. With the exception of the six-mile Ashtabula, Carson, and Jefferson Railroad that operates from Carson to Jefferson, Ohio, the remainder of the original New York Central Railroad (Jamestown and Franklin Railroad) has been abandoned. The Philadelphia and Erie Railroad (later Pennsylvania Railroad) is now operated by the Buffalo and Pittsburgh Railroad from Erie to St. Marys. Most of the Erie and Pittsburgh Railroad (later Pennsylvania Railroad) has been abandoned. The Bessemer and Lake Erie Railroad lines to Meadville and Conneaut Lake Park have been abandoned. The Oil Creek and Titusville Railroad operating from Rynd Farm to Titusville is the surviving portion of the Pennsylvania Railroad's Chautauqua branch. The two and a half miles of Oil Creek and Titusville Railroad from Titusville to East Titusville is the only surviving part of the former Dunkirk, Allegheny Valley, and Pittsburgh Railroad (later New York Central Railroad) in Pennsylvania.

19

Plant manager John Gill (wearing a cap and suit) is standing near the center of the employees at the Galena-Signal Oil Company barrel storage yard in Franklin around 1900. At one time, this company blended and barreled lubricating and signal oils for 98 percent of United States and Canadian railroad, trolley, and subway lines. (*Titusville Herald* collection.)

Conductor Billy Geary and an unidentified engineer, fireman, and brakeman are standing by Pennsylvania Railroad switch engine No. 3145 at South Washington Street in Titusville around 1910. The brick building on the right side was a wholesale liquor warehouse, which also bottled beer and soft drinks. Beer was transported in kegs via the Pennsylvania Railroad from Erie to Titusville, where it was bottled for local distribution. (*Titusville Herald* collection.)

The Titusville Iron Works machine shop, assembly floor, iron and brass foundry, and boiler fabrication shop on South Franklin Street are visible in this view from 1904. Railroad cars appear on the Pennsylvania Railroad siding. Scrap metal from this and other factories was collected and loaded for Pittsburgh-area steel mills in the adjacent storage yard, operated by the Pennsylvania Railroad. (Jane Hayes collection.)

Passengers waiting for a train at Miller Farm Station around 1910 are, from left to right, Clyde Waddell, Jennie Hamilton, Margaret Gilson, William Hamilton, Ruth Gilson, Joe Hamilton, Florence Hamilton, and George Waddell. Clyde and George Waddell were the cousin and uncle respectively of baseball hall-of-famer George "Rube" Waddell, who pitched for the Pittsburgh Pirates, Chicago Cubs, Philadelphia Athletics, and St. Louis Browns. George Waddell briefly lived in Titusville and was the first left-handed pitcher elected to the Baseball Hall of Fame. (Titusville Historical Society collection.)

21

A Pennsylvania Railroad steam locomotive wrecked west of Titusville near the Kerr Milling Company building on January 27, 1910. Two locomotives on a freight train derailed at a gravel pit just outside of the Titusville city limits. Train crewmembers Fred Warren, William Pastorius, V.H. Hughes, and Mitchell Wall were killed. (*Titusville Herald* collection.)

Charred remains of the barrel house are in view at the American Oil Works on South Brown and Water Streets in Titusville in November 1923. The gasoline cracking unit in the background touched off chain-reaction explosions when fumes from the railroad tank car ignited. At the Pennsylvania Railroad siding, gasoline from the Brundred Oil Corporation compressor plant at Columbia Farm was being unloaded from this car for blending. (*Titusville Herald* collection.)

This is an aerial view of the mill of the Universal-Cyclops Steel Company (which became a corporation in 1950) at East Spring and Caldwell Streets in Titusville in 1936. The company was once a major supplier of tool steel to Baldwin Locomotive Company of Philadelphia. Cities Service tank cars were on the siding at the rear of the steel mill and would eventually end up at the oil refinery. In 2011, buildings visible on the left side of the picture are occupied by the Titusville Opportunity Park. (David L. Weber collection.)

This is an aerial view of the Herlehy Machine Shop, Feinberg Scrap Metal Yard, Pennsylvania Refining Company (formerly American Oil Works), and Titusville Forge Division of Struthers Wells Corporation at Spring, Brown, and Water Streets in Titusville in 1938. Trackage of the Pennsylvania Railroad and New York Central Railroad is visible in this picture. Universal-Cyclops plant buildings are at the far right of the picture. (*Titusville Herald* collection.)

Titusville Iron Works Division of Struthers Wells Corporation, the Pennsylvania Railroad freight house (current Oil Creek and Titusville Railroad Perry Street Station), and United Hardware and Supply Company warehouses are in this aerial view of South Perry Street in Titusville in 1946. The Titusville Iron Works Division of Struthers Wells Corporation plant, a manufacturer of World War II defense items including gun barrels and howitzer shells, manufactured steam generators and rotary drilling rigs during peacetime. (*Titusville Herald* collection.)

The Cities Service Oil Refinery, Titusville's last operating oil refinery, is shown at East Main and Spring Streets in Titusville with a tank car visible at the Pennsylvania Railroad siding in 1948. This 3,500-barrel-per-day-capacity refinery, also served by the New York Central Railroad, closed in 1950. Trans Penn Wax Company, now International Waxes Limited, purchased the former refinery site in November 1950. (*Titusville Herald* collection.)

Car tanks built for the Union Tank Car Company of Chicago leave the Titusville Forge Division of Struthers Wells Corporation on flatcars via the Pennsylvania Railroad at Water Street around 1949. Titusville Forge was founded in 1897, specialized in crankshafts for diesel engines, and had a welding department that could handle the fabrication of car tanks. (David L. Weber collection.)

A heavy-welded fractionating tower built for the Pennzoil refinery of Rouseville is leaving the Perry Forge building (Boiler Shop Department) of the Titusville Iron Works Division of Struthers Wells Corporation on two Pennsylvania Railroad flatcars around 1950. The small brick building in the background was formerly part of the Titusville Oil Works refinery, which ended operations in 1930. (David L. Weber collection.)

This is an interior view of the Perry Forge building of the Titusville Iron Works Division of Struthers Wells Corporation around 1950. During World War II, the plant received steel ingots via the Pennsylvania Railroad from Erie Forge and Steel, Sharon Steel Corporation mills at Farrel, and other firms. Items later produced here included aluminum railroad car tanks for the Union Tank Car Company and storage tanks used by the space program to hold rocket fuel. (David L. Weber collection.)

This aerial view of the Titusville Iron Works Division of Struthers Wells Corporation at South Franklin, Mechanic, and South Perry Streets in Titusville around 1952 looks west. The Pennsylvania Railroad freight house (the present Perry Street station of the Oil Creek and Titusville Railroad) and the Pennsylvania Railroad Titusville freight yard are in the upper center of the picture. The Pennsylvania Railroad passenger depot is at the center left. (David L. Weber collection.)

This is a west-looking aerial view of the Universal-Cyclops Steel Corporation mill (center foreground) and the Titusville Forge Division of Struthers Wells Corporation in 1956. The New York Central Railroad Titusville yard is visible on the left of the picture. The Pennsylvania Railroad supplied these plants with steel ingots from a number of mills. (*Titusville Herald* collection.)

Industrial activity can be seen on the east end of Titusville in this 1959 view of the Titusville Forge Division of Struthers Wells Corporation, Universal-Cyclops Steel Corporation, and Trans Penn Wax Company. Freight cars are on the New York Central Railroad tracks on the right side of the picture. The Quaker State Oil Refining Corporation pipeline system and storage tanks at the upper center of the picture were removed after 1990. (David L. Weber collection.)

This is an aerial view of the Fisher and Young Saw Mill in East Titusville in 1960. Hardwood lumber and waste wood chips were shipped by rail from this facility. American Hardwoods purchased the mill in 1973. Weyerhaeuser Choice Woods was operating a planing mill at this site in 2010. The New York Central Railroad trackage in the picture is still used by the Oil Creek and Titusville Railroad. (*Titusville Herald* collection.)

This is a 1963 aerial view of downtown Titusville looking north. A Pennsylvania Railroad yard switch engine is pulling a tank car for the Trans Penn Wax Company, a gondola car, and a flatcar at the bottom of the picture. The former New York Central Railroad passenger station is north of the railroad tracks on the right side of the picture. (*Titusville Herald* collection.)

Two

PENNSYLVANIA RAILROAD

On July 31, 1900, the Pennsylvania Railroad took over the Western New York and Pennsylvania Railway. The *Titusville Herald* of April 25, 1931, reported that on Sunday, April 26, 1931, the early-morning and late-evening passenger and mail trains between Oil City and Corry would be discontinued. The trains were being operated at a loss. To reduce expenses, the Pennsylvania Railroad moved its freight office from the South Perry Street freight station to the east end of the passenger station between Franklin and Washington Streets, effective May 23, 1932.

The Pennsylvania Railroad discontinued two midday passenger trains through Titusville, effective April 30, 1933. This left only two northbound and two southbound passenger trains stopping at Titusville. On April 28, 1935, these trains were restored. The Pennsylvania Railroad operated special passenger train service for the Diamond Jubilee of Oil at Titusville on August 25–27, 1934. The roundtrip fare was 80¢, and trains left Oil City for Titusville at 9:30 a.m. and 1 p.m. The return trips left Titusville at 6:35 p.m. and 10:30 p.m. Shuttle service between Titusville and Drake Memorial Park was also offered at frequent intervals between 10:15 a.m. and 5:30 p.m. The roundtrip fare was 20¢. Few people used the shuttle train, but some of the special trains from Oil City were well patronized, according to the *Titusville Herald* of August 27, 1934. On September 11, 1951, the Pennsylvania Railroad filed with the Pennsylvania Public Utility Commission to remove the Oil City–via–Titusville–to–Corry passenger service. Hearings were postponed while the Pennsylvania Railroad conducted a three-month test period from November 1, 1951, to January 31, 1952, after which the railroad noted that it was losing $57,663 per year on the service. From October 18, 1951, to April 30, 1952, an average of eight passengers were carried per train in each direction. Permission was received to discontinue the service. The final passenger train was operated from Oil City via Titusville to Corry on June 9, 1953.

The merger of the Pennsylvania Railroad and New York Central Railroad into the Penn Central Transportation Company on February 1, 1968, ended in bankruptcy on June 21, 1970. Consolidated Rail Corporation, created by the US government to take over the bankrupt railroad, began operation on April 1, 1976. Trackage from Titusville north was abandoned in 1977, and the last train from Corry to Brocton, New York, was on December 29, 1978. On February 4, 1984, Consolidated Rail Corporation abandoned the line from Rynd Farm to Titusville.

Company K of the Pennsylvania National Guard is leaving the Pennsylvania Railroad station at Titusville on April 27, 1898. National Guard troops from Crawford, Venango, Warren, and McKean Counties took part in the Spanish-American War in 1898. These infantry units, which served in Puerto Rico, were among the most decorated from that conflict, second only to Theodore Roosevelt's famed 1st US Volunteer Cavalry, also known as the Rough Riders. (Titusville Historical Society collection.)

A Pennsylvania Railroad passenger train is passing Hydetown Crossing in this photograph looking southeast toward Titusville. Trolley car passengers on the left side of the picture had to cross the railroad tracks on foot to change cars, because the Pennsylvania Railroad did not permit the Titusville Electric Traction Company to cross its tracks at Hydetown. (Titusville Historical Society collection.)

Table 69—BUFFALO DIVISION.—Buffalo and Oil City.

May 28, 1916.

904	950	902	900	952	926	Mls.	(Exchange Street.)	911	951	907	909	953	935
P M	P M	P M	A M					A M	Noon	P M	P M	P M	P M
*11 10	†3 20	*1 10	*9 15			0	lve.+Buffalo (E.T.) ö ar.	7 15	12 25	5 45	8 25		
	3 35					5.5	Lackawanna		12 05				
	3 40		9 34			7.5	+Blasdell	e6 43	12 01	5 15	e800		
	3 45					11.1	Cemetery		11 55				
	3 50					13.0	Wanakah		11 51				
	3 52					14.0	Shaleton		11 49				
	3 55		9 47			15.6	+Lake View ö		11 46	5 03			
	3 57					16.5	North Evans		11 44				
	4 01		9 52			18.4	+Derby ö		11 40	4 58			
						21.1	Pikes Crossing		11 34				
11 51	4 10		10 00			22.8	+Angola ö	6 21	11 31	4 50			
	4 17		10 07			27.1	Farnham		11 23	4 40			
	4 19		10 10			28.8	+Irving ö		11 19	4 40			
12 06	4 25		10 18			32.7	+Silver Creek ö	6 07	11 12	4 24			
	4 36		10 25			36.5	Sheridan		11 04	4 25			
12 26	4 48	2 07	10 40			42.3	+Dunkirk ö	5 51	10 53	4 11	7 13		
	4 56					46.0	Van Buren		10 39				
12 41	5 05		10 57			50.7	+Brocton ö	5 36	10 32	3 55			
	5 25		11 17			58.6	+Prospect ö		10 18	3 42			
1 17	5 45	2 48	11 34			65.1	arr.+Mayville ö lve.	5 15	10 07	3 27	6 39		
1 17	5 45	2 48	11 34			65.1	lve.+Mayville arr.	5 15	10 07	3 27	6 39		
	5 55		11 46			71.0	+Summerdale ö		9 54	3 10			
1 36	6 03	3 10	11 54			74.6	+Sherman ö	4 54	9 47	3 04	6 17		
	6 19		12 06			81.6	+Panama ö		9 37	2 52			
1 53	6 33		12 14			85.8	+Clymer ö		9 30	2 43			
		3 38				92.6	Columbus Ave. (Corry)					5 49	
1 59	6 53		12 28			94.5	arr.+Corry ö lve.	4 15	9 13	2 25			
2 04	7 10		12 32	*9 20		94.6	lve.+Corry arr.	4 15	9 05	2 17		6 49	
	7 23		9 33				Ormsbee Road		8 52			6 36	
						98.9	Summit						
	7 30		12 52	9 42		102.3	+Spartansburg ö		8 44	1 59		6 28	
	7 36			9 50		106.2	+Glynden ö		8 38			6 21	
	7 42	1 04	9 57			109.6	+Centreville ö		8 31	1 48		6 14	
	7 46		10 02			111.8	+Tryonville ö		8 25			6 05	
						114.2	Gray's Mills						
	7 56					117.0	+Hydetown ö		8 16			5 56	
3 05	8 04	4 22	1 28		*7 30	120.5	+Titusville	3 28	8 09	1 30	5 06	5 50	7 10
	8 10					123.4	+Boughton ö		7 58			5 42	7 02
	8 15					125.9	Miller Farm		7 53			5 37	6 58
						129.1	Pioneer						
	8 24		2 00			130.6	Petroleum Centre ö		7 40			5 28	6 48
						132.0	Columbia						
	8 32					132.6	Rynd Farm		7 31			5 20	6 39
	8 36					134.5	+Rouseville ö		7 28			5 18	6 36
3 45	8 45	4 55	2 00	11 00	8 05	137.5	+Oil City ö	*2 54	7 20	*12 55	*4 32	*5 10	†6 25
A M		P M	P M		Noon		ARRIVE] [LEAVE	A M	A M	Noon	P M	P M	P M
3 58		5 01	2 10		8 15	137.5	lve. Oil City arr.	2 40		12 45	4 22		6 15
4 21		5 21	2 33		8 39	146.8	arr. Franklin lve.	2 16		12 23	4 00		5 49
5 10			3 19		9 34	185.0	arr. Foxburg lve.	1 24		11 33			4 40
5 17			3 25		9 40	187.7	arr. Parkers Landing lve.	1 17		11 26			4 34
7 33		8 10	5 35		12 25	267.1	arr. East Liberty lve.	11 17		9 27	c121		1 41
7 45		8 20	5 45		12 35	270.6	arr. Pittsburgh lve.	*11 05		*9 15	*110		†1 30
A M		P M	P M		Noon		(Eastern time.)	P M		A M	P M		P M

Vertical notes: 950 — First trip June 26th, Last trip September 5th. 952 — Last trip September 5th. 907 — First trip June 26th. 909 — Last trip September 5th.

Legend: Trains marked * run daily, except Sunday; † daily; e regular stop to receive passengers; b stops on notice to conductor to leave passengers; ö stops to leave from Oil City and beyond. ‖ Meals.

THROUGH CAR SERVICE.—Coaches on all trains unless otherwise noted.

No. 907—Broiler Buffet Parlor Car Pittsburgh to Buffalo. No. 909—Parlor Car and Restaurant Car Pittsburgh to Buffalo. Drawing-room Sleeping Car Pittsburgh to Muskoka Wharf week-days (June 29th to September 4th). No. 911—Drawing-room Sleeping Car Pittsburgh to Buffalo (open 9 30 p.m.). Drawing-room Sleeping Car Pittsburgh to Olean (open 9 30 p.m.) (running on train No. 9131 from Oil City). Drawing-room Sleeping Car Pittsburgh to Mayville (open 9 30 p.m.) (June 23d to September 3d). No. 953—Drawing-room Sleeping Car Oil City to Washington, via Central Division train No. 580. No. 900—Broiler Buffet Parlor Car Buffalo to Pittsburgh. No. 902—Parlor Car and Restaurant Car Buffalo to Pittsburgh. No. 904—Drawing-room Sleeping Car Buffalo to Pittsburgh (open 10 00 p.m.). Drawing-room Sleeping Car Olean to Pittsburgh (running on train No. 9134 Olean to Oil City). Drawing-room Sleeping Car week-days (June 30th to September 5th). Muskoka Wharf to Pittsburgh. Drawing-room Sleeping Car Mayville to Pittsburgh (open 10 00 p.m.) (June 25th to September 5th). No. 925—Broiler Buffet Parlor Car Oil City to Pittsburgh. No. 952—Drawing-room Sleeping Car Washington to Oil City, via Central Division train No. 579.

The May 28, 1916, Pennsylvania Railroad schedule shows four southbound and four northbound passenger trains Monday through Saturday and three in each direction on Sunday from Buffalo via Corry, Titusville, and Oil City to Pittsburgh. Locally from Corry to Oil City, five passenger trains ran in each direction Monday through Saturday, and four passenger trains ran in each direction on Sunday. Between Titusville and Oil City, six passenger trains ran in each direction Monday through Saturday and four in each direction on Sunday.

Table 70—ALLEGHENY DIVISION.—Olean and Oil City.

9134	9132	Mls.	May 28, 1916. (Eastern time.)	9131	9143
PM	AM	(Eastern time.)	AM	PM
*513	†740	0	lve....Olean δ....arr.	11 40	8 45
5 20	7 48	3.0Allegany......	11 28	8 34
5 53	7 59	9.3Vandalia...... δ	11 15	8 20
5 58	8 03	11.6	arr..Riverside Junc..lve.	11 06	8 15
7 05	8 40	20.9	arr..+Bradford δ..lve.	*9 15	†7 40
*450	†740	20.9	lve...Bradford...arr.	11 30	8 35
5 38	8 08	11.6	lve..Riverside Junc..arr.	11 06	8 13
5 42	8 12	13.6	+....Carrollton....δ	10 49	8 06
5 53	8 24	19.3	+...Salamanca....δ	10 48	7 54
6 03	8 34	25.3	+....Red House....δ	10 35	7 42
6 15	8 44	31.2	+...Quaker Bridge..δ	10 24	7 31
6 20	8 49	33.3	+.....Wolf Run....δ	10 18	7 24
6 25	8 54	36.4Onoville.....	10 12	7 18
6 31	8 59	39.1	+....Corydon....	10 06	7 12
6 48	9 11	45.6	+....Sugar Run....δ	9 53	6 59
6 54	9 17	47.8	+....Kinzua....δ	9 48	6 54
7 10	9 33	54.2Hemlock....	9 33	6 40
7 24	9 48	59.2	+....Struthers....δ	9 23	6 28
7 30	9 57	60.5	+.....Warren....δ	9 18	6 21
7 41	10 07	66.3	arr..+Irvineton δ lve.	9 03	6 07
7 59	10 07	66.3	lve..Irvineton..arr.	8 50	6 07
8 12	10 19	72.8Althom....	8 36	5 53
8 29	10 36	81.0	+....Tidioute....	8 20	5 35
8 47	10 53	89.6	+...West Hickory..	8 02	5 15
9 02	11 06	95.9	+.....Tionesta....δ	7 48	5 01
9 07	11 11	98.8Hunter....	7 41	4 54
9 15	11 19	103.1President....	7 32	4 45
9 18	11 22	104.2	+....Eagle Rock....	7 28	4 42
9 26	11 30	107.4Oleopolis....	7 21	4 34
9 40	11 43	112.8	+....Rock'mere....δ	7 10	4 23
8 48	11 50	115.5Siverly....	7 03	4 17
9 53	11 55	116.5	arr..+Oil City δ..lve.	7 00	†4 12
3 58	2 10		lve....Oil City....arr.	2 40	12 45
4 21	2 33		arr...Franklin...lve.	2 16	12 23
5 17	3 25		arr..Parkers Landing..lve.	1 17	11 26
7 33	5 35		arr..East Liberty..lve.	11 17	9 27
7 45	5 45		arr..Pittsburgh..lve.	*1105	†9 15
AM	PM		(Eastern time.)	PM	AM

Drawing-room Sleeping Car on trains Nos. 9131 and 9134 between Pittsburgh and Olean.

Table 71—BETWEEN OLEAN AND BRADFORD.

NORTHERN DIVISION—Continued.

Table 72—BUFFALO DIVISION.—Rochester and Olean.

9336	9334	9332	Mls.	May 28, 1916. (W. Ave. Station.)	9331	9333	9335
PM	PM	AM	(W. Ave. Station.)	AM	AM	PM
†800	*5 00	*6 30	0	lve.+Rochester δ arr.	8 30	11 20	7 55
- -	5 12	6 42	5.8	...Genesee June...	8 15	11 07	7 41
8 25	5 26	6 54	12.4	+...Scottsville...δ	8 01	10 53	7 25
- -	5 49	7 15	23.8	+...Fowlerville...δ	7 37	10 27	6 58
- -	5 54	7 20	26.3	+.....York....δ	7 32	10 22	6 53
58 53	6 00	7 26	29.2	+.....Piffard....δ	7 26	10 16	6 47
9 13	6 07	7 34	33.0	+...Cuylerville...δ	7 06	10 06	6 38
9 13	6 27	7 44	36.8	+...Mount Morris..δ	6 50	9 55	6 27
9 21	6 37	7 56	40.6	+.....Sonyea....δ	6 42	9 47	6 17
9 31	6 47	8 14	45.2	+...Tuscarora...δ	6 31	9 37	6 04
- -	6 54	8 21	48.2	...Nunda June...	6 26	9 32	5 58
	7 10	8 27	50.6	arr..+Nunda δ .lve.	*6 20	†9 26	*5 52
9 43	PM	- -	50.3	...West Nunda...	AM		
- -		9 13	56.3	...Letchworth Park..		8 54	5 15
10 00		9 17	57.5	+...Portageville...δ		8 49	5 10
10 12		9 31	63.8	+...Rossburg....δ		8 36	4 58
10 24		9 43	67.7	+.....Fillmore....δ		8 26	4 46
10 33		9 55	71.9	+...Houghton....δ		8 16	4 35
10 40		10 06	74.9	+...Caneadea....δ		8 09	4 27
10 54		10 22	79.9	+.....Belfast....δ		8 00	4 16
11 13		10 46	86.2Black Creek....δ		7 44	3 55
11 25		11 01	91.0	+......Cuba......δ		7 35	3 45
11 40		11 17	98.6	+....Hinsdale....δ		7 20	3 30
11 55		11 30	105.6	arr..+Olean δ .lve.		†7 10	*3 20
PM		AM		(Eastern time.)		AM	PM

+ Coupon stations. δ Telegraph stations.

PENNSYLVANIA SYSTEM — PENNSYLVANIA RAILROAD

Adams Express Company

The Oil City–Olean, New York line of the Pennsylvania Railroad schedule of May 28, 1916, had two passenger trains in each direction Monday through Saturday and one passenger train in each direction on Sunday. Oil City was a regional passenger railroad hub. At Olean, connections could be made to Rochester, New York, and Bradford, Pennsylvania.

A Pennsylvania Railroad train is in downtown Corry over a flooded Center Street in this early scene looking north around 1900. The freight car in the lower right corner of the picture is a boxcar on the Erie Railroad, which crossed the Pennsylvania Railroad one block east of this spot at Maple Street. Oil was shipped from Titusville to Corry by railroad, and Corry become a regional marketplace. Corry began when the Atlantic and Great Western Railroad (later Erie Railroad) crossed the Sunbury and Erie Railroad (later Pennsylvania Railroad) on May 27, 1861.

This Erie Railroad passenger train has stopped at Corry, an important railroad center, around 1910. The straight trackage on the left side of the photograph was the Philadelphia-to-Erie line of the Pennsylvania Railroad. Titusville residents enjoyed convenient railroad passenger service to Corry, where connections could be made to many locations. Corry grew rapidly, having its first borough council meeting on August 22, 1863, and it was incorporated as a city on March 8, 1866.

P. R. R. Station, Titusville, Pa.

Around 1910, no passengers are in sight at the Pennsylvania Railroad station midway between Washington and Franklin Streets in Titusville. The station was completed on February 20, 1871, at a cost of $35,000, and that year, about 9,000 passengers per month boarded trains there. The station remained in use until passenger service was discontinued on June 9, 1953. By July 30, 1964, it had been razed. (*Titusville Herald* collection.)

Union Station, Oil City, Pa.

Union Station appears as an important rail transportation hub in downtown Oil City, as shown in this postcard mailed on September 11, 1912. The Erie Railroad had four trains in each direction Monday through Saturday and three on Sunday on its Oil City–to–Meadville line, according to its schedule from May 28, 1916. The Pennsylvania Railroad had passenger service to many locations, including Pittsburgh, Buffalo, and Olean.

34

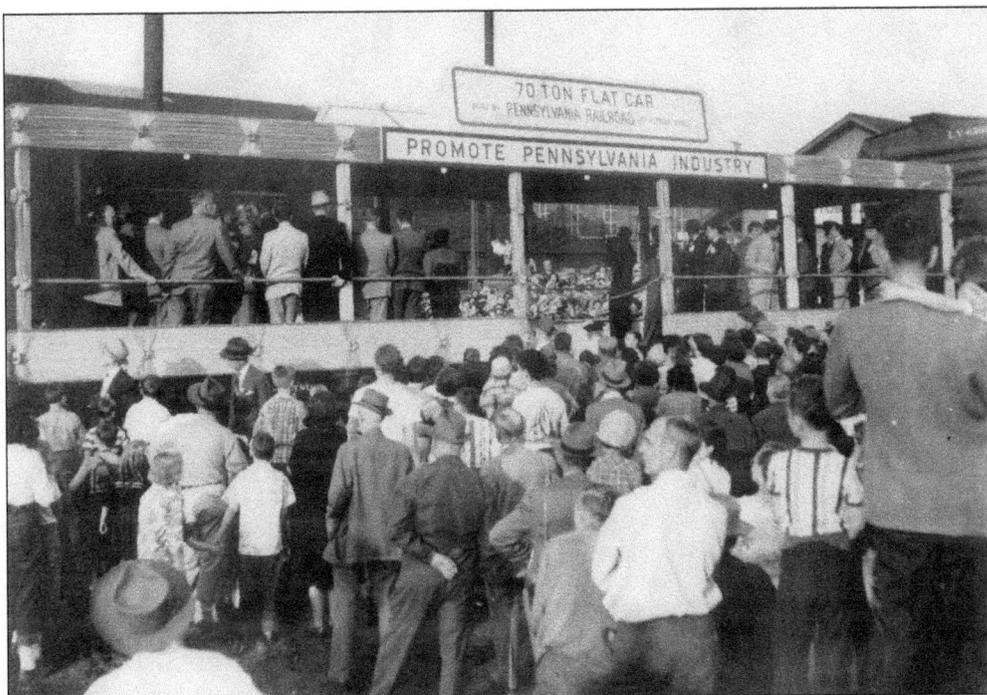

About 5,000 people are at the Pennsylvania Railroad freight station at South Perry Street in Titusville viewing the 70-ton flatcar built by the Pennsylvania Railroad Altoona shops. The flatcar was part of the special Pennsylvania Week train that ran on October 18, 1950. Passengers could enjoy entertainment at the 50-minute stop, and Ezra Stone, famous for his radio role as Henry Aldrich, was master of ceremonies. Pictured in the upper level, fifth from left, is film, stage, and television actress Alexis Smith. (*Titusville Herald* collection.)

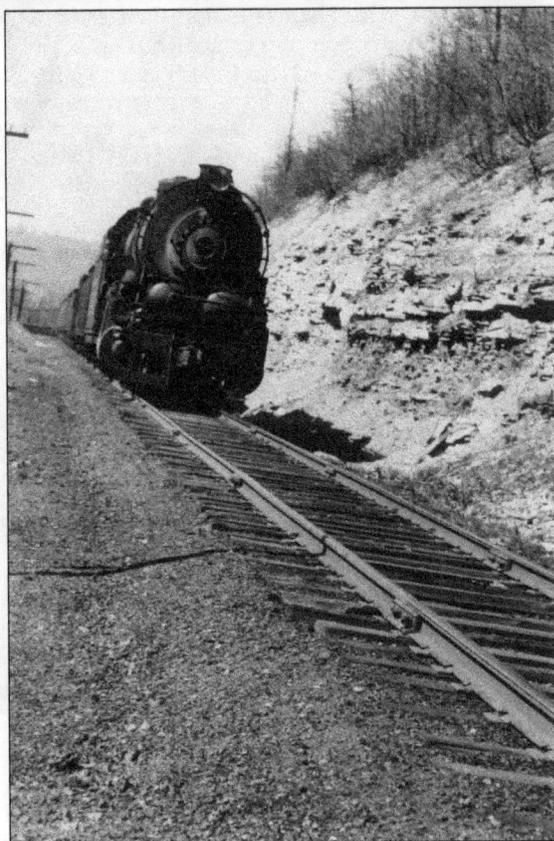

A Pennsylvania Railroad freight train is southbound from Titusville near Drake Well Park around 1950. Photographer Richard Kookogey captured this scene of one of the last steam locomotives operating in the Oil Creek Valley. The trackage now belongs to Oil Creek and Titusville Railroad. (*Titusville Herald* collection.)

Vice presidential candidate Richard M. Nixon and his wife, Pat, are at Titusville for a campaign stop on October 10, 1952. The *Titusville Herald* of October 11, 1952, noted that Nixon "spoke from the rear platform of his campaign train before a crowd estimated by police at 2,000 along the Pennsylvania Railroad tracks at South Monroe Street." (*Titusville Herald* collection.)

During his run for vice president, then-senator Richard M. Nixon is giving a campaign speech on his special Pennsylvania Railroad passenger train at South Monroe Street in Titusville on October 10, 1952. The train had made campaign stops at New Castle, Franklin, and Oil City. After leaving Titusville, the train stopped at Corry and Erie. (*Titusville Herald* collection.)

The campaign train of vice presidential candidate Richard M. Nixon, powered by class M1 Mountain type Pennsylvania Railroad steam locomotive No. 6925 with a 4-8-2 wheel arrangement, is northbound from Titusville near Spartansburg for its next stop at Corry on October 10, 1952. During the 1952 campaign, Nixon covered smaller communities, and presidential candidate Dwight D. Eisenhower covered the bigger cities. (Oil Creek and Titusville Railroad collection.)

Pennsylvania Railroad passenger train No. 980 is shown at the Kerr Milling Company building (erected in 1918–1919) in Titusville northbound to Corry. The timetable from October 31, 1948, shows No. 980 as the afternoon local daily train from Oil City via Titusville to Buffalo, New York. In the morning, it operated daily as train No. 981 from Buffalo via Titusville to Oil City. There was also one passenger train in each direction between Oil City and Pittsburgh. (Oil Creek and Titusville Railroad collection.)

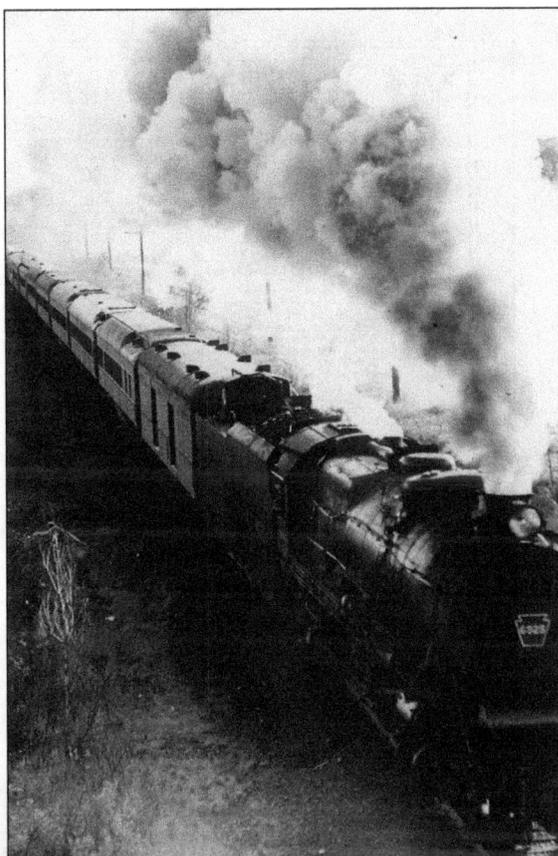

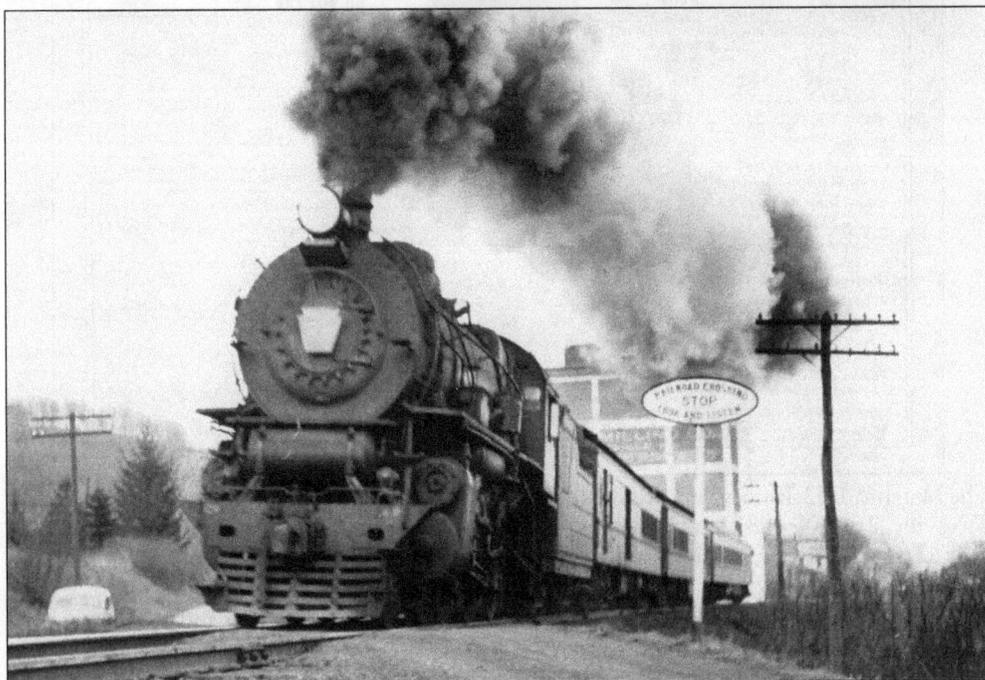

PENNSYLVANIA RAILROAD
Serving the Nation

For Through Car Service, see page 341.

Table 142.
NEW YORK, PHILADELPHIA AND WASHINGTON TO ERIE.

581-981	1-581-981	Mls.	March 2, 1952. Eastern time.	580-980-68-36	
			LEAVE [ARRIVE	A M A M A M	
	*PM	New York....	A M A M A M	
	o645		+.....Pennsylvania Station	8 55 f734 ü045	
	o630		Hudson Term. (H. & M. R.R.)	9 10 f930 ü103	
	o659		+.........Newark....	8 40 f919 ü029	
	o743		+.........Trenton....	7 50 -- ü943	
P M	c8 11		lve..+North Phila..arr.	ü720 -- -- --	
*810			lve..+Phila.(Broad St.) arr.	f7 38 §8 56	
815			lve..+Penn.Sta.(30th St.) arr.	d731 c8 46	
847	839		lve....+Paoli....arr.	d655 d705 §8 22	
957	923		lve..+Lancaster....arr.	6 05 f6 12 §7 12	
10 40	10 00	Harrisburg....	*530 f5 35 §6 30	
P M	P M		ARRIVE [LEAVE	A M A M A M	
P M			LEAVE [ARRIVE	A M	
*745			+.....Washington....	*8 25	
832			lve.+Baltimore..arr.	7 38	
1002			lve.....+York....arr.	5 52	
1045			lve.....Harrisburg....	5 15	
P M			ARRIVE [LEAVE	A M	
P M			LEAVE [ARRIVE	P M	
*400			+.....Pittsburgh..	u415	
947		Harrisburg....	8 10	
P M			ARRIVE [LEAVE	A M	
P M			LEAVE [ARRIVE	A M	
*1100	0		+.....Harrisburg....	4 40	
12 12	53.4		+.....Sunbury....	3 27	
1 25	93.3		+.....Williamsport....	1 54	
2 00	117.8		+.....Lock Haven....	1 20	
2 58	145.8		+.......Renovo....	12 30	
3 59	191.0		arr..+Emporium..lve.	11 20	
3 59	191.0		lve..+Emporium..arr.	11 20	
4 46	212.7		+.......St. Marys....	10 35	
5 21	223.1		+.......Ridgway....	10 09	
5 41	230.8		+.....Johnsonburg....	9 39	
*553	237.3		+.......Wilcox....	A912	
6 25	246.3		+.........Kane....	8 55	
6 53	261.9		+.......Sheffield....	8 17	
7 29	275.3		+.......Warren....	7 52	
t745	283.7		+.....Youngsville....	t723	
8 20	303.9		+.........Corry....	*655	
A M			ARRIVE [LEAVE	P M	
A M			LEAVE [ARRIVE	P M	
*8 45	303.9	Corry....	6 20	
9 30	331.4	Titusville....	5 17	
10 15	348.4	Oil City....	*4 45	
A M			ARRIVE [LEAVE	P M	
A M			LEAVE [ARRIVE	P M	
*8 40	303.9	Corry....	6 45	
8 58	314.9		+.....Union City....	6 27	
f913	322.6		+.....Waterford....	-- --	
10 00	340.3		+.........Erie....	*5 45	
A M			ARRIVE [LEAVE	P M	

EXPLANATION OF SIGNS.

* Daily.
† Daily, except Sunday.
‡ Daily, except Saturday.
¶ Daily, except Monday.
§ Sunday only.
a Passengers for New York transfer at Pennsylvania Station (30th St.) on Sunday.
c Stops only to receive passengers.
d Stops only to discharge passengers.
e Stops only to discharge passengers on Sunday.
f Stops only on signal or notice to agent or conductor to receive or discharge passengers.
h Stops on signal to discharge passengers from Corry and beyond and to receive passengers for Renovo and beyond.
i Passengers for New York transfer at Pennsylvania Station (30th St.).
k Saturday only.

Table 143.
PHILADELPHIA AND WASHINGTON TO CANANDAIGUA AND ROCHESTER.

581-575-595	Mls.	March 2, 1952.	596-580-36	598-580-36	
		Eastern time.			
P M		lve.....+North Phila...arr.	A M A M A M		
*810		lv..+Phila.(Broad St.)...arr.	f7 35 §8 50 □735		
815		lve..+Pa.Sta.(30th St.)..arr.	d731 c8 46 §7 31		
847		lve.......+Paoli....arr.	d705 §8 22 §7 05		
957		lv...+Lancaster....ar.	f6 12 §7 12 □612		
1040	Harrisburg....	f5 35 §6 30 □535		
P M		ARRIVE [LEAVE	A M A M A M		
P M		LEAVE [ARRIVE	A M A M		
*745		+.....Washington....	§8 25 8 25		
832		lv.+Baltimore....ar.	7 38 7 38		
1002		lve.......+York....arr.	5 52 5 52		
1045	Harrisburg....	5 15 5 15		
P M		ARRIVE [LEAVE	A M A M		
P M		LEAVE [ARRIVE	A M A M		
*1120	0	+.....Harrisburg....	4 40 4 40		
12 34	53.4Sunbury....	3 27 3 27		
1 25	93.3	arr.+Williamsport.lve.	†2 21 □221		
A M		LEAVE [ARRIVE	A M A M		
*305	93.3Williamsport....	f147 □125		
†344	117.0Ralston....	f1259 f1244		
f349	121.1Roaring Branch....	f1252 f1236		
4 13	131.3	+.......Canton....	12 34 12 21		
4 34	143.5	+.........Troy....	f1208 □1201		
5 15	168.1	arr.+Elmira....lve.	†1120 §H 18		
5 24	168.2	lve.....+Elmira....arr.	10 55 11 08		
5 36	173.4	+.....Horseheads....	f1046 f1057		
5 58	186.4	+.....Montour Falls....	10 18 10 32		
6 08	189.7	+.....Watkins Glen....	10 12 10 26		
f6 32	200.6	+.......Starkey....	f9 53 f1007		
f6 40	204.6	+.......Himrod....	-- --		
6 58	212.2	+.......Penn Yan....	9 37 9 51		
7 15	220.0	+.........Hall....	9 19 9 34		
7 20	224.6	+.......Stanley....	f915 f929		
7 50	236.4	arr..+Canandaigua.lve.	†855 §910		
		(New York Central)	P M P M		
§9 05		lve....Canandaigua...arr.	8 02 8 02		
§10 05		+.......Rochester....	7 10 7 10		
11 45	Buffalo (Cent. Term.)....	†445 §445		
A M		ARRIVE [LEAVE	P M P M		

Table 144.
OIL CITY AND CORRY.

No. 980	Mls.	March 2, 1952.	No. 981	
*4 45 P M	0	+........Oil City....	10 15 A M	
4 52 "	2.9	+.......Rouseville....	10 00 "	
f5 02 "	7.0	+.....Petroleum Center....	f9 50 "	
5 17 "	17.0	+.......Titusville....	9 30 "	
f5 42 "	25.6	+.......Tryonville....	9 17 "	
5 48 "	27.8	+.......Centerville....	9 13 "	
6 01 "	35.0	+.....Spartansburg....	9 01 "	
6 20 P M	44.5	+.........Corry....	*8 45 A M	
		ARRIVE [LEAVE		

n Stops only on signal to discharge passengers from Renovo and beyond and to receive passengers for Corry and beyond.
p Stops only to discharge passengers Mondays only.
u On Sunday arrives Pittsburgh 2 45 p.m.
v Stops only to receive passengers for points west of Philadelphia.
y Daily, except Sunday and Monday.
□ Monday only.
On Sunday leaves Canandaigua 8 46 a.m., arrives Rochester 9 36 a.m.
‖ Meals.
+ Coupon stations.
STANDARD — Eastern time.
■ Rail-Auto Service available at this point.

The March 2, 1952, Pennsylvania Railroad schedule shows one daily train in each direction serving Titusville. Train No. 980 left Oil City at 4:45 p.m., arriving at Titusville at 5:17 p.m. and Corry at 6:20 p.m., where connection was made at 6:55 p.m. for Harrisburg, Baltimore, Washington, Philadelphia, and New York City. The train from the East Coast arrived at Corry at 8:20 a.m., where train No. 981 left Corry at 8:45 a.m., arriving at Titusville at 9:30 a.m. and Oil City at 10:15 a.m. Trains Nos. 980 and 981 made their last run on March 9, 1953. Oil City–to–Pittsburgh and Corry-to-Buffalo railroad passenger service made its last run on January 8, 1950.

Class G5s steam locomotive No. 5738 with a 4-6-0 wheel arrangement is powering Pennsylvania Railroad train No. 980 as it passes through Drake Well Park northbound on its way to Titusville and Corry in June 1953. At Corry, the Pullman car from this train was switched to train No. 580 en route to Harrisburg and Philadelphia. (Oil Creek and Titusville Railroad collection.)

The Titusville passenger station is the scene of the last run for Pennsylvania Railroad passenger train No. 980, powered by steam locomotive No. 5746 on June 9, 1953. This trip ended passenger service to Titusville. The Italian villa–style station, built by the Oil Creek and Allegheny River Railroad, opened on February 20, 1871. (Donald Kaverman/Harold O. Myers collection.)

Conductor J.A. McCoy waves goodbye on the last Pennsylvania Railroad passenger train leaving Titusville on June 9, 1953. This final northbound run to Corry also carried a Railway Express shipment of radio and television tube bases manufactured by the Ruel Smith Enterprises plant (later General Telephone and Electronics–Sylvania) near Titusville. (*Titusville Herald* collection.)

Titusville's last passenger train No. 980 is leaving for its northbound run to Corry on June 9, 1953. The *Titusville Herald* newspaper from June 10, 1953, reported the train ridership: "258 fares for various destinations between Oil City and Corry, 20 riders on passes, and about 50 children under five riding free." (Oil Creek and Titusville Railroad collection.)

At 6:15 a.m. on June 1, 1956, 33 cars of a southbound 66-car Pennsylvania Railroad train derailed because of a broken rail near the Titusville Country Club. The *Titusville Herald* of June 2, 1956, noted the train was "a Buffalo-Pittsburgh scheduled freight. It was pulled by Alco hood units Nos. 8460 and 8457." The wreck tore up about 900 feet of track. (*Titusville Herald* collection.)

On June 1, 1956, a special Pennsylvania Railroad train with two locomotives and a big-hook derrick are en route from the Oil City yard, arriving at 9:30 a.m. to clear up the derailment near the Titusville Country Club. Within a day, the track was back in service, but it took several days to remove all the wrecked cars and complete the track rebuilding. (*Titusville Herald* collection.)

A Pennsylvania Railroad diesel switcher is moving box cars past the Titusville Iron Works Division of Struthers Wells Corporation boiler shop department at South Perry Street in Titusville heading west around 1950. Railroads have played an important role in linking Titusville industries to the outside world in both wartime and peacetime. (*Titusville Herald* collection.)

Children are fascinated by the vintage locomotives on display at the Pennsylvania Railroad exhibit in Oil City in October 1957. The famous *Freedom Train* also occupied this siding when it visited Oil City on September 30, 1948. (*Titusville Herald* collection.)

Two young boys are viewing the John Bull locomotive of the Pennsylvania Railroad Historic Rolling Stock Traveling Exhibit in Oil City in October 1957. The display was adjacent to the Pennsylvania Railroad and Erie Railroad freight houses at Seneca and Elm Streets. The seldom-used station facilities were burned as part of Oil City's downtown redevelopment project five years after the exhibit. (*Titusville Herald* collection.)

The Pennsylvania Railroad locomotive *Pioneer* is on display at the Pennsylvania Railroad Historic Rolling Stock Traveling Exhibit in Oil City in October 1957. This was a great opportunity to showcase the railroad and bring to light the history of its growth and how it benefited the region. (*Titusville Herald* collection.)

A Pennsylvania Railroad section crew poses with their speeder car and its attached trailer car at the Titusville yard on August 8, 1958. Speeder cars were small, motorized vehicles used to take workers and supplies to railroad sites for inspection and maintenance purposes. They were replaced in the 1990s by motorized vehicles that can operate on roadways and on track by lowering flanged wheels. (*Titusville Herald* collection.)

A Pennsylvania Railroad section gang and their self-propelled, mobile track maintenance crane No. S5278 are in Titusville on August 8, 1958. Track repair had come along way from when workers nicknamed "gandy dancers" used handcars. Keeping a railroad line in good shape still required a lot of planning and hard work. (*Titusville Herald* collection.)

The locomotive and 19 freight cars are strewn about just south of the Mystic Park crossing, less than a quarter-mile north of the Hydetown borough line. The derailment that caused the mess took place at 4:50 a.m. on August 28, 1958. The train was southbound from Buffalo to the Conway yard near Pittsburgh. A salvage train with a big-hook derrick has arrived from Oil City. (*Titusville Herald* collection.)

Pennsylvania Railroad freight crewmembers discuss with the road foreman of engines the August 28, 1958, derailment that occurred north of the Hydetown borough line. From left to right are the following: H.C. McMullen, brakeman; J.P. Garvey, conductor; G.A. Sweeney, brakeman; E.F. Allen, fireman; R.P. Haslett, engineer; and an unidentified railroad official. (*Titusville Herald* collection.)

45

Pennsylvania Railroad workmen are using the big-hook derrick to lift diesel locomotive No. 9732 (a 1,600-horsepower type RF16 built by Baldwin Lima Hamilton in 1951) back on its front trucks so that it can be taken to the repair shop. This operation, which occurred at the August 28, 1958, derailment north of the Hydetown borough line, had to be skillfully performed to prevent the locomotive from toppling over. (*Titusville Herald* collection.)

Wrecked freight cars are being cleared from the track by the Pennsylvania Railroad derrick following the August 28, 1958, derailment north of the Hydetown borough line. Signal apparatus had fallen off the front of the locomotive, derailing the locomotive's front trucks, which began to tear up the track and caused the freight cars to derail also. (*Titusville Herald* collection.)

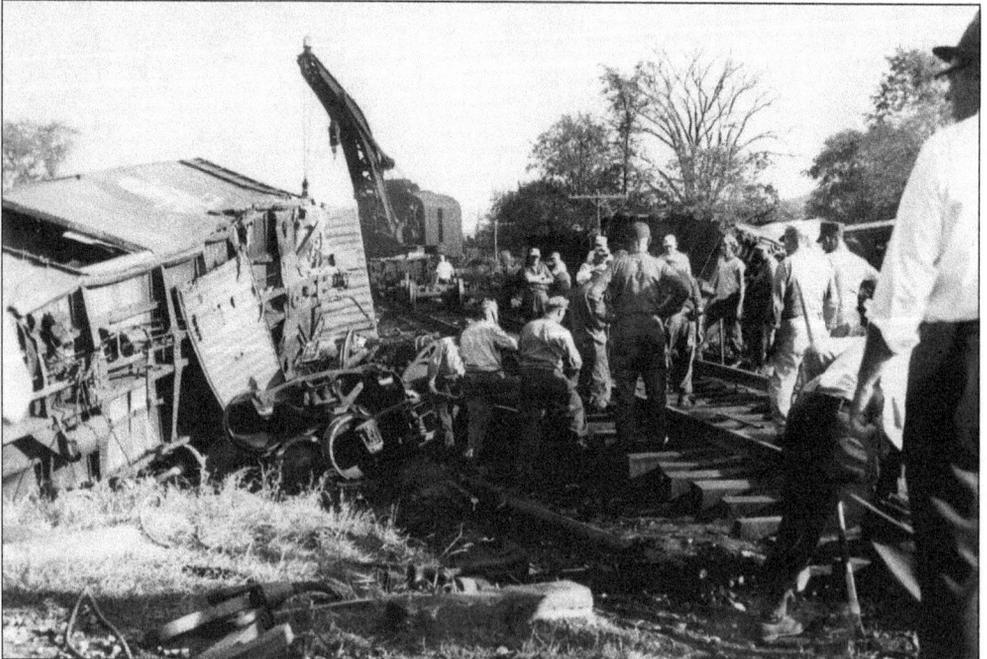

Pennsylvania Railroad crews are removing damaged derailed freight cars at the August 28, 1958, derailment north of the Hydetown borough line. Trucks were rented from Titusville to move some of the freight. The *Titusville Herald* of August 29, 1958, noted, "Cases of the 8 O'Clock brand coffee were passed in a human chain from inside the boxcar to the waiting trucks." (*Titusville Herald* collection.)

Railroad salvage crews are examining derailed boxcars at the August 28, 1958, derailment north of the Hydetown borough line. The *Titusville Herald* of August 29, 1958, reported, "One of the crew said the train was traveling 35 miles an hour, the speed limit for freights along that stretch, when the wreck occurred." (*Titusville Herald* collection.)

Residents from Titusville, Hydetown, and the surrounding area are watching the Pennsylvania Railroad crew clearing wreckage, repairing track, and transferring freight from the derailed freight cars to trucks. After the August 28, 1958, derailment north of the Hydetown borough line, there were over 100 railroad section men from all over western Pennsylvania and western New York State involved in the cleanup. (*Titusville Herald* collection.)

Freight trains roll by the site of the derailment north of the Hydetown borough line on August 28, 1958, after the wreckage was cleared and the track repaired. The crew had the line reopened for service in less than 24 hours. (*Titusville Herald* collection.)

On December 4, 1958, a northbound, 102-car Pennsylvania Railroad freight train had 10 cars that left the track at Drake Well Park by the Densmore tank-car display. The December 5, 1958, *Titusville Herald* noted, "A broken rail was the cause, a railroad spokesman said." The article continued, "The accident happened at 1:15 p.m. as the train was traveling north at 25 miles per hour." (*Titusville Herald* collection.)

Derailed boxcars are in view after the December 4, 1958, train wreck at Drake Well Park. The December 5, 1958, *Titusville Herald* reported, "An old fracture indicated that the rail had been cracked in the middle for some time. Two new breaks showed where the top part of the rail broke yesterday." The train was headed from Conway yard near Pittsburgh to Buffalo, New York. (*Titusville Herald* collection.)

A 15-ton shifting locomotive arrives at the Hasbrouck Scrap Iron and Metal yard at South Kerr Street in Titusville on June 17, 1959. Albert Hasbrouck is standing beside the locomotive, which was built in 1927 by the Brookville Locomotive Company. Powered by a four-cylinder McCormick-Deering gasoline engine, the locomotive was formerly used by the West Hickory Tannery of Forest County, Pennsylvania. (*Titusville Herald* collection.)

The former West Hickory Tannery locomotive is being unloaded at the Hasbrouck Scrap Iron and Metal Salvage yard in Titusville on June 17, 1959. The June 18, 1959, *Titusville Herald* noted, "For years the chain-drive locomotive shifted cars on the siding tracks of the tannery, moving its last car, a PRR boxcar loaded with leather, in 1952." (*Titusville Herald* collection.)

A Pennsylvania Railroad passenger train is leaving Corry bound for Erie in 1959. The Ajax Iron Works is in view on the left side of the picture. Corry's rail connections helped the city become a diversified manufacturing center with lumber, wood and metal furniture, leather tanning, machinery for oil fields and industrial power plants, locomotives, steel forging, dairy-product plants, and metal wire springs to absorb shocks (made by Raymond Spring Company, which later became Associated Spring Division of the Barnes Group). (*Titusville Herald* collection.)

A westbound Pennsylvania Railroad passenger train is leaving the station in Corry for Erie in 1959. Corry was a major railroad hub served by two Pennsylvania Railroad lines and one Erie Railroad line. At its peak, all three lines had railroad passenger service, providing the area with excellent access to the rest of the country. (*Titusville Herald* collection.)

Pennsylvania Railroad engineer J.S. Powers is looking out the cab window as fireman W.E. Schneider is demonstrating how to correctly board locomotive No. 9352 (a 44-ton, 400-horsepower diesel locomotive built by General Electric Company in 1949) in the Titusville yard behind the freight house on February 3, 1960. Pittsburgh Gauge and Supply Company warehouses are in the background. (*Titusville Herald* collection.).

Conductor Wilfred Grolemund is showing the correct way to climb onto a boxcar on the siding near the foot of South Monroe Street in Titusville during Pennsylvania Railroad's Safety Rules Competition on February 3, 1960. Safety programs were important for keeping railroad employees alert. (*Titusville Herald* collection.)

In the Pennsylvania Railroad Safety Rules Competition of February 3, 1960, conductor Wilfred Grolemund (left) and freight agent Gerald Wallace watch brakeman William B. Marsh throw a switch. The photograph was taken at the rear of the Titusville Iron Works Division of Struthers Wells Corporation on South Monroe Street. (*Titusville Herald* collection.)

Freight purser William McCluer (in charge of freight accounts) is at the Pennsylvania Railroad freight house's loading-unloading platform in Titusville on February 5, 1960. Oil Creek and Titusville Railroad excursion passenger trains board at this location today. The boxcar with the slogan "Main Line of Mid America" was from the Illinois Central Railroad, which was acquired by the Canadian National Railway in 1998. (*Titusville Herald* collection.)

The Pennsylvania Railroad yard crew included brakeman William B. Marsh (left) and conductor Wilfred Grolemund. They are behind the freight house (Present Oil Creek and Titusville Railroad station parking area) on South Perry Street on February 5, 1960. (*Titusville Herald* collection.)

A safety-test trip is being conducted at the Pennsylvania Railroad yard with diesel switcher No. 9352 on February 5, 1960. Boilers made by the Titusville Iron Works Division of Struthers Wells Corporation are lined up adjacent to the railroad yard. (*Titusville Herald* collection.)

Pennsylvania Railroad diesel switcher No. 9352 is at South Perry Street in Titusville on February 5, 1960. Lumber piled adjacent to the building was cut at local sawmills and trucked to the Pennsylvania Railroad Titusville freight house for shipment. In the background was the Perry Forge building of the Titusville Iron Works Division of Struthers Wells Corporation boiler fabrication department. The siding area became the Caboose Motel, Inc. (*Titusville Herald* collection.)

Conductor Wilfred Grolemund is near a gondola car loaded with scrap metal shavings from the Titusville Forge Division of Struthers Wells Corporation machine shop department at the rear of the Pennsylvania Railroad freight station on Perry Street on February 5, 1960. Diesel switcher No. 9352 is handling the yard activity. (*Titusville Herald* collection.)

Conductor Wilfred Grolemund (left) and brakeman William B. Marsh are checking boxcars at the Pennsylvania Railroad yard in Titusville on February 5, 1960. The Oil City Safety District of the Pennsylvania Railroad, which included Titusville, won the Northern Region safety contest in 1959. (*Titusville Herald* collection.)

A Saturn rocket-fuel storage tank is beside the Pennsylvania Railroad freight house, which is today the Perry Street station of the Oil Creek and Titusville Railroad. The Titusville Iron Works Division of Struthers Wells Corporation built the tank for the National Aeronautics and Space Administration in 1964. It was one of the last contracts handled by the Titusville Iron Works Division, which closed in 1971. (*Titusville Herald* collection.)

The St. Joseph Academy High School class of 1963 is pictured alongside former Baltimore and Ohio Railroad passenger car No. 912 on South Perry Street in Titusville. On the baggage cart are, from left to right, Deanna Miller, Ann Radack, Michele Vandemeulebrouck, Jennifer James, Doris Moran, Margaret Butler, Sally Gratkowski, Karen Sloan, Mary Ellen Brady, and Martha Schultz. On the ground are, from left to right, Jesse Dowd, Ronald Dewey, Richard Powers, Ricardo Bolio, John Rice, Louis Moronski, Paul Prenatt Jr., Joseph Fadden, Thomas Buser, John Brickner, Chester Barker, Claron Rosman, and Lester Strawbridge Jr. (*Titusville Herald* collection.)

On February 7, 1960, replacement of the Tubbs Run culvert with a larger one to prevent flooding is underway on the Pennsylvania Railroad. This view looks toward Hale's Crossing on West Central Avenue in Titusville. (*Titusville Herald* collection.)

Sperry Rail Service detector car No. 129 is at South Franklin Street on the Pennsylvania Railroad in Titusville in July 1960. This self-propelled car, built in 1925 for the Lehigh Valley Railroad and acquired by Sperry Rail Service in August 1939, was used to find defective rail. To the left of the car is the Seward House (demolished in the 1970s), where Pennsylvania Railroad employees stayed overnight. (*Titusville Herald* collection.)

In July 1960, Sperry Rail Service detector car No. 129 is passing through Titusville on the Pennsylvania Railroad. In 1923, Dr. Elmer Sperry developed the inspection concept using metal brushes to contact the rail. A defective spot in the rail changes the magnetic field. When the sensing coil detects a change in the magnetic field, the portion of the rail with the defect is marked for replacement. (*Titusville Herald* collection.)

Three

NEW YORK
CENTRAL RAILROAD

The Jamestown and Franklin Railroad was incorporated on April 5, 1862, so a line could be built from Jamestown to Franklin to tap the coal reserves in eastern Mercer County for commercial markets. It was leased by the Cleveland, Painesville, and Ashtabula Railroad, which in 1863 began construction of a railroad to link Ashtabula, Ohio, with the coal fields near Franklin, Pennsylvania. In 1869, it became part of the Lake Shore and Michigan Southern Railway, and it was completed in 1872. Construction of the Dunkirk, Allegheny Valley, and Pittsburgh Railroad took place during 1870–1872. Iron bridges replaced wooden structures, steel rail replaced iron rail, and the entire line was newly ballasted, as noted by the *Titusville Morning Herald* of December 7, 1897.

Beginning on June 12, 1898, and continuing each Sunday and Wednesday throughout that summer, the Dunkirk, Allegheny Valley, and Pittsburgh Railroad operated a special excursion train for Chautauqua Lake that left Titusville at 8 a.m. The return trip arrived at Titusville at 9:15 p.m. In 1914, the Lake Shore and Michigan Southern Railway was merged into the New York Central Railroad. The Dunkirk, Allegheny Valley, and Pittsburgh Railroad became the New York Central Railroad's Valley branch. In March 1932, it was announced that the morning train from Dunkirk, New York, which arrived in Titusville at 11:50 a.m. and left Titusville at 2:10 p.m., would be discontinued because ridership had steadily declined. Often, only one or two passengers would arrive at and depart from Titusville.

The discontinuation of the train would leave only one daily except Sunday roundtrip between Titusville and Dunkirk. The New York Public Service Commission conducted hearings that revealed the railroad's operating cost was $49,922 in 1931, but its revenue was only $17,791. The hearings concluded the trains were no longer needed, and the last day of operation was June 26, 1932. The remaining passenger service made its last run on June 12, 1937. Consolidated Rail Corporation planned to abandon the section from Carson, Ohio, to Jefferson, Ohio, and the State of Ohio acquired it in 1984, with the Ashtabula, Carson, and Jefferson Railroad now operating it for the state. By 1988, all remaining trackage east of Dorset, Ohio, to Franklin had been removed.

The Dunkirk, Allegheny Valley, and Pittsburgh Railroad announced an excursion from Titusville to Falconer, New York, with a connecting trolley car from Falconer via Jamestown to Chautauqua Lake on September 10, 1891. Roundtrip fare from Titusville was $1, and the train left Titusville at 8 a.m. with arrival at Falconer at 10:05 a.m. and Chautauqua at 12:40 p.m.

Dunkirk, Allegheny Valley, and Pittsburgh Railroad passenger cars are parked at the train station on South Martin Street in Titusville on June 5, 1892. The floodwaters were receding when this picture was taken. The men on the pile of debris in front of the passenger cars are believed to be railroad employees. (*Titusville Herald* collection.)

Floodwaters are receding around the Dunkirk, Allegheny Valley, and Pittsburgh Railroad station in Titusville after the fire and flood of June 5, 1892. The brick station structure located on the northwest corner of Martin Street and the railroad tracks survived but, according to the June 6, 1892, *Titusville Morning Herald*, was flooded to a depth of four feet. Nearby, many of the freight cars were burned to the wheels. (*Titusville Herald* collection.)

The Dunkirk, Allegheny Valley, and Pittsburgh Railroad station is in view on the right side of the photograph behind the Burton Edwards Coal and Roofing yard. People and passenger cars block South Martin Street (looking towards Oil Creek) in Titusville after the fire and flood of June 5, 1892. This photograph was taken around June 7, 1892, after the floodwaters had receded. Passenger and freight service on the Dunkirk, Allegheny Valley, and Pittsburgh Railroad from Titusville to Dunkirk, New York, was restored on June 8, 1892. (John Dunn collection.)

With a boxcar beside the freight house in the distance, the Dunkirk, Allegheny Valley, and Pittsburgh Railroad (later New York Central Railroad) station at Fredonia, New York, appears in a quiet mode. For many years, two passenger trains ran in each direction from Titusville to Dunkirk, New York. As traffic declined, the October 22, 1960, *Titusville Herald* reported the freight station at Fredonia was closed.

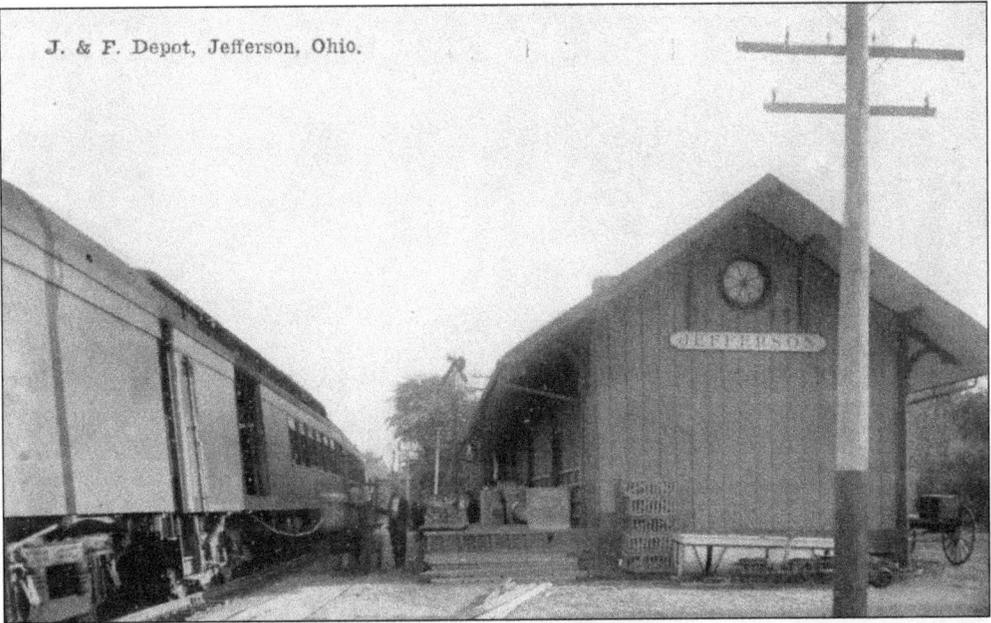

A passenger train is northbound at the station in Jefferson, Ohio. By 1872, the Lake Shore and Michigan Southern Railway had completed a line from Ashtabula, Ohio, via Jefferson, Dorset, Andover, Jamestown, Stoneboro, and Franklin to Oil City, thereby linking Pennsylvania's oil region to the oil refineries in Cleveland, Ohio. The Jefferson station was built in 1872. The last scheduled passenger train stopped at Jefferson on August 4, 1956.

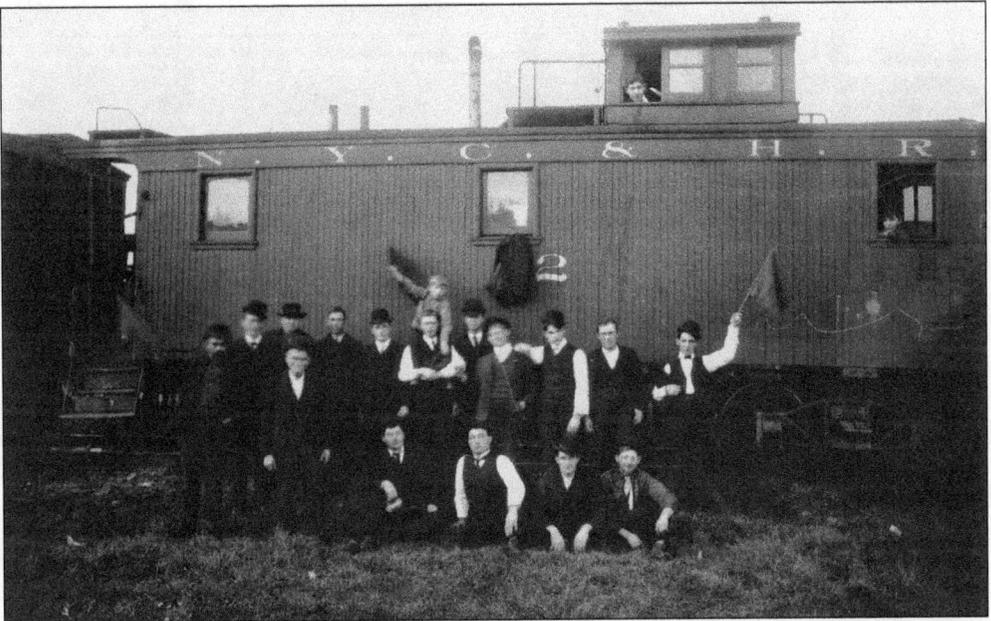

A group of men and boys are posing next to a New York Central and Hudson River Railroad (later New York Central Railroad) caboose on Water Street near the passenger station in Titusville around 1906. The line through Titusville was previously the Dunkirk, Allegheny Valley, and Pittsburgh Railroad. The railroad's Titusville yard facilities were located in the east end from the city limits to South Franklin Street. (*Titusville Herald* collection.)

Chestnut St. looking south. Jefferson, Ohio.

Looking south, a Pennsylvania and Ohio Railway trolley car is making its way along unpaved Chestnut Street in Jefferson, Ohio, around 1905. Operating 16 cars on 26 miles of track in 1918, this line connected the Ohio communities of Jefferson, Ashtabula, and Conneaut. The New York Central Railroad also operated between Jefferson and Ashtabula, but the trolley line provided more frequent local service.

North Chestnut Street. Jefferson, Ohio.

North Chestnut Street in Jefferson, Ohio, is the scene for a Pennsylvania and Ohio Railway trolley car around 1905. Service was operated hourly from Conneaut to Jefferson, the county seat of Ashtabula County. The line was opened from Conneaut to Ashtabula in 1901 and reached Jefferson in 1902, but the entire trolley system was abandoned on March 1, 1924.

NEW YORK CENTRAL RAILROAD

BUFFALO AND WEST

American Express Co.

The New York Central Railroad Valley branch schedule from June 4, 1916, for the Dunkirk-to-Titusville line shows two passenger trains in each direction. At Irvineton and Warren, connections could be made with the Pennsylvania Railroad (the former Philadelphia and Erie Railroad) west to Erie and east to Philadelphia. At Falconer, connections could be made via the Erie Railroad (the former Atlantic and Great Western Railroad) west to Cleveland and Chicago and east to New York City. The Jamestown Street Railway provided connections to Jamestown, New York, and the Chautauqua Lake resort area. Monday through Saturday, two passenger trains ran in each direction from Ashtabula, Ohio, via Andover, Ohio, to Oil City. One passenger train ran in each direction on Sunday. Including the Ashtabula-to-Pittsburgh passenger service, three daily passenger trains ran in each direction stopping at Jefferson, Ohio.

NEW YORK CENTRAL SYSTEM
The Water Level Route—You Can Sleep

Table 42—DETROIT-SAGINAW-BAY CITY-MACKINAW CITY-SAULT STE. MARIE AND CONNECTIONS.

No. 337	633	Miles.	December 2, 1951.	No. 338	No. 634
	A M		LVE]. (East.time.) [ARR.			
*1045 P M	*8 15	0	+....Detroit...	*7 05 A M	4 25 P M	
10 54 P M	8 23	4.3	...Woodward Ave...	6 52 "	4 16 "	
-- --	f8 40	15.6Warren......	g6 30 "	-- --	
-- --	f8 49	22.4	+......Utica......	g6 20 "	-- --	
-- --	9 00	29.5	+...Rochester...	6 10 "	3 40 "	
-- --	9 12	38.9	+...Lake Orion...	g5 55 "	f3 27 "	
11 48 P M	9 19	42.2	+....Oxford....	5 49 "	3 22 "	
-- --	-- --	50.6Metamora...			
12 19 A M	9 41	58.9	+......Lapeer...	5 18 "	3 00 "	
f12 33 "	9 51	67.6	...Columbiaville..	g5 03 "	f2 50 "	
-- --	9 59	72.2Otter Lake..	g4 56 "	-- --	
f12 50 "	10 07	78.2	+...Millington...	g4 46 "	2 37 "	
1 05 "	10 17	84.8Vassar....	4 35 "	2 29 "	
-- --	-- --	91.2Richville...			
1 54 "	10 53	105.8	+.Saginaw(Gen.Ave.)..	3 58 "	2 00 "	
2 20 A M	11 10	119.6	arr...Bay City..lve.	3 13 A M	*1 35 P M	
............	*1120	0	lve.. Bay City ..arr.	1 30 P M	
............	11 59	19.6	arr.. Midland ..lve.	*1250 P M	
2 40 A M	A M	0	lve. +Bay City arr.	2 59 A M	
-- --	10.8	Linwood....		130 P M	
3 20 "	18.9		.. . Pinconning ...	2 05 "		
3 33 "	27.7	Standish....	1 49 "		
-- --	32.4	Sterling....	-- --		
4 11 "	40.7	Alger......	1 09 "		
4 20 "	52.7		+..West Branch...			
4 29 "	64.5	St. Helen....			
4 49 "	77.1		+...Roscommon...	12 29 "		
5 00 "	92.4		arr.+Grayling..lve.	12 02 A M		
5 21 "	92.4		lve...Grayling...arr.	11 55 P M		
a5 46 "	111.7		...Otsego Lake...	e11 27 "		
6 12 "	119.2		+....Gaylord....	11 18 "		
6 26 "	127.7		+..Vanderbilt...	10 58 "		
6 41 "	138.3		...Wolverine....	10 40 "		
7 00 "	148.4		+..Indian River...	10 20 "		
7 10 "	153.9		+..Topinabee....	10 05 "		
7 20 "	160.4		+..Mullet Lake...	9 55 "		
7 40 "	166.3		+...Cheboygan...	9 45 "		
8 10 A M	182.3		ar.+Mackinaw City.lv.	*9 15 P M		
............			.lv.Mackinaw City.ar.		
............			(Arnold Transit Co.)		
............			..+.Mackinac Island..		
............			ARR.](East.time.) [LVE.		

No. 1			(D. S. S. & A. Ry.)	No. 2		
............			(Central time.)		
†7 45 A M			.lv.Mackinaw City.ar.	†7 05 P M		
8 55 A M			...lve. St. Ignace .arr.	5 55 P M		
†9 45 A M			arr..Trout Lake .lve.	†5 10 P M		

No. 8			(M. St. P. & S. S. M. R.R.)	No. 7		
*10 25 A M			.lve. Trout Lake ..lve.	*5 03 P M		
*11 45 A M			ar..Sault Ste. Marie.lv.	*3 50 P M		

No. 1			(D. S. S. & A. Ry.)	No. 2		
†1 40 P M			arr..Marquette..lve.	†1 30 P M		
f6 10 f12 10			lve..Marquette..arr.	7 00 12 50		
f6 37 2 42			lve..Negaunee..lve.	f6 38 12 47		
f6 57 2 55			lve..Ishpeming..lve.	f6 38 12 47		
†8 30 4 00			lve..Nestoria..lve.	†5 20 11 44		
.... 5 36			lve..Houghton..lve. 10 20		
.... 5 53			lve..Hancock..lve. 10 10		
.... f6 25			arr..Calumet..lve. f9 45		
†7 10 P M			lve...Saxon ...lve.	†1 10 A M		
f7 30 "			lve..Ashland ..lve.	f1 35 "		
7 30 "			lve..Iron River..lve.	10 26 "		
f5 05 "			lve..Superior..lve.	f8 45 "		
†5 40 "			lve....Duluth....	†8 15 "		
A M			ARRIVE] [LEAVE	P M		

Table 43.
CINCINNATI-CLEVELAND-HAMILTON-TORONTO.

(Eastern time.)	No. 52	No. 24
Lve.Cincinnati (Union Term.).	*5 00 P M	
Lve.Dayton..........	6 15 P M	
Lve.Columbus........	8 00 P M	
Arr.Cleveland (Union Term.)..	*8 10 A M	10 50 P M	
Lve.Cleveland (Union Term.)..	11 20 A M	10 50 P M	
Lve.Erie............	*12 01 P M	11 59 P M	
Arr.Buffalo (Central Term.)..	2 18 P M	-- --	
Lve.Buffalo (Central Term.)..	4 20 P M	2 54 A M	
Arr.Hamilton........	5 30 P M	5 15 A M	
(T. H. & B. Ry.)	7 45 P M	7 25 A M	
Arr.Toronto (Union Station.)..	8 55 P M	8 35 A M	
(Canadian Pacific Ry.)			

TORONTO-HAMILTON-CLEVELAND-CINCINNATI.

(Eastern time.)	No. 43	No. 15	57-19
(Canadian Pacific Ry.)			
Lve.Toronto (Union Station.)..	*8 15 A M	*8 30 P M	*8 30 P M
(T. H. & B. Ry.)			
Lve.Hamilton........	*9 35 A M	*9 35 P M	*9 35 P M
Arr.Buffalo (Central Term.)..	*11 40 A M	*11 45 P M	*11 45 P M
Lve.Buffalo (Cent. Term.)..	*1 30 P M	*11 59 P M	
Arr.Erie............	3 12 P M	-- --	
Arr.Cleveland (Union Term.)..	5 20 P M		*7 39 A M
Lve.Cleveland (Union Term.)..	6 00 P M		
Arr.Columbus........	9 30 P M	5 45 A M	
Arr.Dayton..........		7 20 A M	
Arr.Cincinnati (Union Term.)..		8 35 A M	

Table 44.
BUFFALO-ASHTABULA-YOUNGSTOWN-PITTSBURGH.

283	35-	279	Miles.	January 20, 1952.	282-	284	272	
P M	251	A M		lv.(Cent. Term.)ar.	52	P M	A M	
*5 15	*7 48	*8 30		+.Buffalo (E. T.)	4 20	10 35	4 30	
7 08	9 24	4 00		lve..+Erie...ar.	2 18	8 50	2 25	
P M	A M	P M		[LEAVE	P M	P M	A M	
*8 20	*10 25	*4 45		0	+..Ashtabula..	12 55	8 00	1 10
			4.5	...Carson ...				
8 42	10 48	--	10.9	+...Jefferson..	12 28	7 38	--	
	f10 57	--	16.8	+...Dorset ...	--	--	--	
			20.7	...Leon.....				
8 58	11 09	5 32	24.5	+..Andover..	12 10	7 18	12 30	
--	11 19	--	29.9	.Williamsfield.	--	--	--	
--	--	--	32.6	..Stanhope...	--	--	--	
--	11 29	--	37.1	..Kinsman..	--	f7 02	--	
--	--	--	42.7	..Latimer...	--	--	--	
--	--	--	46.0	...Fowler....	--	--	--	
--	--	--	48.8	...Tyrrell....	--	--	--	
--	f11 49	--	51.8	..Brookfield..	--	f6 43	--	
--	--	--	55.1	...Coalburg...	--	--	--	
--	--	--	60.9	..Doughton..	--	--	--	
9 55	12 10	6 35	62.8	+.Youngstown...	*12 20	*6 28	*11 40	
P M	P M	A M		ARRIVE] [LEAVE	A M	P M	P M	
11 35	1 45	8 30		Pittsburgh...	*9 45	*5 00	*9 50	
P M	P M	A M		ar.(P. & L. E.).lv.	A M	P M	P M	

Table 45.
DRESDEN, N.Y.-PENN YAN, N.Y.

No. 19	Miles.	December 2, 1951.	No. 20	
Mixed.		[LEAVE] [ARRIVE	Mixed.	
b10 00 A M	0Dresden	1 30 P M	
f10 07	2.2	..Cascade Mills..	f1 22 "	
f10 10 "	2.6	..May's Mills...	f1 18 "	
f10 14 "	3.3	..Seneca Mills..	f1 16 "	
f10 27 "	4.6	..Milo Mills...	f1 12 "	
f10 21 "	5.2	..Keuka Mills..	f1 08 "	
10 30 A M	6.1	...Penn Yan...	f1 05 P M	
		[ARRIVE] [LEAVE		

EXPLANATION OF SIGNS.

*Daily.

†Daily, except Sunday.

‡Daily, except Saturday.

¶Daily, except Monday.

§Sunday only.

a Stops on signal to leave passengers from Bay City and beyond.

b Tuesday, Thursday and Saturday; if any of these days are legal holidays, service will be performed the preceding day.

e Stops on signal to take passengers for Bay City and beyond.

f Stops on signal to receive or discharge passengers.

g Stops on signal to discharge passengers from Saginaw and beyond and receive passengers for Detroit

i Stops daily, except Sunday.

h Stops on signal to leave passengers from Detroit and beyond.

■ On Sunday arrives Cleveland 6 05 a.m.

+ Coupon stations.

... Rail-Auto Service available at this point.

For Pullman, Coach and Dining Car Service, see pages 184-192.

For number of table upon which each station is located, see General Index of Stations in back part of Guide.

The New York Central Railroad schedule Table 44 from January 20, 1952, shows two trains in each direction stopping at Jefferson, Ohio, on the route from Buffalo to Pittsburgh via Erie, Ashtabula, and Youngstown. During 1957 and 1958, the New York Central Railroad removed trackage from Jefferson, Ohio, south to Dorset, Ohio. Consolidated Rail Corporation abandoned all remaining trackage east of Dorset, Ohio, in 1988.

Engineer Ora Near Jr. is on the steps of the slightly damaged northbound (Titusville to Warren) New York Central Railroad diesel locomotive No. 852 (type S-1, built by American Locomotive Company). A car-train collision on Pennsylvania State Highway 27 at Grand Valley between Titusville and Warren on July 2, 1959, caused the damage and injured a family of four. (*Titusville Herald* collection.)

This is a 1965 view of the former Dunkirk, Allegheny Valley, and Pittsburgh Railroad (later New York Central Railroad) passenger station on South Martin Street in Titusville. Architect Enoch Curtis designed the building in 1872. The last day of passenger service was June 12, 1937. Fisher and Young bought the station and converted it into a retail feed business, which became Altman's Farm Service Company. The building was demolished in 1966. (*Titusville Herald* collection.)

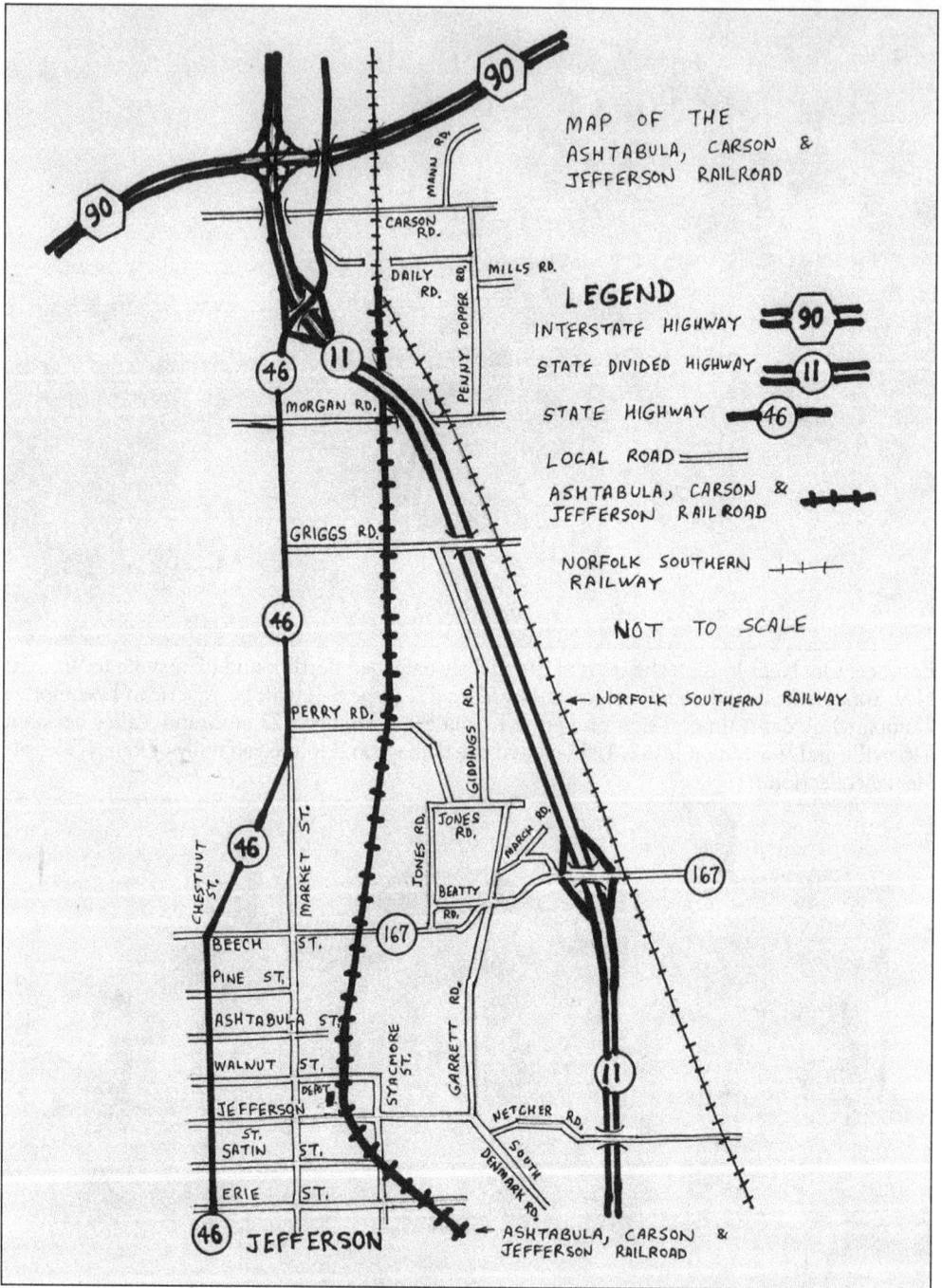

The six-mile Ashtabula, Carson, and Jefferson Railroad connects Jefferson, Ohio, with the Norfolk Southern Railway at Carson, Ohio. This is the last remaining segment of the Lake Shore and Michigan Southern Railway's (later New York Central Railroad) high-grade line that linked Carson, Ohio, with Oil City. In the 1890s, the Lake Shore and Michigan Southern Railway built a low-grade line (level and straight) from the Carson yard to Youngstown, Ohio. The Norfolk and Southern Railway operates the line today.

68

Just north of the Jefferson, Ohio, train station, Ashtabula, Carson, and Jefferson Railroad diesel locomotive No. 107 is ready for departure on July 24, 1993. This 1,000-horsepower locomotive type S-2 was built by American Locomotive Company in June 1950 as No. 45 for the New York, Chicago, and St. Louis Railroad and later became No. 107 for the Fairport, Painesville, and Eastern Railroad. (Photograph by Kenneth C. Springirth.)

Carson yard, located about six miles north of Jefferson, Ohio, is the setting for Ashtabula, Carson, and Jefferson locomotive No. 107 powering a passenger train with a caboose and two passenger cars on July 24, 1993. This was the interchange point with the Norfolk Southern Railway, which was originally the low-grade line to Youngstown. (Photograph by Kenneth C. Springirth.)

A horse-drawn carriage meets Ashtabula, Carson, and Jefferson Railroad diesel locomotive No. 107 at the Jefferson, Ohio, station on June 21, 2003. This station was identical in design to the Lake Shore and Michigan Southern Railway station in Oil City, which was demolished in 1966. (Photograph by Kenneth C. Springirth.)

On June 23, 2003, Ashtabula, Carson, and Jefferson Railroad locomotive No. 107 is heading a train southbound across East Walnut Street just north of the Jefferson, Ohio, train station. This was the original high-grade line of the Lake Shore and Michigan Southern Railway, which linked Jefferson with Oil City. (Photograph by Kenneth C. Springirth.)

The northbound Ashtabula, Carson, and Jefferson Railroad locomotive No. 107 is leading a passenger train across East Beech Street in Jefferson, Ohio, to the Carson yard on July 19, 2003. Chartered on June 24, 1984, the Ashtabula, Carson, and Jefferson Railroad has preserved railroad service from Carson to Jefferson. Initially, it operated only freight service, but it began passenger excursion service in 1991. (Photograph by Kenneth C. Springirth.)

Pictured at the southern terminus in Jefferson, Ohio, on June 21, 2003, Ashtabula, Carson, and Jefferson Railroad locomotive No. 107 will shortly switch around the train for the next northbound trip to Carson yard. At Carson yard just south of Interstate 90, the railroad interchanges with the Norfolk Southern Railway. (Photograph by Kenneth C. Springirth.)

On June 26, 2010, Ashtabula, Carson, and Jefferson Railroad diesel locomotive No. 7371 is crossing East Jefferson Street in Jefferson, Ohio, as it prepares to switch over to the other end of the passenger train for the next run to Carson yard. Formerly with the US Army, the 660-horsepower type S-1 locomotive built by American Locomotive Company served at the Aberdeen Proving Grounds in Maryland. (Photograph by Kenneth C. Springirth.)

Diesel locomotive No. 7371 is powering the northbound Ashtabula, Carson, and Jefferson Railroad passenger train, which is ready to cross East Beech Street in Jefferson, Ohio, on June 26, 2010. Consolidated Rail Corporation was planning to abandon railroad service in the early 1980s. Local interests working with the State of Ohio saved a six-mile portion of the line from Carson yard to Jefferson. (Photograph by Kenneth C. Springirth.)

On July 17, 2010, Ashtabula, Carson, and Jefferson Railroad locomotive No. 7371 is on the siding at Jefferson, Ohio. Bay window caboose No. 425 (with windows set in the extended walls to resemble architectural bay windows) is from the New York, Chicago, and St. Louis Railroad. Caboose No. 518573 with a cupola (a small windowed projection on the roof) is from the Norfolk and Western Railway. (Photograph by Kenneth C. Springirth.)

Operating on the Ashtabula, Carson, and Jefferson Railroad, steam locomotive No. 6 (with a 0-4-0 T wheel arrangement, with the "T" denoting a tank locomotive) is arriving at the Jefferson, Ohio, station on July 17, 2010. Baldwin Locomotive Works built this locomotive in November 1925 for the Viscose Company (later American Viscose Company) rayon plant in Roanoke, Virginia. Gem City Iron and Metal Company of Pulaski, Virginia, acquired the locomotive in the early 1960s. (Photograph by Kenneth C. Springirth.)

Operating a steam locomotive is labor-intensive, as evidenced by the crew working on locomotive No. 6 between trips on the Ashtabula, Carson, and Jefferson Railroad south of East Jefferson Street in Jefferson, Ohio, on July 17, 2010. Patrick D. Connors holds the hose. Scott Symans (who is looking down from the cab) purchased the locomotive in September 2004 and privately funded its restoration, which was completed in June 2007. (Photograph by Kenneth C. Springirth.)

Southbound on the Ashtabula, Carson, and Jefferson Railroad, steam locomotive No. 6 is ready to cross East Beech Street in Jefferson, Ohio, on July 17, 2010. Lasting from September 2004 to June 2007, the restoration work by Scott Symans and friends included disassembly of the engine, installation of a new steel cab and a new smokebox, and modifications to meet Federal Railroad Administration regulations. (Photograph by Kenneth C. Springirth.)

74

Four

TROLLEY MEETS TRAIN

On Monday June 14, 1897, final survey work began for the Titusville Electric Traction Company. According to the *Titusville Morning Herald* of Wednesday July 14, 1897, "The work of grading in the East End for the roadbed of the Titusville Electric Traction Company's tracks is being pushed rapidly forward, and an increased force of men were put to work Monday [July 12, 1897] under the direction of Civil Engineer Edward Wrigley, assistant engineer of the road."

The October 4, 1897, *Titusville Morning Herald* noted the trolley car company began laying track from East Titusville west to Titusville and that "the heavy T rail, the solid hardwood ties, and the well graded roadbed give the line the appearance of a steam railroad." Four trolley cars were purchased from American Car Company; they were powered by Westinghouse motors and mounted on trucks made by Peckham Truck Company. The 30-foot-long cars seated 30 passengers each and were light amber in color with green and gold trimming. "War Over a Crossing," read the headline in the Friday May 27, 1898, *Titusville Morning Herald* article: "Shortly after 2 o'clock Wednesday afternoon, an unusual stir on Franklin Street at the Water Street intersection attracted attention, and in a few minutes, the vicinity was the scene of an exciting scrimmage between the employees of the traction company and those of the WNY&P [Western New York and Pennsylvania] Railway Company."

The trolley construction crew was attempting to lay track across the railroad line when railroad employees pushed a loaded coal car to block the crossing of their track. In the original agreement, the trolley car line was to place a temporary crossing pending negotiations over the upkeep of the crossing. The problem was resolved following a visit by railroad superintendent J.P. Heindell and railroad engineer G.W. Emory. The trolley construction crew was able to complete the crossing by 4 p.m. on Thursday, May 26, 1898. Trolley car service began on June 1, 1898. With the coming of the automobile, patronage declined. The last trolley car operated in Titusville on December 31, 1924.

Workers on the construction train for the Titusville to Pleasantville trolley line are posing for a picture in 1897. Warren and Pleasantville investors who financed the building of the Titusville Electric Traction Company system used a homemade steam engine for the heavy grading work in the Fieldmore Gorge area. (Cathy Coffaro and David L. Weber collection.)

Titusville Electric Traction Company car No. 8 is on the bridge near Hydetown shortly after 1901. The motorman was John Mitcham, shown at the front of the car with conductor Clifford Jennings standing beside the car. The trolley line through Hydetown carried residents of Titusville and Pleasantville to Mystic Park, a summer resort and picnic area owned by the trolley company. (Titusville Historical Society collection.)

Titusville Electric Traction Company car No. 2 is at the Pennsylvania Railroad crossing on Main Street in Hydetown around 1905. The Pennsylvania Railroad prevented the trolley company from crossing its track at Hydetown. A separate trolley line was built from Hydetown to Mystic Park and Canadea (also known as Tryonville). Hence passengers walked across the Pennsylvania Railroad track to board the connecting trolley car for Mystic Park. (Charles V. Hess collection.)

Pleasantville's Holeman Block (designed by architect Enoch Curtis and constructed by Pleasantville merchants Ashbel Holeman and Harvey Hopkins) stands on the corner of State and South Main Streets in this 1906 photograph. A Titusville Electric Traction Company trolley car is at the State Street terminus with side trackage on South Main Street. John Dack's Drug Store, Wiley Ward Dry Goods and Clothing, and the Harrison Mapes Hardware Store and planing mill (rear of the building) are close to the intersection. (David L. Weber collection.)

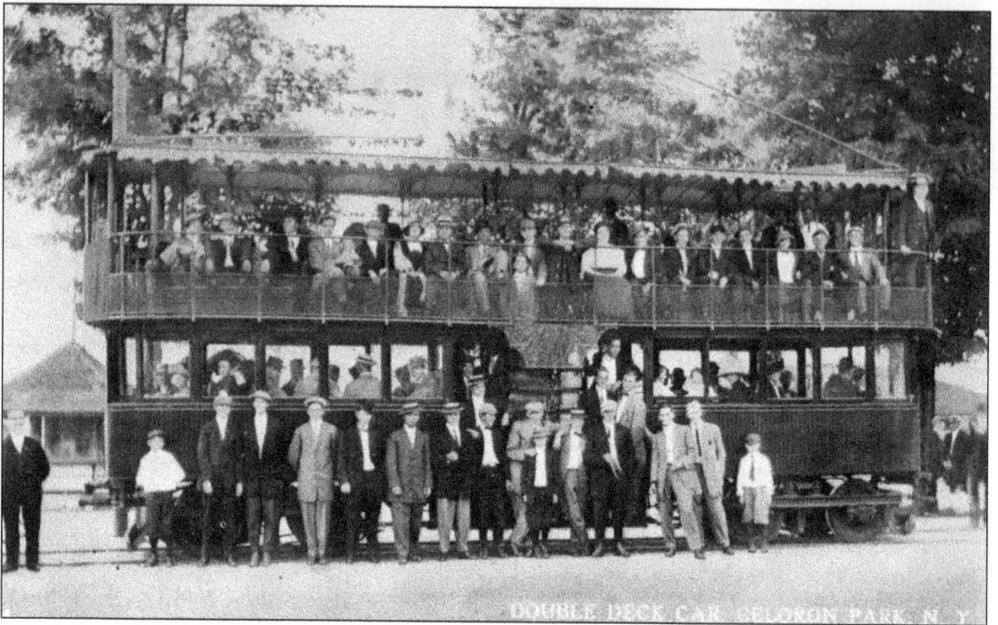

The Jamestown Street Railway Company double-deck trolley car *Columbia* is at Celoron Park just outside of Jamestown, New York, in this postcard marked July 26, 1910. This car was purchased from the Pullman Palace Car Company of Pullman, Illinois, and arrived on May 30, 1893. Titusville residents used the Dunkirk, Allegheny Valley, and Pittsburgh Railroad passenger service to Jamestown and reached the Chautauqua Lake resort area by trolley car.

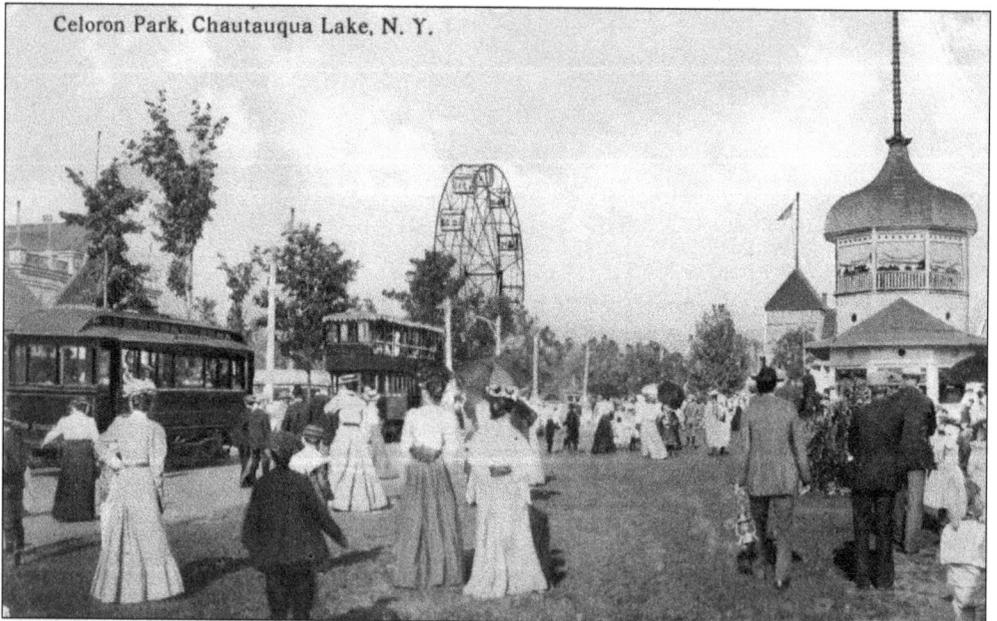

Celoron Park, Chautauqua Lake, N. Y.

Two Jamestown Street Railway Company trolley cars, including the double-deck *Columbia*, are at Celoron Park. The amusement park on Chautauqua Lake, New York, was popular with Titusville residents. In 1918, the Jamestown Street Railway Company operated 73 trolley cars on 28 miles of track serving Lakewood, Celoron, Jamestown, and Falconer. The *Columbia* had been taken out of service by 1923 and was scrapped around 1926.

A Titusville Electric Traction Company trolley car is crossing the East Titusville trestle on its way to Pleasantville during the Pine Creek Gorge ice flood of February 1910. The work crew in the photograph is strengthening the bridge and breaking the ice. Trolley car service from Titusville to Hydetown and Pleasantville was hourly, with service every 30 minutes during Mystic Park's open season. (Titusville Historical Society collection.)

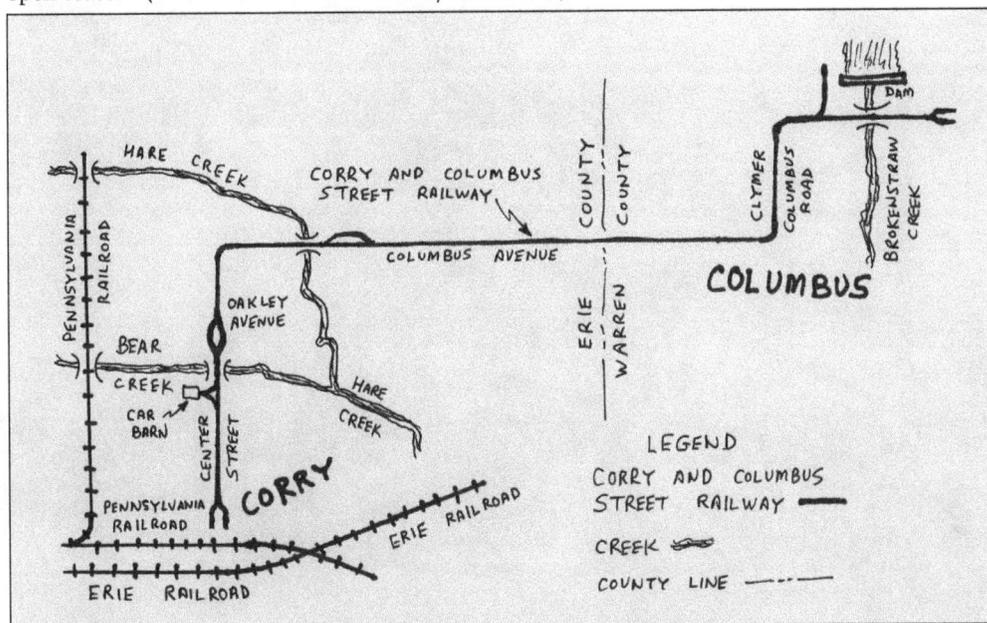

A map of the Corry and Columbus Street Railway shows convenient connections with both the Pennsylvania Railroad and Erie Railroad in Corry. The four-and-a-half-mile trolley car line operated every 30 minutes between Corry and Columbus. Service began on September 4, 1906, and ended on August 27, 1923. Titusville residents travelled to Corry to make east and west train connections and to ride the trolley car to Columbus.

An open-air Citizens Traction Company trolley car is in Oil City on its way to Pearl Avenue and Wyllis Street around 1904. Local businessman John B. Smithman chartered the Oil City Street Railway on June 25, 1889, and operations began on November 30, 1893. During 1900, Smithman sold the system to Citizens Traction Company, which was headed by Oil City industrialist Daniel Geary. (Jim Watson collection.)

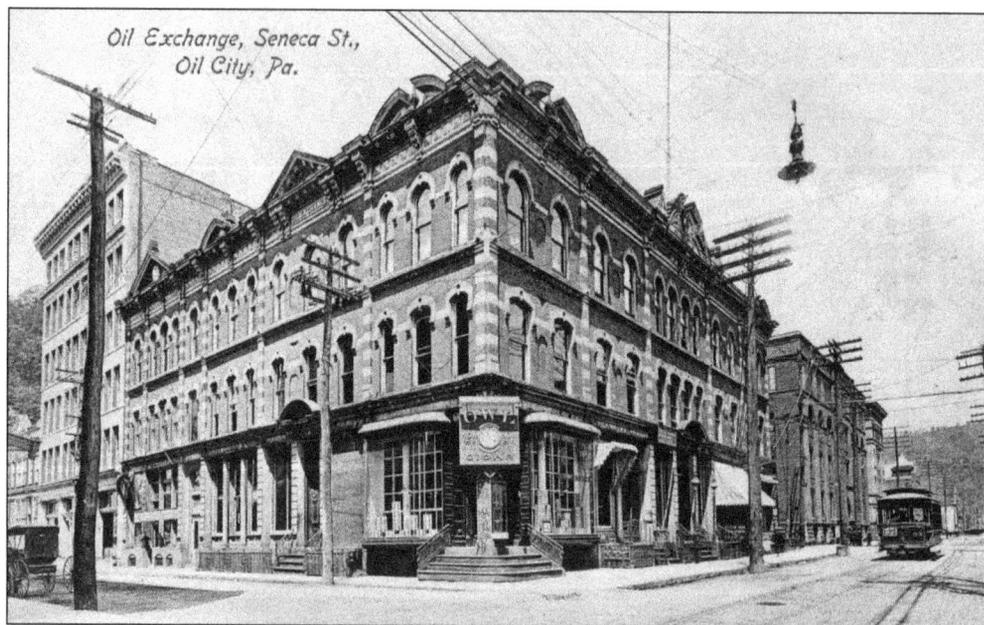

A Citizens Traction Company trolley car passes the Oil City Oil Exchange on Seneca Street around 1910. The company had purchased 13 new, one-man-operated trolley cars by 1923. In 1924, the company operated 34.7 miles of track with 58 trolley cars connecting Oil City to Rouseville plus two trolley car routes (one on the north side and another on the south side of the Allegheny River) between Oil City and Franklin.

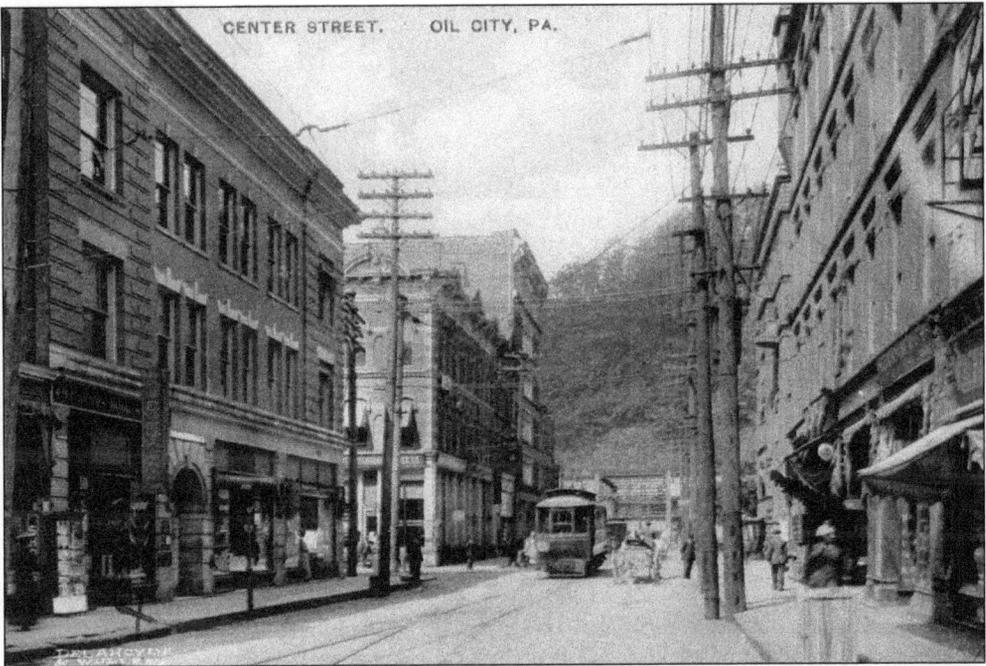

Center Street in Oil City is the setting for the vintage Citizens Traction Company trolley car in this postcard mailed on July 5, 1917. The 9.86-mile northern route from Oil City via Reno to Franklin was a 30-minute ride, and service was every 30 minutes. The 11.58-mile southern route from Oil City via Monarch Park to Franklin was a 40-minute ride, and service was every 30 minutes.

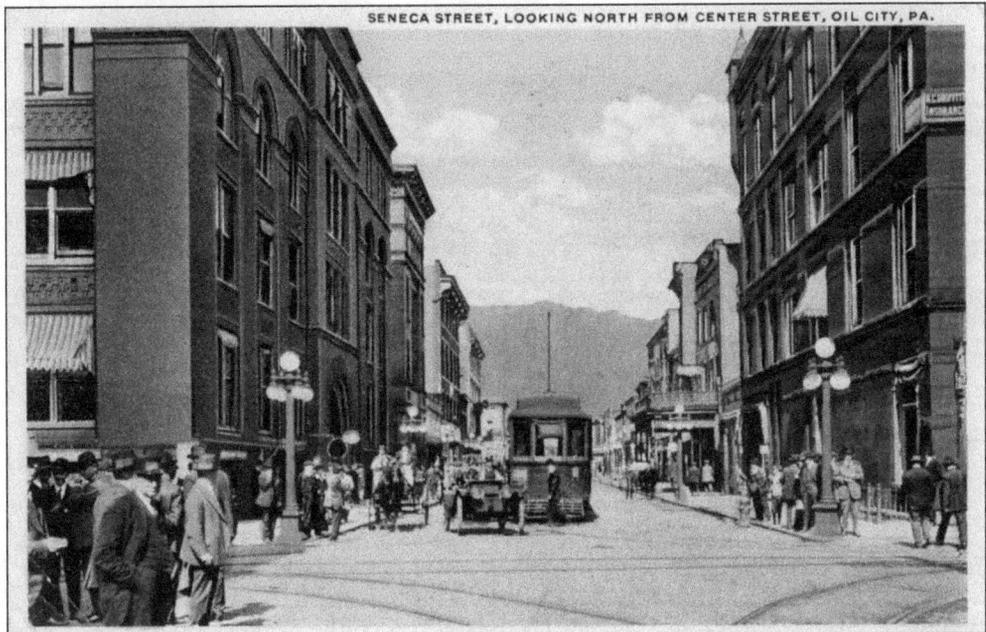

SENECA STREET, LOOKING NORTH FROM CENTER STREET, OIL CITY, PA.

Downtown Oil City is alive with activity as a Citizens Traction Company trolley car is on Seneca Street looking north from Center Street in Oil City in this postcard with a September 24, 1924, postmark. Before the advent of the automobile, most local travel was by trolley car; this is what brought in customers for the downtown businesses.

Business Centre, Rouseville, Pa.

The business center of Rouseville is the location for this Citizens Traction Company trolley car. Travel time on the three-mile trolley line from Oil City north to Rouseville was 15 minutes with one car providing service every 30 minutes. Oil City trolley routes were completely converted to bus operation on May 28, 1928, and the rural line to Rouseville closed on June 25, 1928.

Big Rock Bridge, Franklin, Pa.

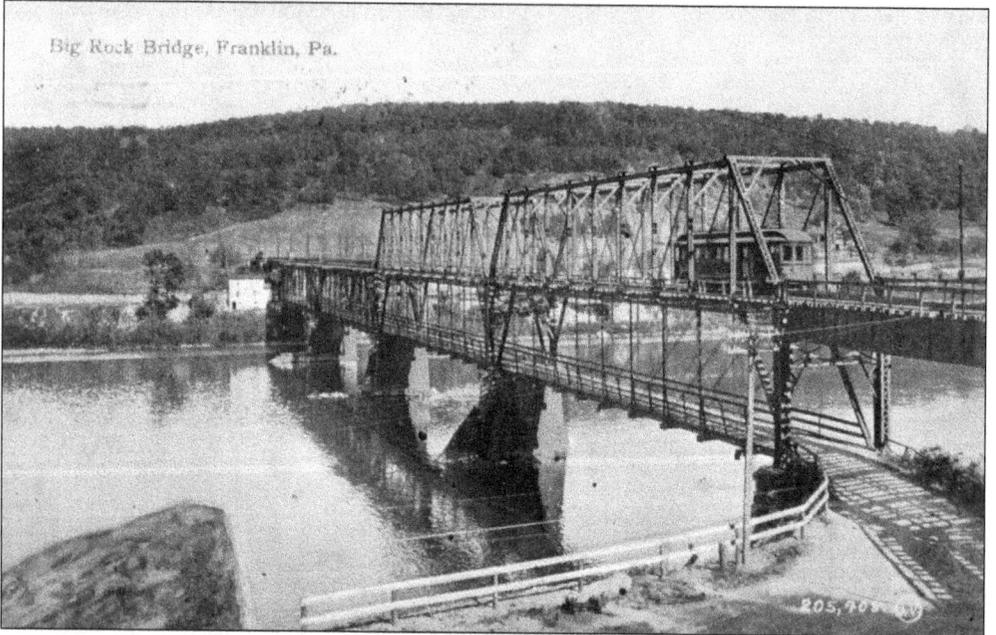

A Franklin Electric Street Railway Company trolley car is on the Big Rock Bridge crossing the Allegheny River in this postcard postmarked June 10, 1911. The Franklin Electric Street Railway Company and the Franklin and Oil City Electric Railway Company were chartered on August 4, 1893, later organized as the Franklin Electric Street Railway Company, and merged into the Citizens Traction Company in May 1902.

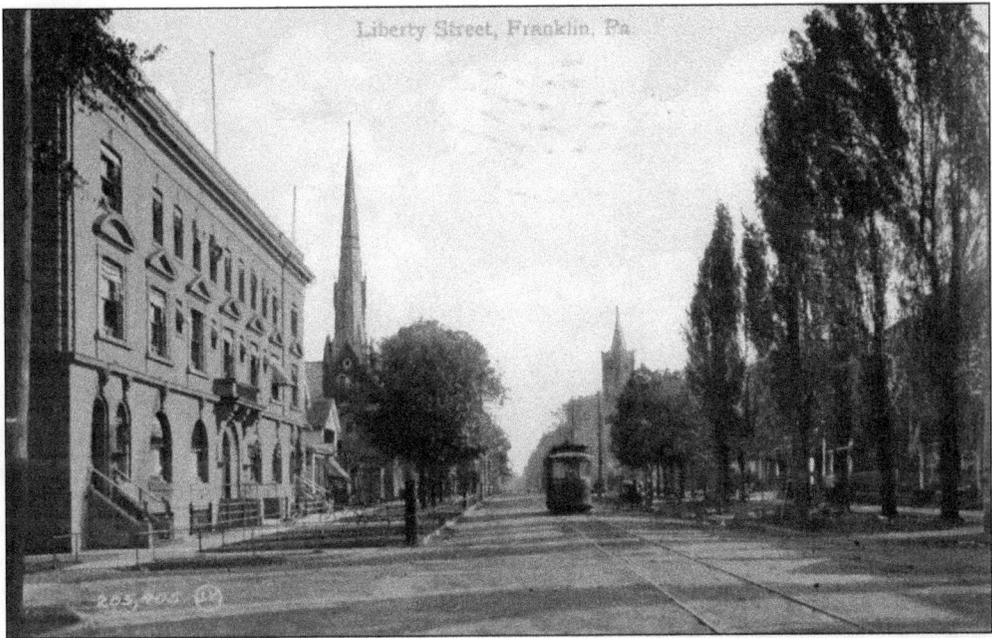

Liberty Street in Franklin, with the Galena-Signal Oil Company office building on the left, is the scene for a Citizens Traction Company trolley car in this postcard postmarked June 4, 1909. For the year ending June 30, 1902, the Citizens Traction Company in Oil City carried 733,995 passengers, and the Franklin Electric Street Railway in Franklin carried 810,255 passengers.

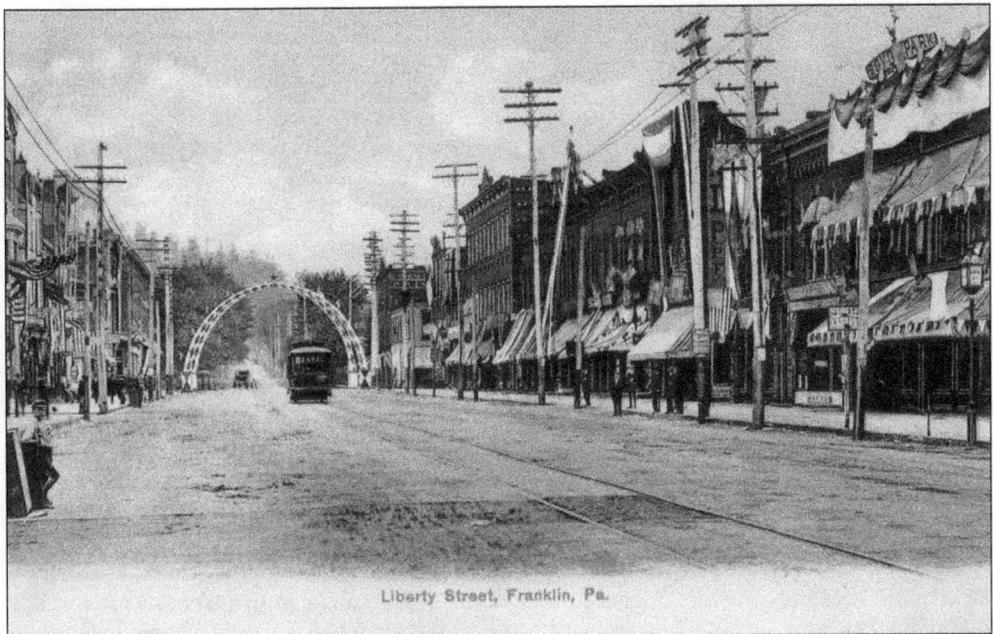

Liberty Street is quiet as a Citizens Traction Company trolley passes under an Old Home Week celebration archway in downtown Franklin around 1909. Following the consolidation of the Oil City and Franklin trolley car systems, the new company carried 4,277,410 passengers for the year ending June 30, 1903.

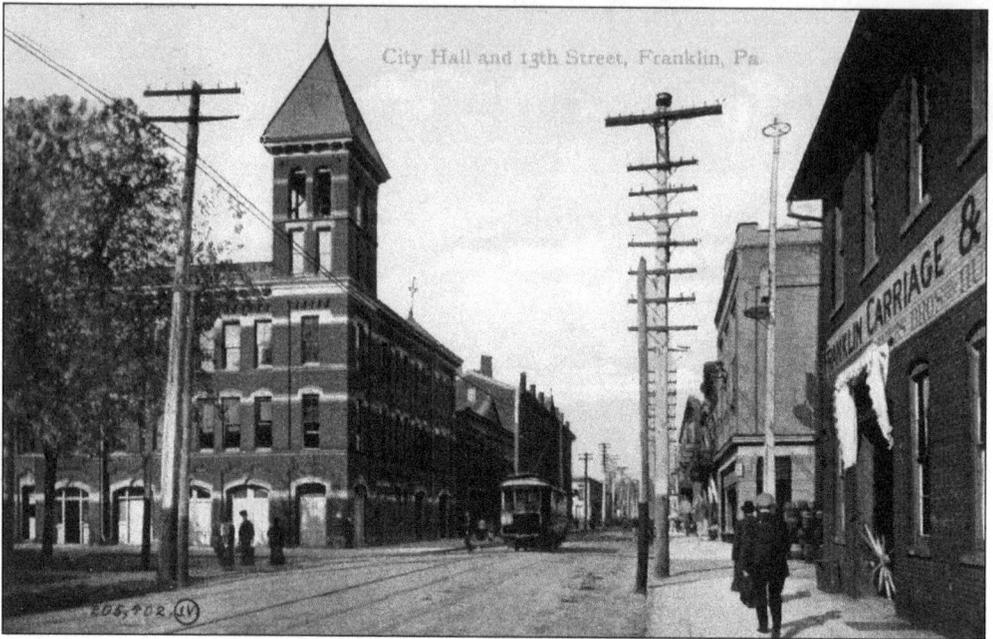

A Citizens Traction Company trolley car is at city hall and Thirteenth Street in Franklin in this postcard postmarked June 4, 1909. During 1910, the system carried its peak ridership of almost five million. The first major cutback occurred in 1915, when the trolley car line on the north side of the Allegheny River from Oil City via Reno to Franklin was abandoned due to landslides near Reno.

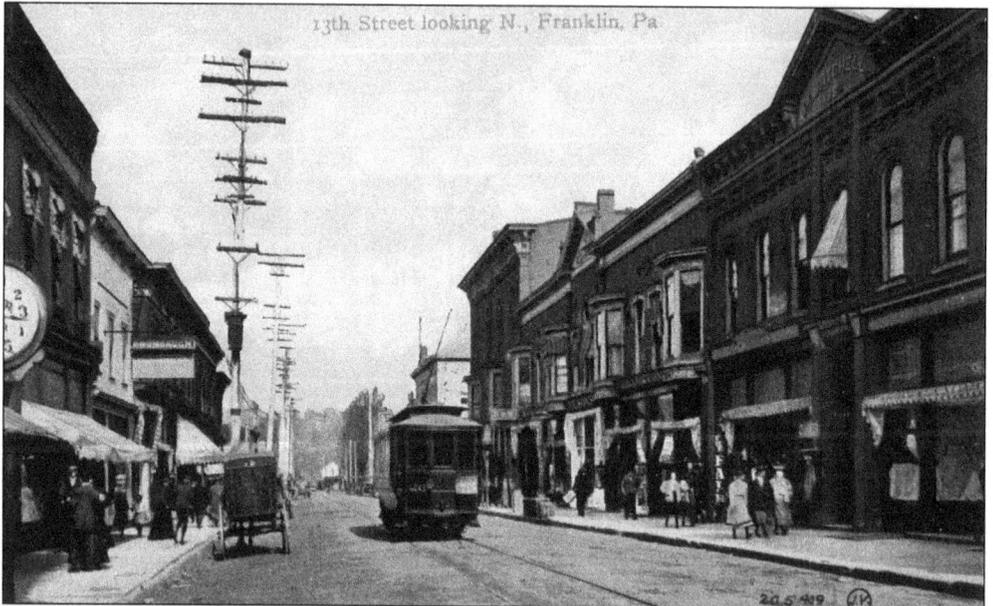

A Citizens Traction Company trolley car appears in this postcard of Thirteenth Street in Franklin looking north around 1910. The trolley car system here experienced the same financial problems faced by the rest of industry after World War I, with declining ridership and increased expenses. The system began converting to bus operation in 1924. Trolley car service in Franklin ended in 1927.

Five

OIL CREEK AND
TITUSVILLE RAILROAD

"History was made at Drake Well Park last night as the first run of the Oil Creek and Titusville Railroad became a reality, the culmination of years of work by the Oil Creek Railway Historical Society," read an article by reporter Tom Boyle in the July 19, 1986, *Titusville Herald*. The Oil Creek and Titusville Railroad made its first run, restoring rail service to Titusville, on July 18, 1986, with the golden spike driven by James B. Stevenson, publisher of the *Titusville Herald* and railway society board member.

Over 1,300 people rode the train that first weekend, according to Lou Petulla, president of the Oil Creek Railway Historical Society. The first freight cars for the Oil Creek and Titusville Lines arrived at the Perry Street depot in Titusville on September 24, 1986, at 9:40 p.m. On September 25, 1986, Baillie Lumber Company shipped two boxcars of lumber, making it the first shipment to leave Titusville via the Oil Creek and Titusville Lines. On March 27, 1987, the first four of seven passenger cars used for commuter service in New Jersey were parked on the siding at the Perry Street station in Titusville. The seven cars, each seating 76 passengers, had been purchased for a total of $49,000 and were soon rehabilitated. Improvements included the removal of their motors, sandblasting, painting, the removal and reassembly of seats for cleaning, and the replacement of broken glass. According to the April 29, 1987, *Titusville Herald*, during the winter of 1986–1987, over 3,000 ties had been replaced, brush had been cleared along the right of way, and station upgrades were underway at Drake Well Park and Rynd Farm. In Titusville, a tent served as a passenger shelter, and a trailer was used for ticket sales until renovations were completed on the former Perry Street freight station, which reopened on May 27, 1988. On June 9, 1990, railway post office car No. 66 was dedicated and placed in service. While the Oil Creek and Titusville Railroad passenger excursions have made the region a tourist designation, the excellent freight service provided by the Oil Creek and Titusville Lines has enhanced industrial development in Titusville.

A southbound Oil Creek and Titusville Railroad passenger train is at Drake Well station on October 18, 2009, using the 1,000-horsepower type S-2 diesel switcher No. 75. Weighing 112 tons, the locomotive was built in 1947 by the American Locomotive Company for Bethlehem Steel in Lackawanna, New York. (Photograph by Kenneth C. Springirth.)

The 11 a.m. Oil Creek and Titusville Railroad passenger train has left Perry Street station in Titusville and is crossing Franklin Street on October 25, 2009. The once-elegant Pennsylvania Railroad passenger station was located about midway between Perry and Franklin Streets on the north side of the tracks from its opening day on February 20, 1871, until it was demolished on July 30, 1964. (Photograph by Kenneth C. Springirth.)

MAIN ST.

CENTRAL AVE.

EAST TITUSVILLE

27

SPRING ST.

MONROE ST.

WASHINGTON ST.

DIAMOND ST.

BROWN ST.

RAILROAD YARD

OIL CREEK

FORMER NEW YORK CENTRAL RAILROAD

WATER ST.

ST. JOHN ST.

JERSEY BRIDGE

PINE CREEK

227

PERRY ST. RAILROAD STATION

BLOSS ST.

BLACK BRIDGE

DRAKE WELL RD.

DRAKE WELL TRAIN STATION

KUNZ RD.

TITUSVILLE

PERRY ST.

FRANKLIN ST.

DUTCH HILL RD.

BRYNER RD.

BLACK RD.

WHITE CITY RD.

SHREVE RD.

OIL CREEK & TITUSVILLE RAILROAD

FLEMING RD.

8

227

TURKEY FARM RD.

MILLER FARM RD.

OIL CREEK PARK RD.

CARTER RD.

OIL CREEK

RUSSELLS CORNER RD.

OIL CREEK STATE PARK

CHRISTIE HILL RD.

417

OLD PETROLEUM CENTRE RD.

PETROLEUM CENTRE STATION

PETROLEUM CENTRE TRUSS BRIDGE

BURNS LA.

EAGLE ROCK RD.

LEGEND

CREEK

PARK BOUNDARY

RAILROAD TRACK

STATE HIGHWAY 8

8

COLUMBIA BRIDGE

OLD BANKSON RD.

127

LOCAL PAVED ROAD

LOCAL UNPAVED ROAD

MAP OF OIL CREEK & TITUSVILLE RAILROAD NOT TO SCALE

CEMETERY HILL RD.

RYND FARM STATION

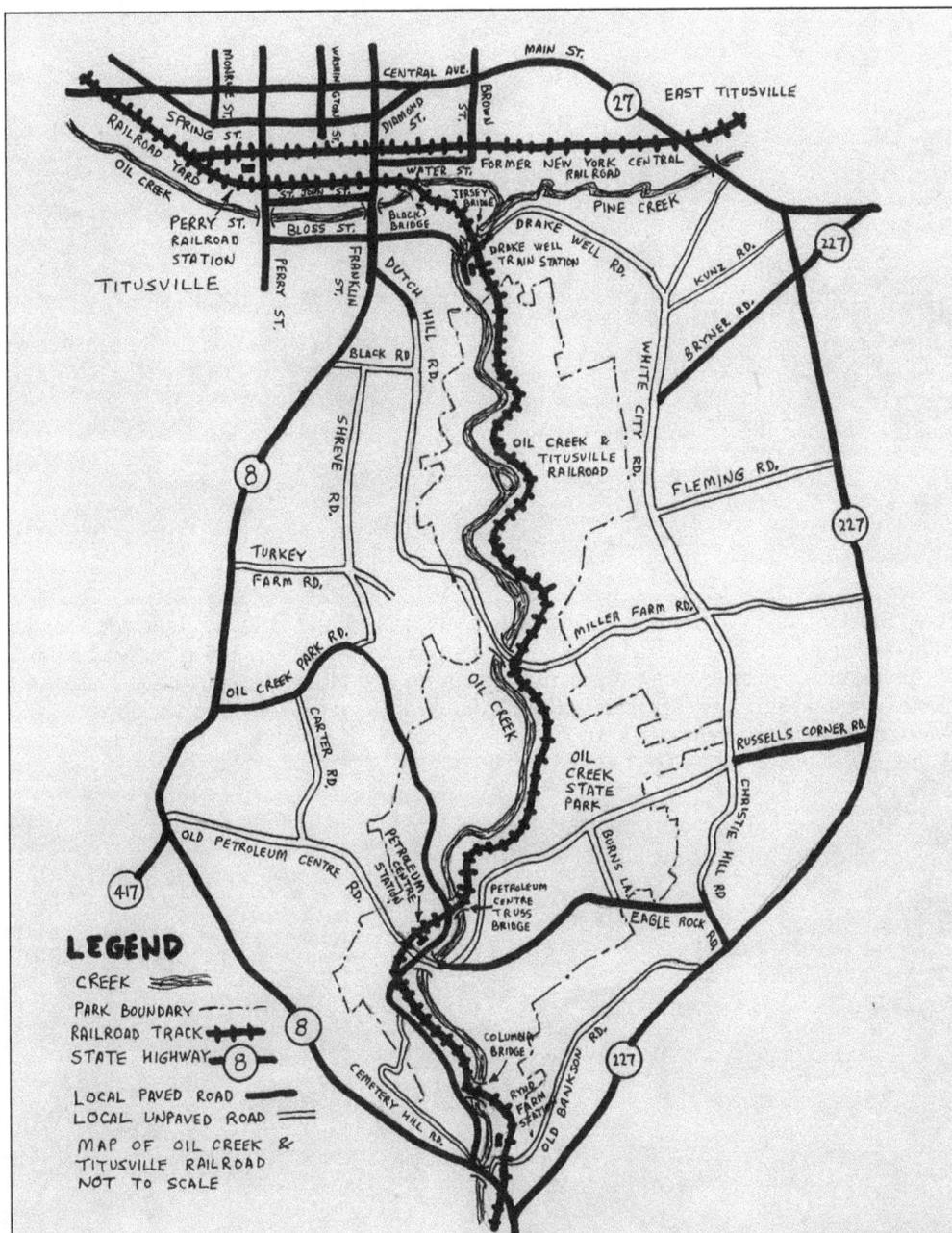

The Oil Creek and Titusville Railroad traverses Oil Creek State Park. In this book, passenger service is designated as Oil Creek and Titusville Railroad. Freight service is designated as Oil Creek and Titusville Lines. It should be noted that the Oil Creek and Titusville Lines is the provider of service for the Oil Creek and Titusville Railroad. Oil Creek valley produced most of the world's oil during the 1860s. Lumber was in the Oil Creek valley before oil was discovered and remains here today. In the fall, scattered remnants of the once-prominent oil industry can be seen. (Drawn by Kenneth C. Springirth.)

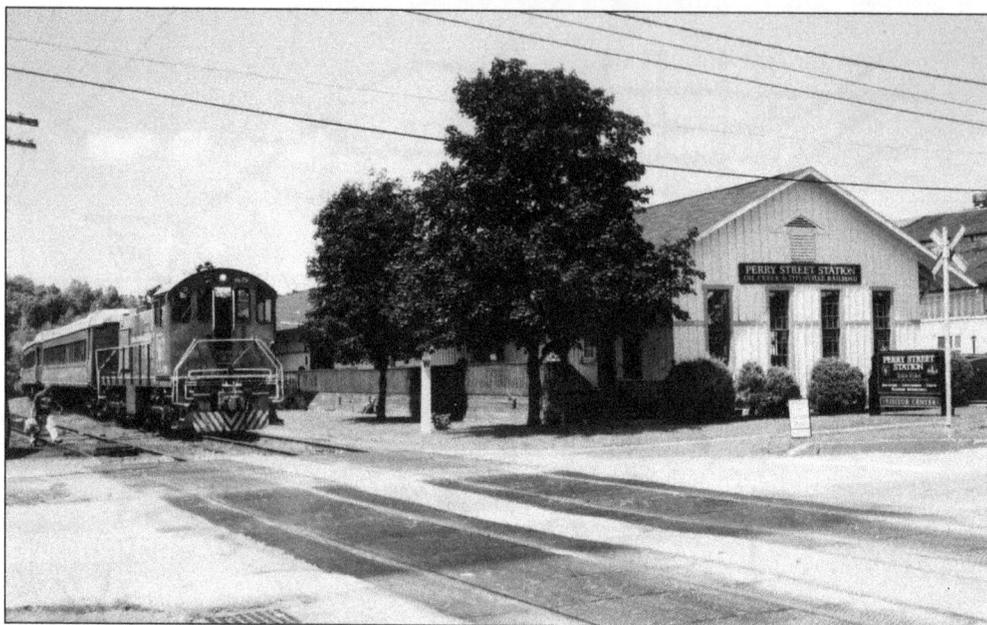

Perry Street station in Titusville is the setting for the Oil Creek and Titusville Railroad passenger train on August 8, 2010. Headed by the 1,000-horsepower, type S-2 diesel switcher No. 85 (built by American Locomotive Company in 1950), the train is awaiting departure time. The former electric, multiple-unit passenger cars were built during 1930 for the Delaware, Lackawanna, and Western Railroad and were used until 1985. (Photograph by Kenneth C. Springirth.)

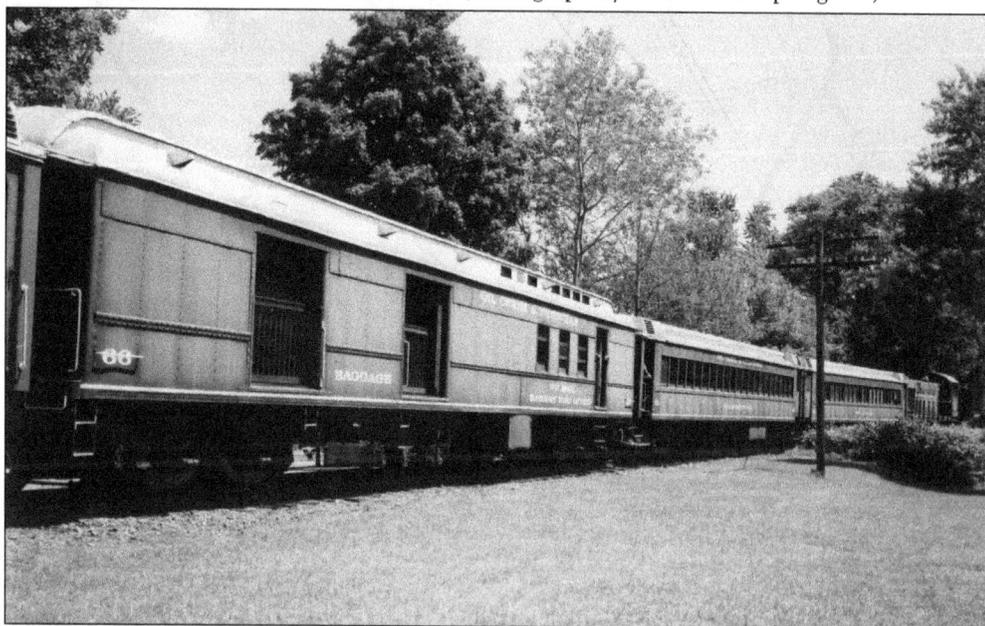

The Oil Creek and Titusville Railroad passenger train has crossed Franklin Street in Titusville on August 8, 2010. The third car from the engine is railway post office car No. 66, where postcards can be purchased and mailed. This car was built in 1927 as No. 68 for the Chesapeake and Ohio Railroad and later became Bangor and Aroostook Railroad car No. 570. (Photograph by Kenneth C. Springirth.)

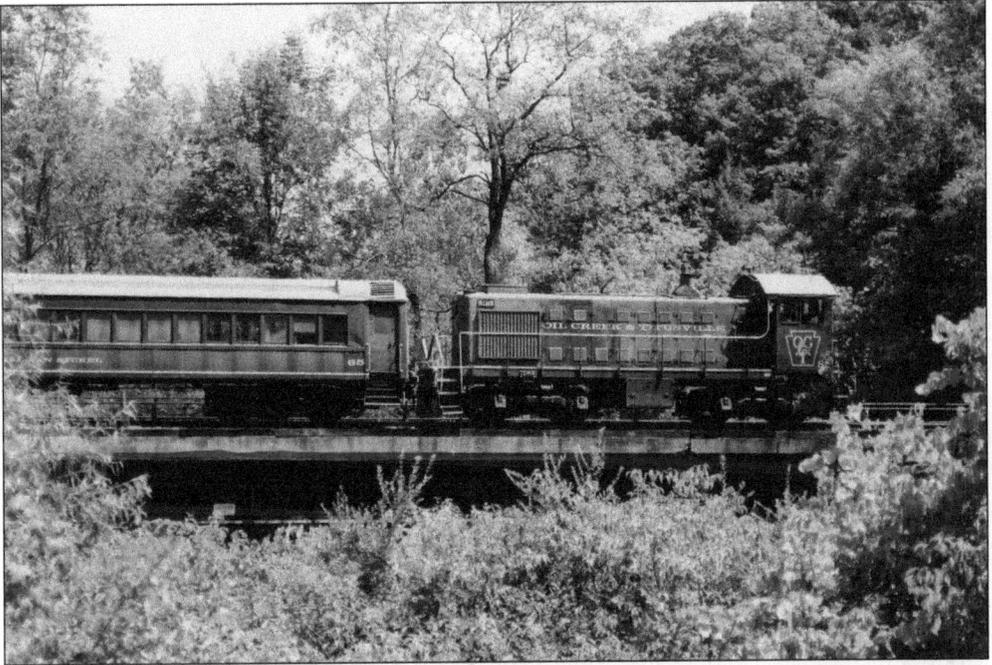

Just north of Drake Well station, Oil Creek and Titusville Railroad locomotive No. 85 is crossing Oil Creek on its August 8, 2010, southbound passenger trip to Rynd Farm. The July 31, 1986, *Titusville Herald* reported that over 1,300 people rode the railroad over the July 29–30, 1986, weekend. Many people took pictures of the train with the start of excursion service. (Photograph by Kenneth C. Springirth.)

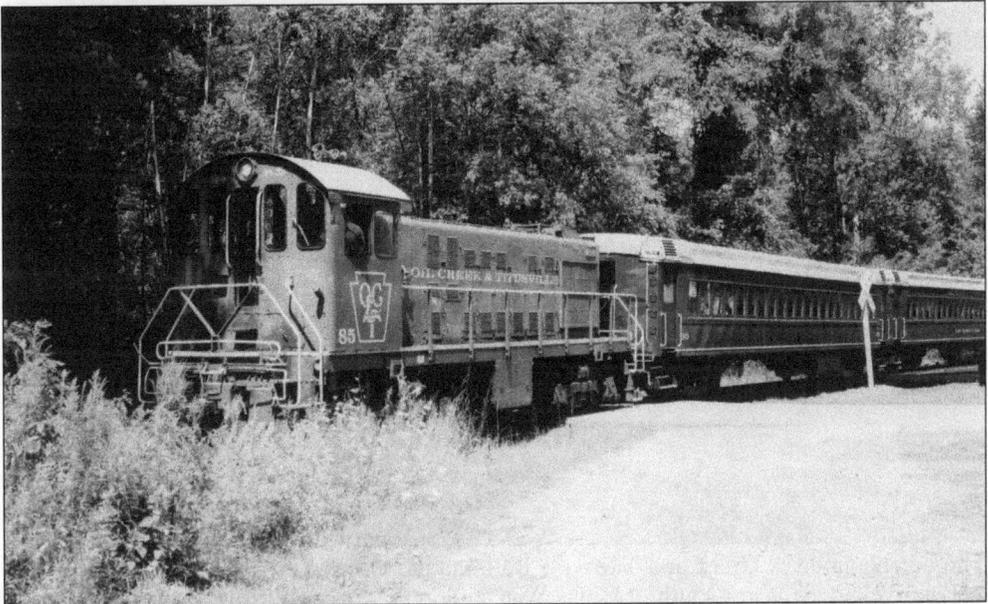

The southbound Oil Creek and Titusville Railroad passenger train powered by locomotive No. 85 is crossing Stevenson Hill Road at Petroleum Centre on August 8, 2010. This locomotive once served Bethlehem Steel at Lackawanna, New York. The passenger cars once handled commuter runs around Hoboken, New Jersey. (Photograph by Kenneth C. Springirth.)

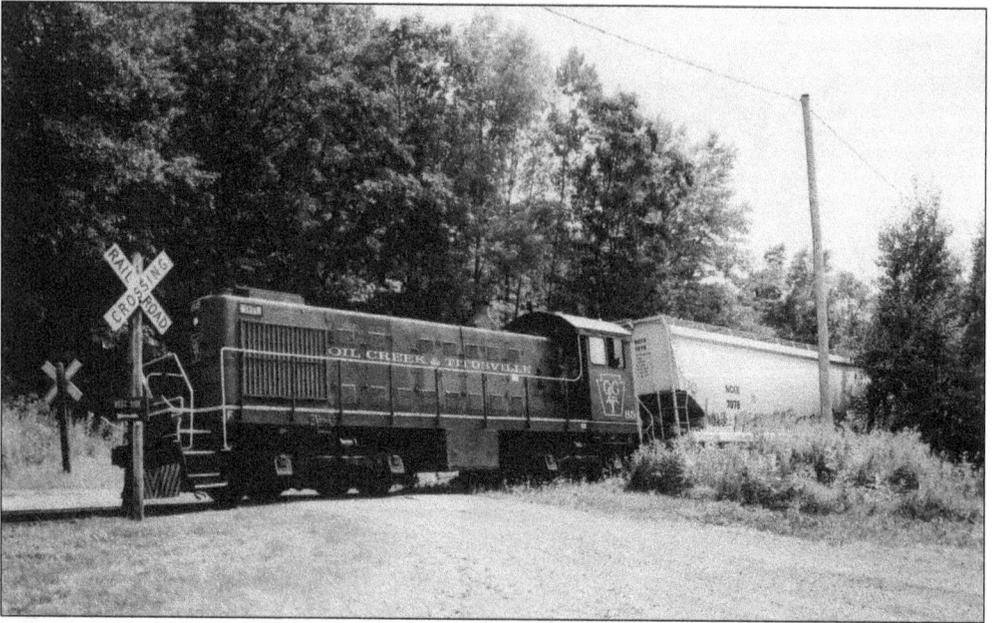

On August 8, 2010, locomotive No. 85 is preparing to retrieve freight cars at the interchange point with the Western New York and Pennsylvania Railroad in Rynd Farm, which was the southern terminus of the Oil Creek and Titusville Railroad. These freight cars were placed at the front of the returning passenger train to Titusville. (Photograph by Kenneth C. Springirth.)

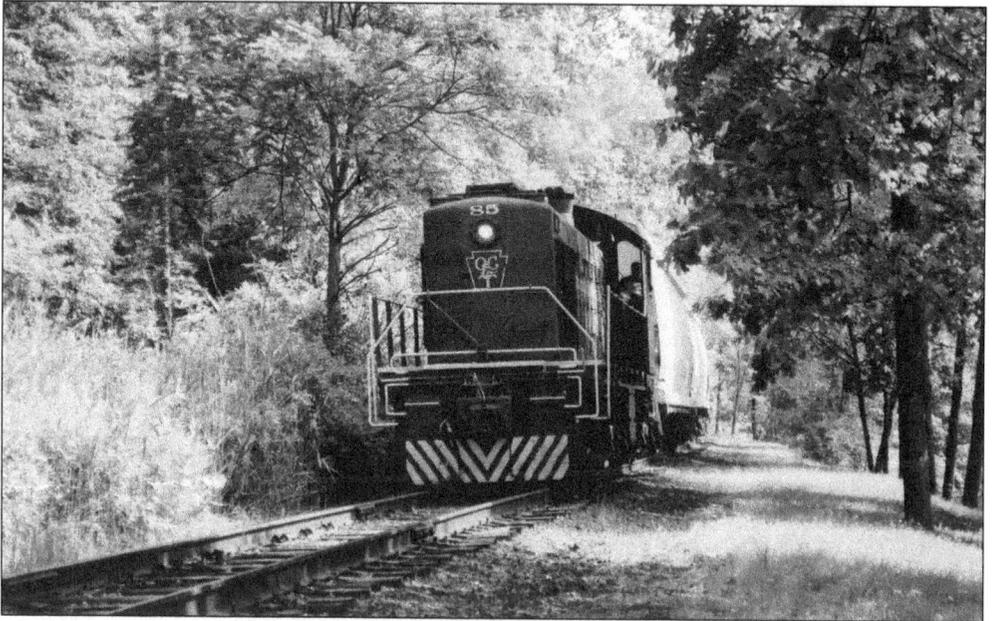

The northbound Oil Creek and Titusville Railroad passenger train with freight cars behind locomotive No. 85 is just south of Drake Well station on August 8, 2010. Passengers can see freight cars switched onto or off the train at the interchange with the Western New York and Pennsylvania Railroad at Rynd Farm. This is not the same Western New York and Pennsylvania Railroad that in 1895 reorganized and became the Western New York and Pennsylvania Railway. (Photograph by Kenneth C. Springirth.)

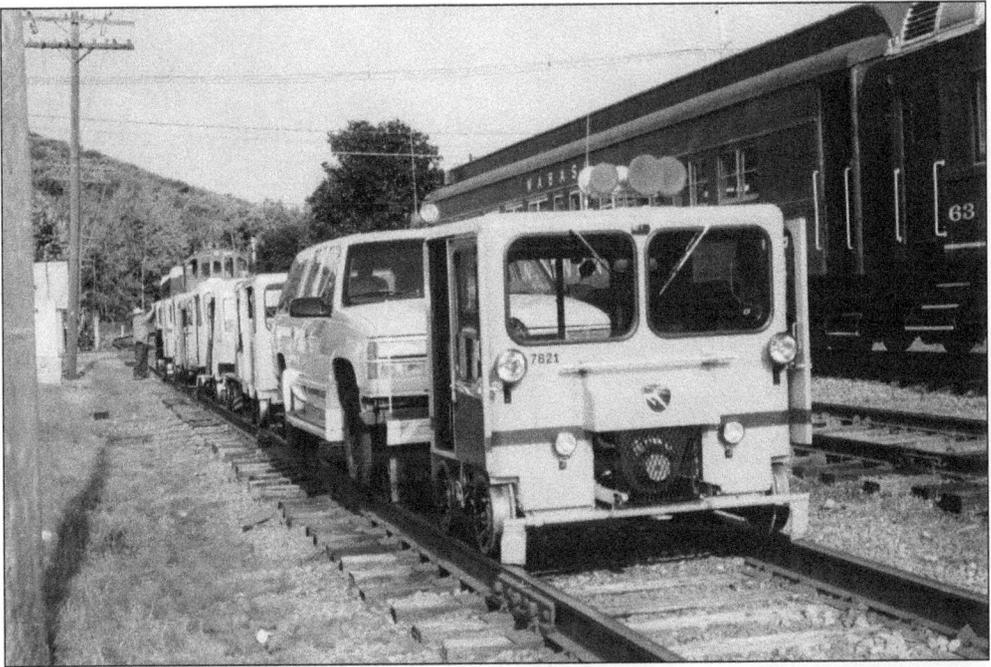

Rail vehicles are in line just east of Perry Street in Titusville on August 14, 2010. Speeder car No. 7821 Fairmont Rail Car model MT19-A with a Tomah cab is followed by a Chevrolet Suburban high-railer and a group of speeders. Speeders are maintenance-of-way motorized vehicles once used on railroads by track inspectors and work crews. (Photograph by Kenneth C. Springirth.)

Dale Humes and Raymond E. Grabowski Jr. (in short pants) are flagging the Franklin Street crossing in Titusville on August 14, 2010. Speeder No. 2706-91 Fairmont Rail Car model M19 is followed by a Fairmont Rail Car model MT14L, and the third speeder is a Fairmont Rail Car model MT19. It was called a speeder because it replaced slow hand-pumped cars. (Photograph by Kenneth C. Springirth.)

A group of riders at Perry Street station in Titusville are waiting to board a speeder like this beautiful Woodings Motor Car model CBI for a trip over the Oil Creek and Titusville Railroad on August 14, 2010. In the 1990s, speeders were replaced by motor vehicles equipped with flanged wheels that could be lowered for travel on railroad track. (Photograph by Kenneth C. Springirth.)

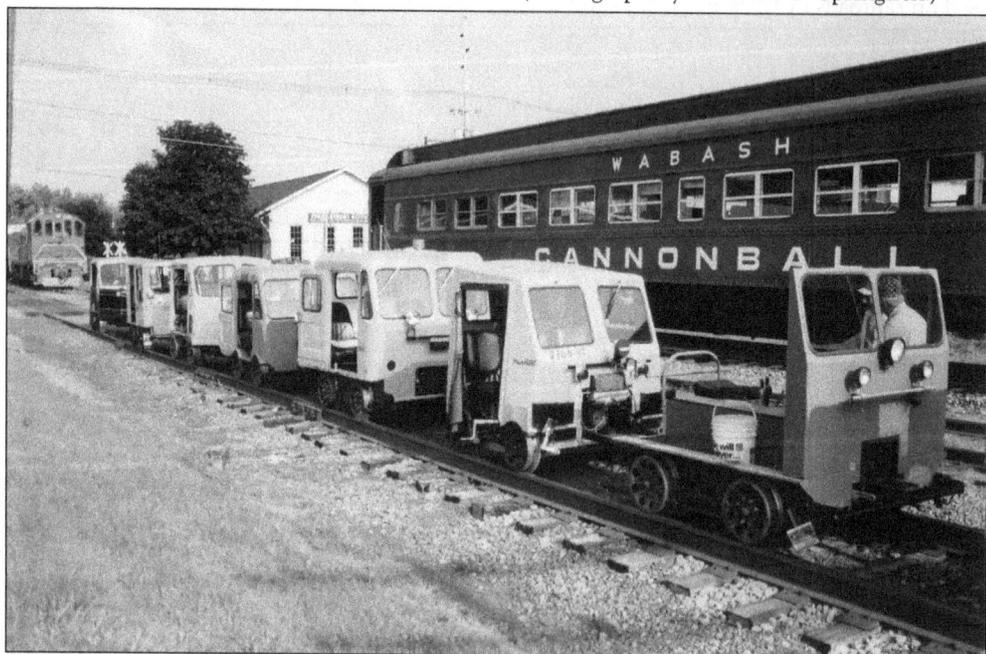

On August 14, 2010, Fairmont Rail Car model MT14 speeder is heading a group of speeders that will take passengers for a ride on the Oil Creek and Titusville Railroad. Sitting about two feet above the top of the rail, a speeder makes it possible to see every part of the railroad infrastructure, as well as nearby buildings, from a unique perspective. (Photograph by Kenneth C. Springirth.)

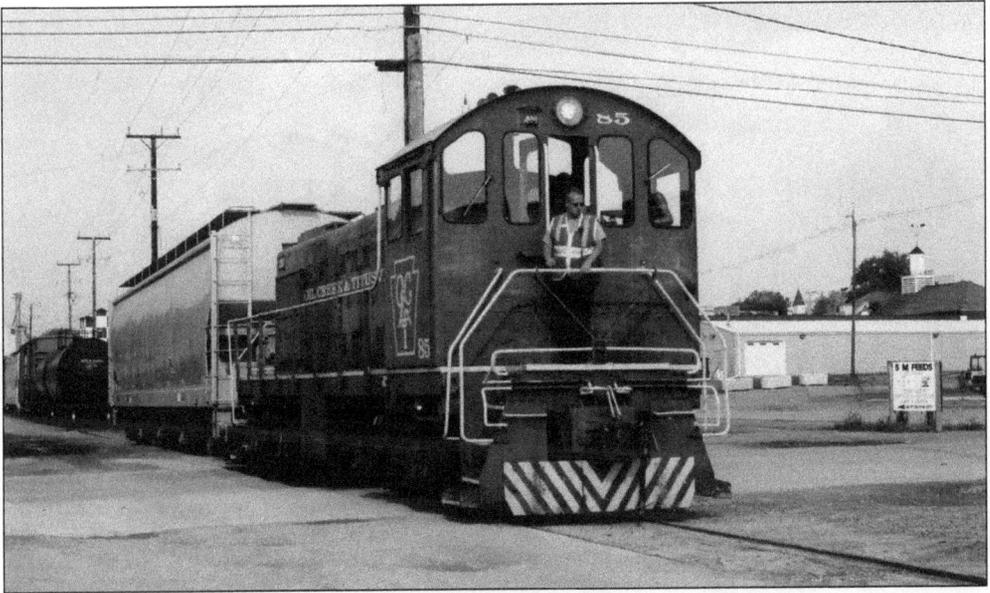

Oil Creek and Titusville Lines locomotive No. 85, with conductor Chuck Brown on the platform, is crossing Perry Street in Titusville on September 24, 2010, to deliver a covered hopper car loaded with plastic resin pellets to Charter Plastics, Inc., via the former Fieldmore branch of the New York Central Railroad. Charter Plastics, Inc., on South Perry Street, contributes to the economic vitality of Titusville. (Photograph by Kenneth C. Springirth.)

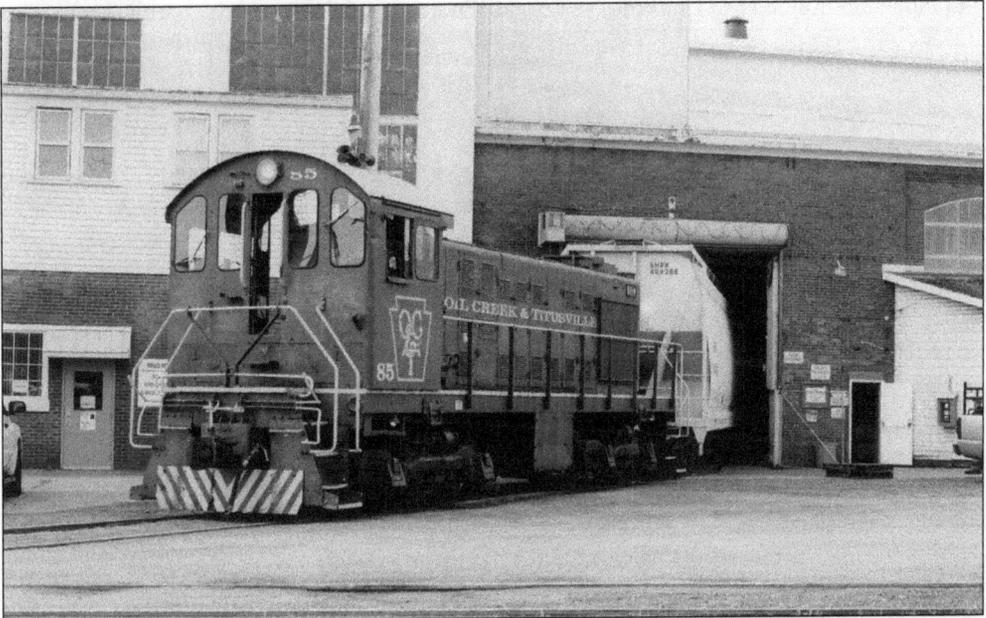

Charter Plastics, Inc., in Titusville (located in the former Titusville Iron Works Division of Struthers Wells Corporation boiler shop) receives a covered hopper car delivered by Oil Creek and Titusville Lines locomotive No. 85 on September 24, 2010. Charter Plastics, Inc., makes a wide variety of polyethylene pipe used in rural, residential, municipal, and industrial installations. The railroad's excellent service has been a factor in retaining industry in Titusville. (Photograph by Kenneth C. Springirth.)

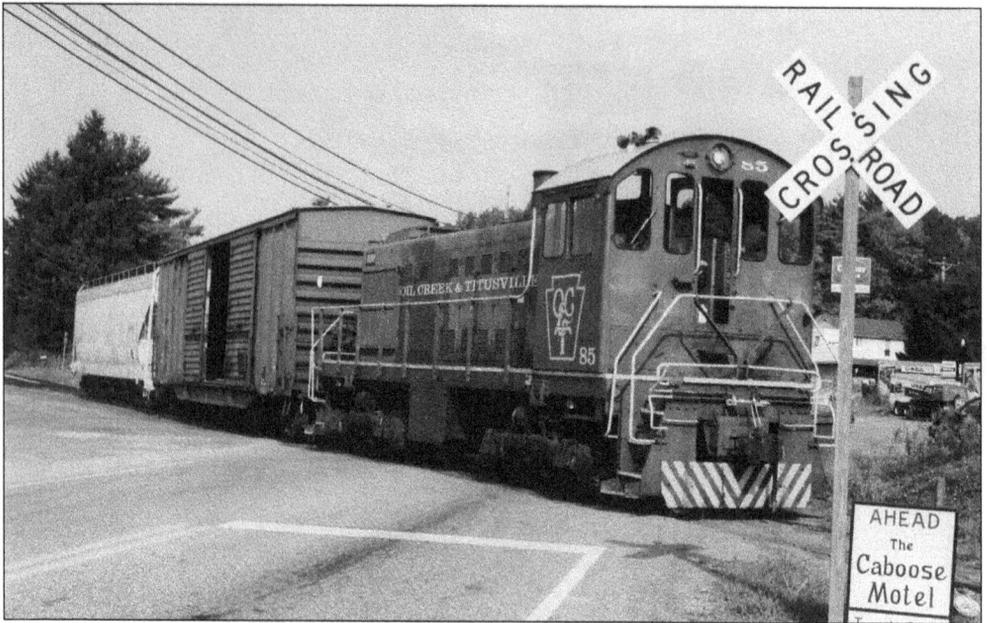

East Titusville is the scene for Oil Creek and Titusville Lines locomotive No. 85 crossing Pennsylvania Highway 27 on September 24, 2010, heading eastward to perform switching operations at Weyerhaeuser, which ships out planed, kiln-dried hardwood. This was the former Fieldmore branch of the New York Central Railroad, which was originally the Dunkirk, Allegheny Valley, and Pittsburgh Railroad to Dunkirk, New York. (Photograph by Kenneth C. Springirth.)

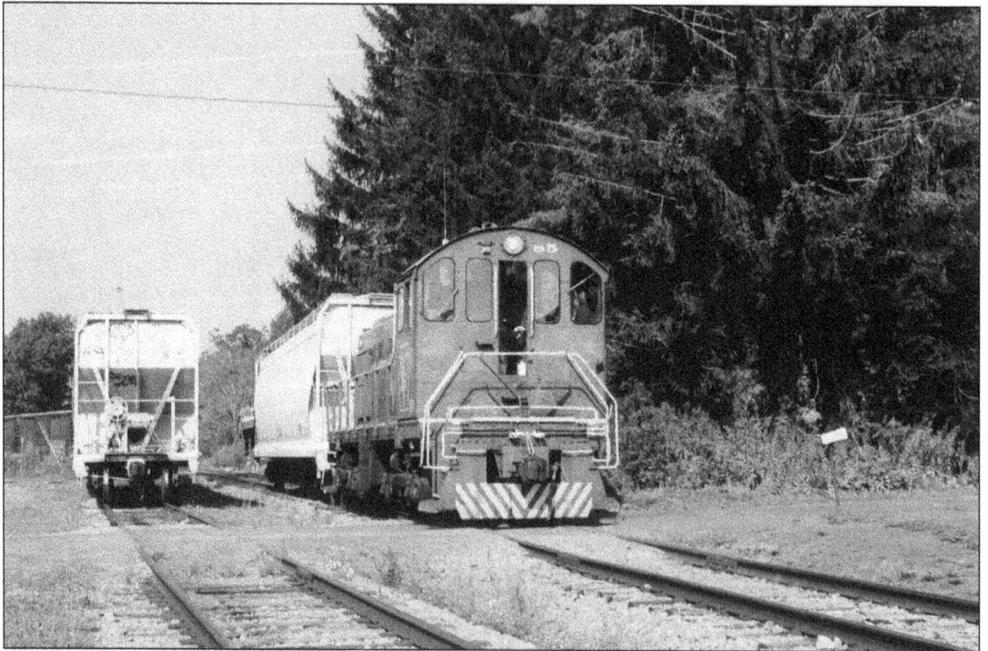

Switching occurs at Oil Creek Plastics, Inc., by Oil Creek and Titusville Lines locomotive No. 85 on September 24, 2010. Oil Creek Plastics, Inc., manufactures polyethylene pipe for a variety of applications. The railroad works closely with customers like Oil Creek Plastics, Inc., to make sure raw materials arrive as needed. (Photograph by Kenneth C. Springirth.)

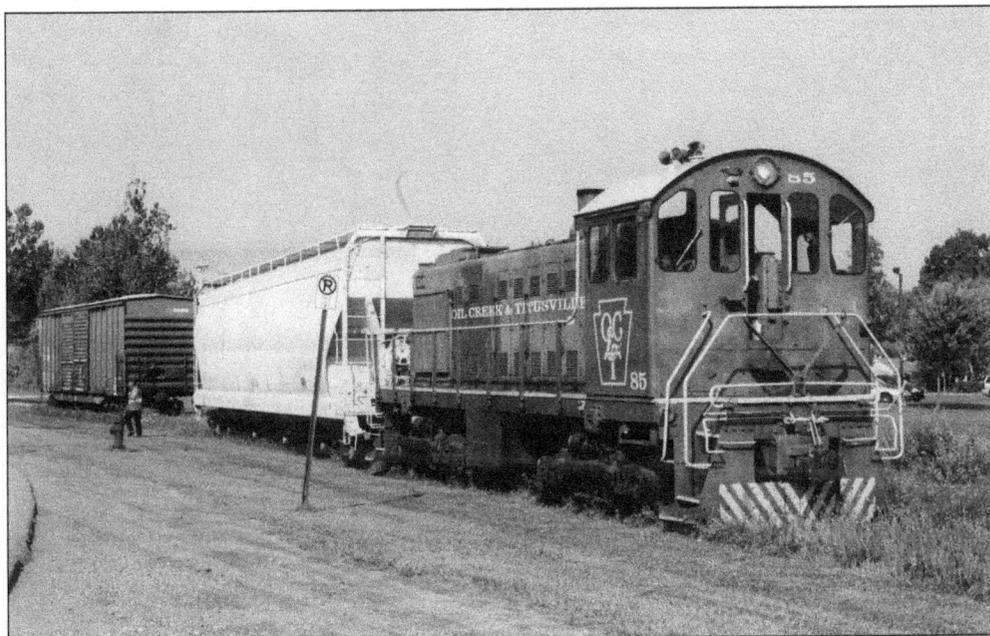

Oil Creek and Titusville Lines locomotive No. 85 is entering the siding to pick up a boxcar on Water Street at Brown Street in Titusville on September 24, 2010. This area was once a New York Central freight yard with adjacent oil refineries, cooper shops, and lumberyards. Excellent railroad service has retained industry that might have been lost if this line had been abandoned. (Photograph by Kenneth C. Springirth.)

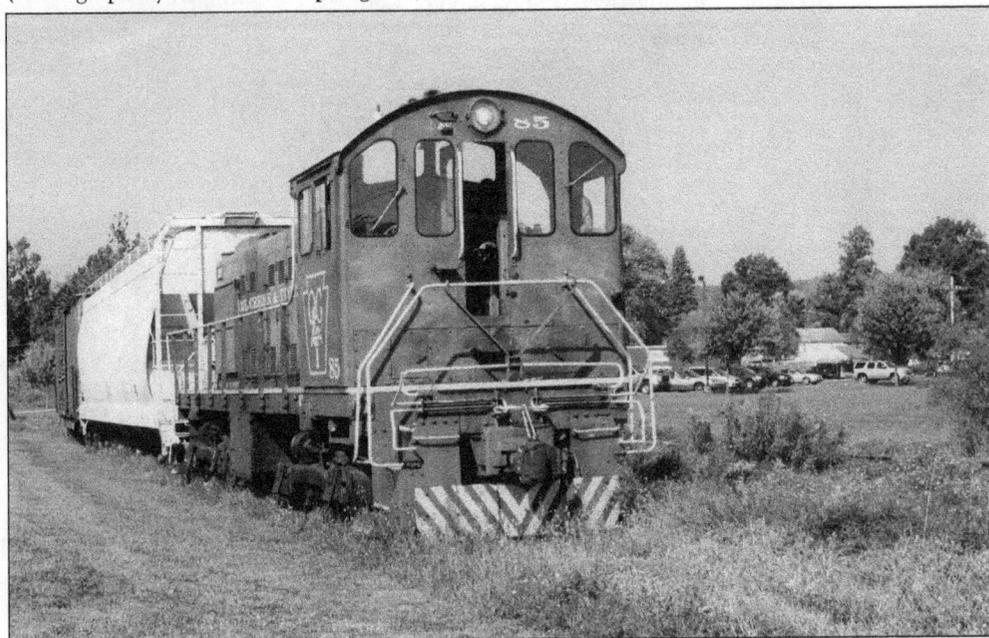

This siding on Water Street at Brown Street in Titusville is in use by the Oil Creek and Titusville Lines on September 24, 2010. Locomotive No. 85 is preparing to clear the siding and head westward. Over the years, this area has changed from a railroad yard and industrial area to a middle school located on the south side of Water Street. (Photograph by Kenneth C. Springirth.)

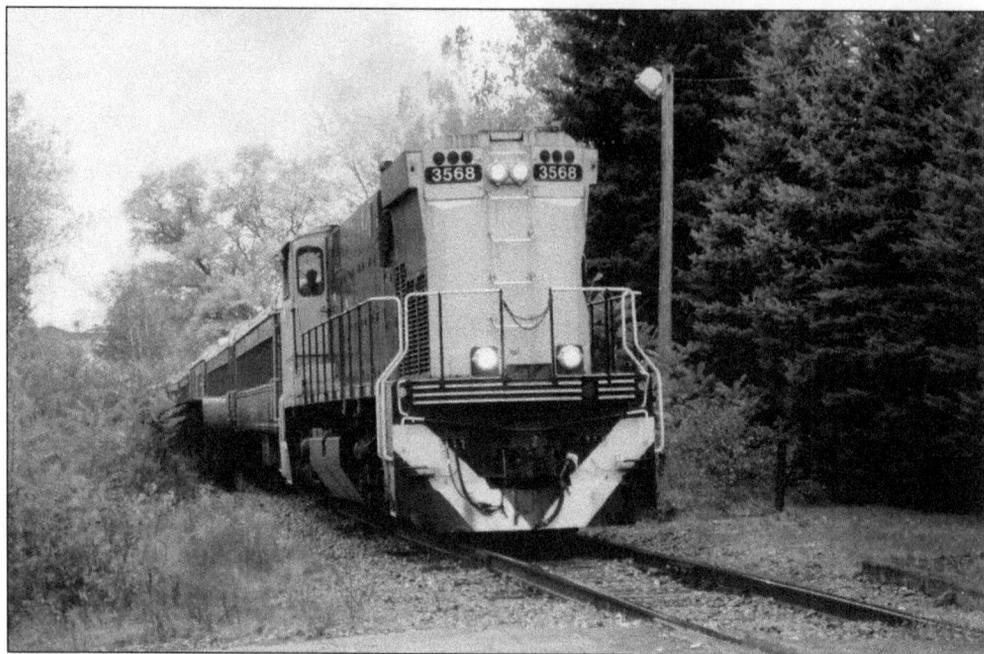

The October 14, 2010, Oil Creek and Titusville Railroad passenger train powered by the 2,000-horsepower type M420W diesel locomotive No. 3568 is about to cross Bank Street near Roberts Street in Titusville. This locomotive was built by Montreal Locomotive Works in 1977 for the Canadian National Railway and was later used on the St. Thomas and Eastern Railway before coming to Titusville during 1999. (Photograph by Kenneth C. Springirth.)

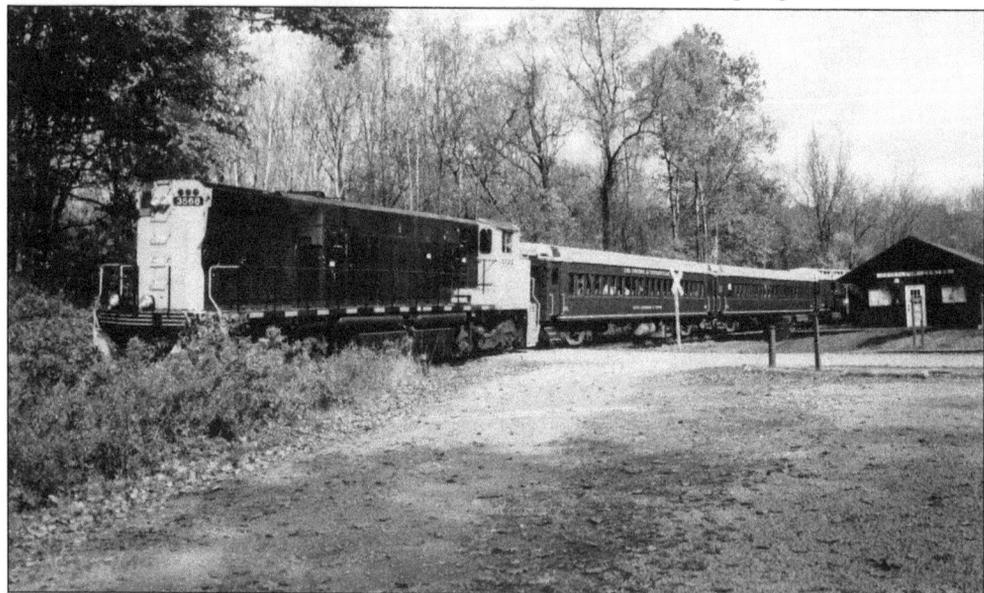

The southbound Oil Creek and Titusville Railroad passenger train is at Petroleum Centre station in Oil Creek Park on October 14, 2010. On August 26, 1988, the train station at Petroleum Centre was dedicated. The August 27, 1988, *Titusville Herald* quoted Joan Johnsen, vice president of the Oil Creek Railway Historical Society, saying, "So many people donated so many hours" for the railroad. (Photograph by Kenneth C. Springirth.)

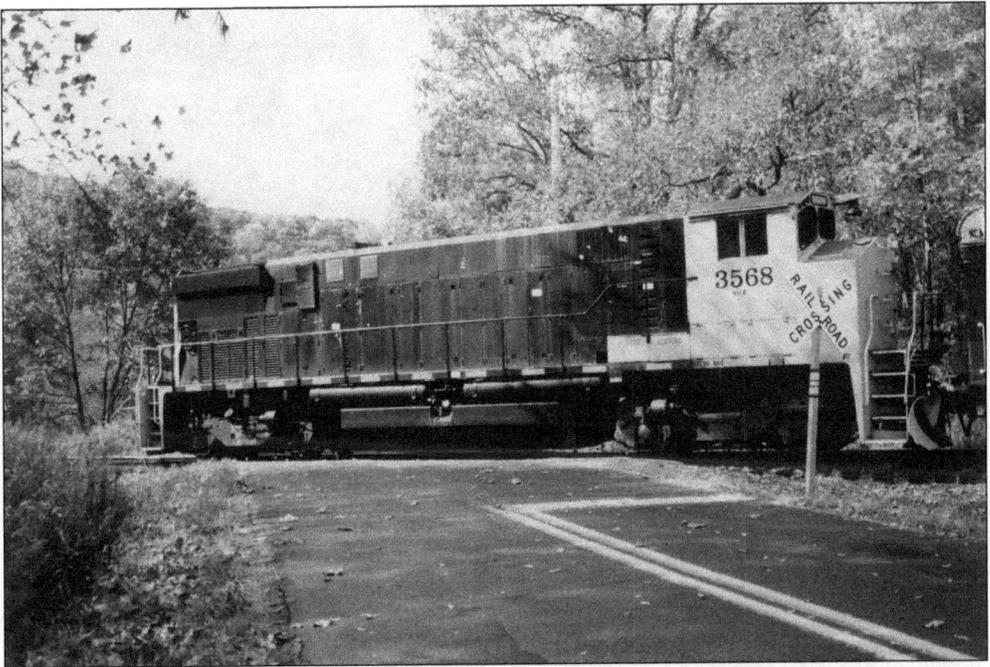

Oil Creek and Titusville Railroad locomotive No. 3568 is crossing State Park Road south of Petroleum Centre for a passenger run on October 14, 2010. After oil was discovered on August 27, 1859, thousands of people poured into the Oil Creek valley. Roads became impassable as oil and mud soon mixed. (Photograph by Kenneth C. Springirth.)

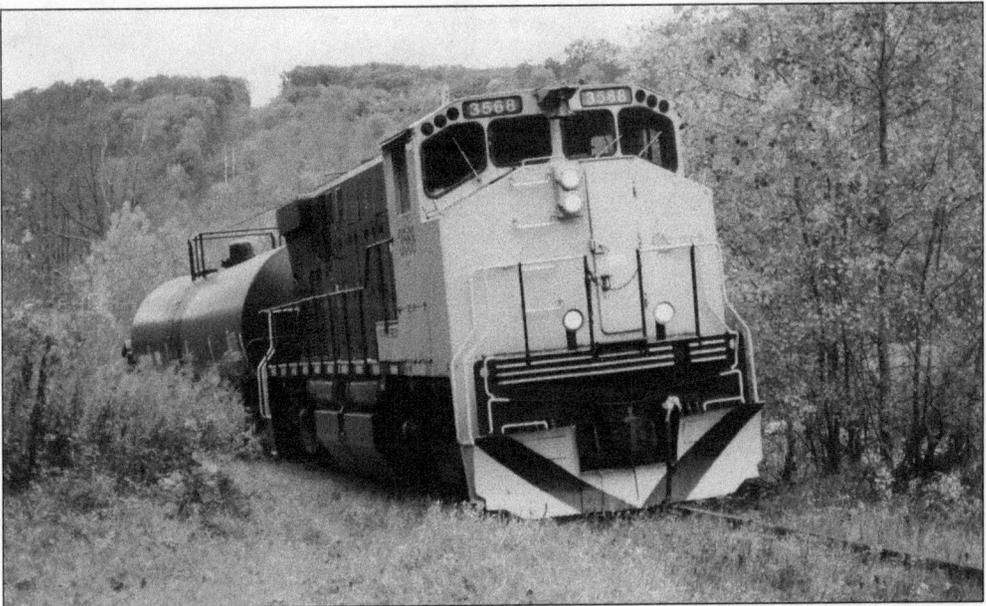

At the Rynd Farm interchange with the Western New York and Pennsylvania Railroad (which in December 2005 leased the Norfolk Southern Railway line from Meadville to Rynd Farm), locomotive No. 3568 is retrieving a tank car to add to the northbound passenger train on October 14, 2010. While passenger excursions are primarily during the tourist season, the railroad operates freight service throughout the year. (Photograph by Kenneth C. Springirth.)

On October 14, 2010, the interior of the Perry Street station in Titusville features elaborate displays of historical scenes and information. In 1987, the work of rebuilding this station began, including replacing the roof, replacing outside siding boards that were broken or missing, installing new decks, and removing paint and dirt on the interior walls to reveal the natural beauty of the original wood. (Photograph by Kenneth C. Springirth.)

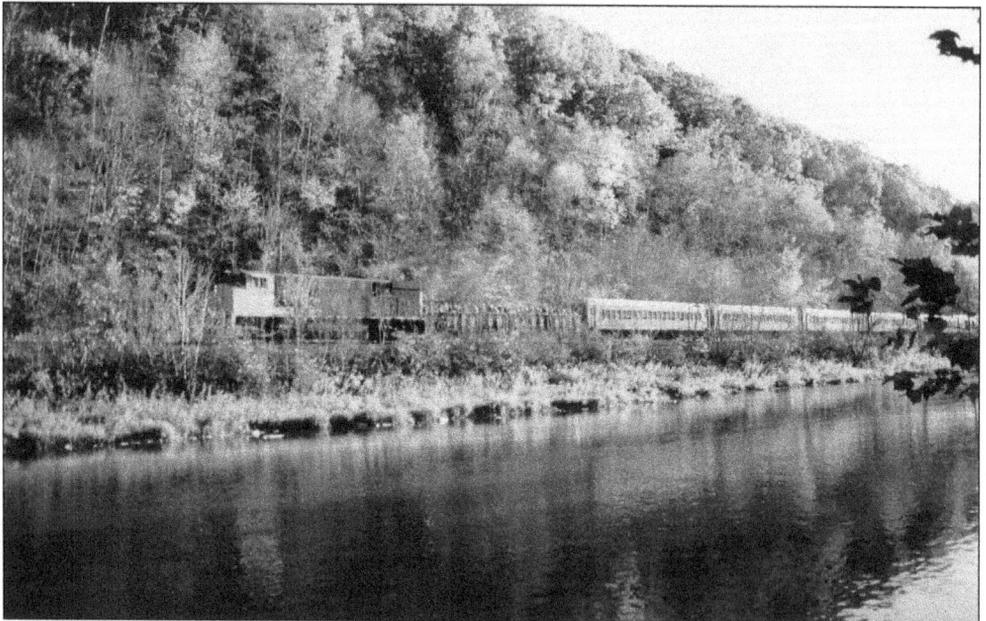

Along the east bank of Oil Creek, a northbound Oil Creek and Titusville Railroad passenger train headed by locomotive No. 3568 is just north of Rynd Farm in the autumn sun of October 16, 2010. After oil was discovered, thousands of people poured into this valley; derricks replaced trees, and Oil Creek was covered with oil. Production had dwindled by 1871, and nature has reclaimed the area. (Photograph by Kenneth C. Springirth.)

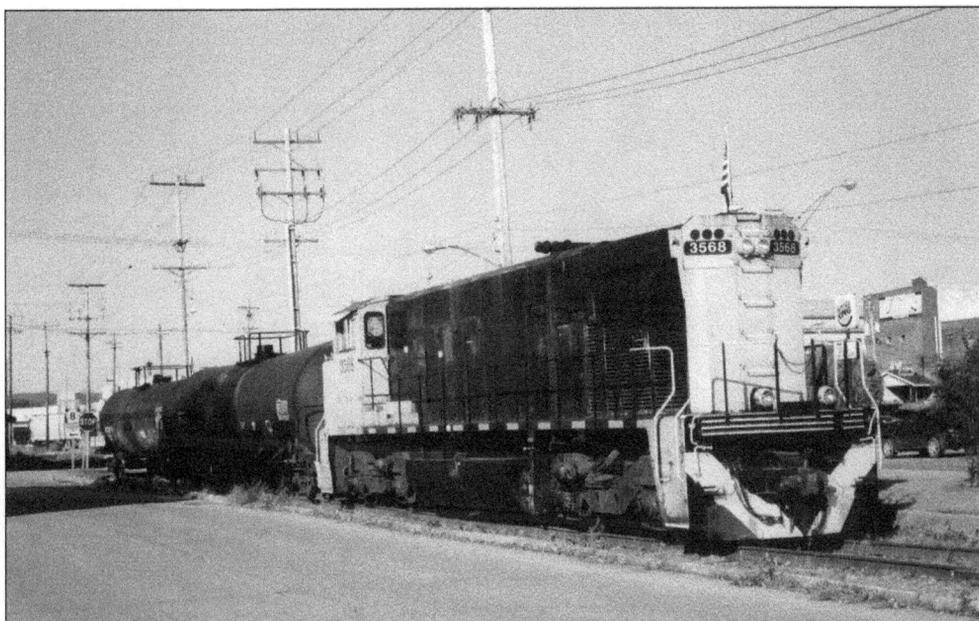

Water Street at Franklin Street in Titusville is the scene for Oil Creek and Titusville Lines locomotive No. 3568 heading west on the Fieldmore branch of the former New York Central Railroad on October 20, 2010. Years ago, the northeast and southeast corners of this intersection were home to a number of retail businesses, taverns, and machine shops. (Photograph by Kenneth C. Springirth.)

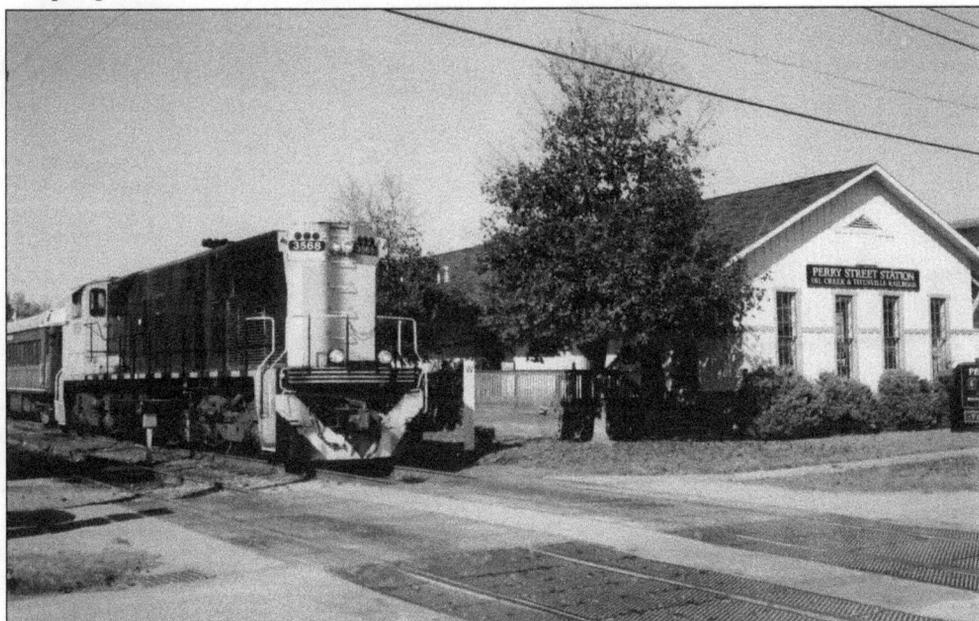

Locomotive No. 3568 waits for departure time at Perry Street on October 20, 2010. On May 27, 1988, the Perry Street station opened. The May 28, 1988, *Titusville Herald* reported, "A crowd of about 150 people from all walks of life formed yesterday to see the official opening of the Oil Creek and Titusville Railroad's Perry Street station at a ribbon cutting ceremony outside the totally refurbished building." (Photograph by Kenneth C. Springirth.)

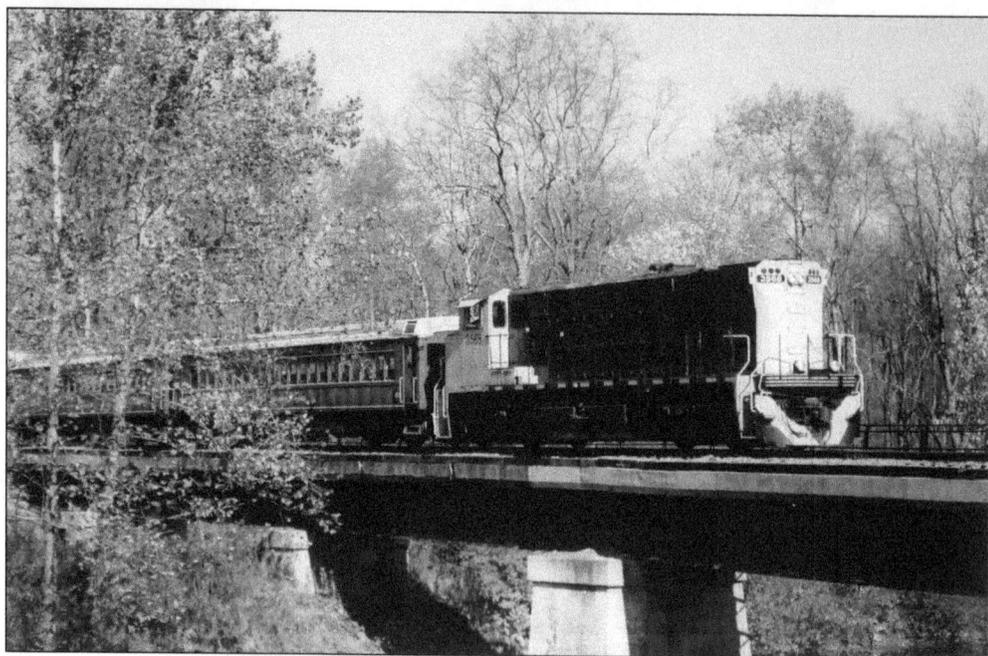

The southbound Oil Creek and Titusville Railroad passenger train is crossing Jersey Bridge (built in 1915 by American Bridge Company) over Oil Creek north of Drake Well station on October 20, 2010. This concrete-beam bridge had a section replaced in 2009. (Photograph by Kenneth C. Springirth.)

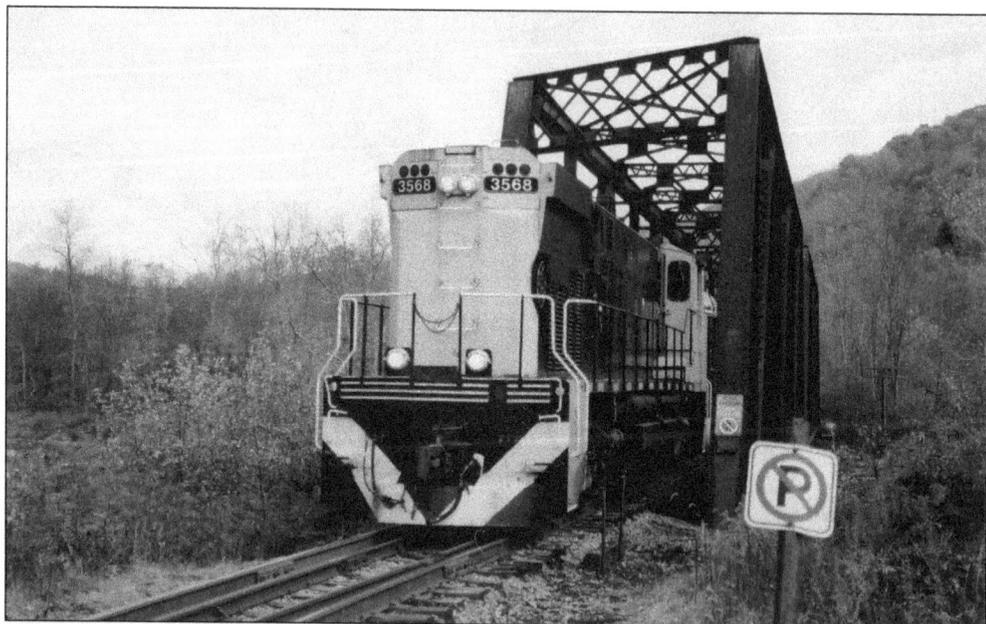

Just north of Petroleum Centre, Oil Creek and Titusville Railroad locomotive No. 3568 is southbound with a passenger train crossing Oil Creek and approaching Petroleum Centre Road on October 20, 2010. After oil production declined, lumber became a major industry. Oil drilling and production returned between the 1920s and World War II. Oil Creek State Park was created between 1962 and 1970. (Photograph by Kenneth C. Springirth.)

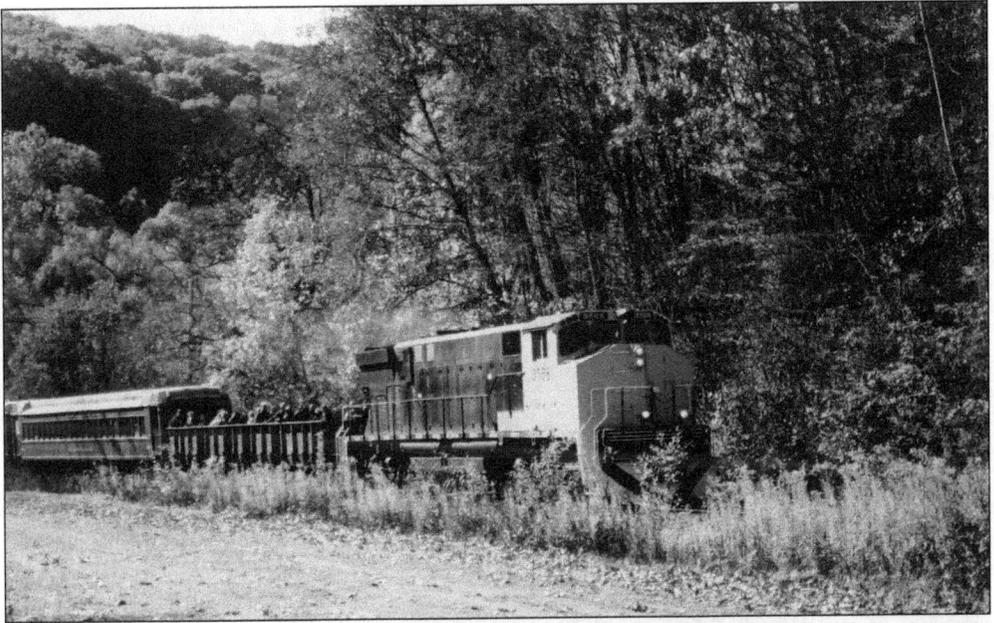

Amid the fall foliage, an Oil Creek and Titusville Railroad passenger train headed by locomotive No. 3568 is northbound approaching Petroleum Centre station on October 20, 2010. Petroleum Centre was founded in 1861, during the Pennsylvania oil rush. When oil production declined, drillers and speculators went to other areas, and Petroleum Centre was virtually abandoned after 1873. (Photograph by Kenneth C. Springirth.)

Oil Creek and Titusville Railroad locomotive No. 3568 is approaching Perry Street station in Titusville on October 20, 2010. The Buffalo Structural Steel building in the background was formerly the Titusville Iron Works Division of Struthers Wells Corporation welding shop, packaged boiler assembly, warehouse, and tube storage bay, plus a steam and electric power plant. (Photograph by Kenneth C. Springirth.)

Edward J. Rost, motive power mechanic for the New York and Lake Erie Railroad from Gowanda, New York, is spray-painting locomotive No. 75 at the Titusville yard of the Oil Creek and Titusville Lines on October 20, 2010. The New York and Lake Erie Railroad (a short-line railroad in Gowanda, New York) is the parent railroad for the Oil Creek and Titusville Lines. (Photograph by Kenneth C. Springirth.)

With a good weather forecast and the proper temperature, Edward J. Rost is spray-painting locomotive No. 75 at the Titusville yard (formerly used by the Pennsylvania Railroad) on October 20, 2010. Soon after the painting was completed, the normal winter weather set in, but the paint job was beautiful. (Photograph by Kenneth C. Springirth.)

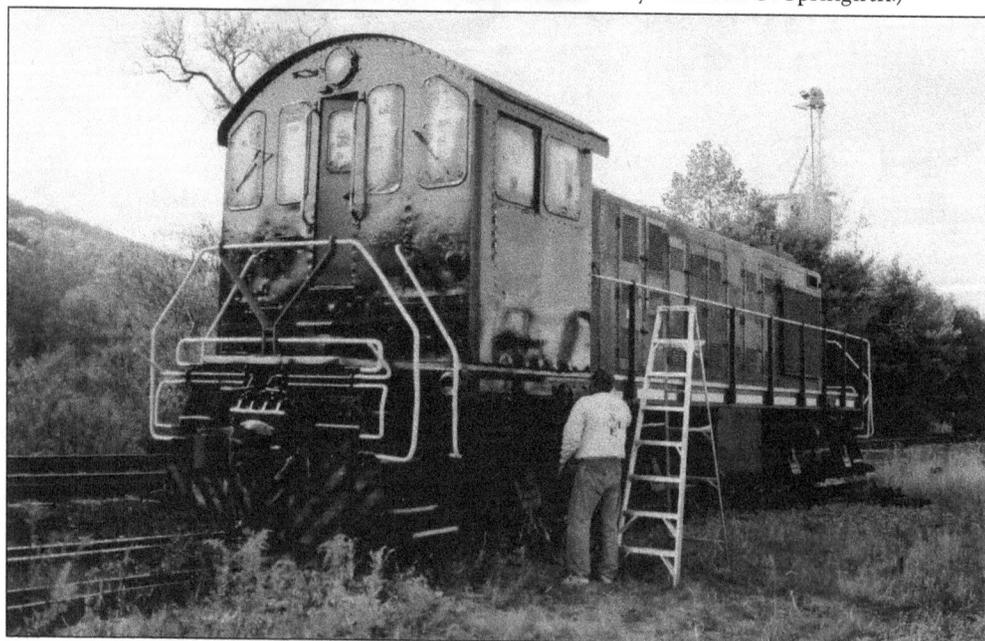

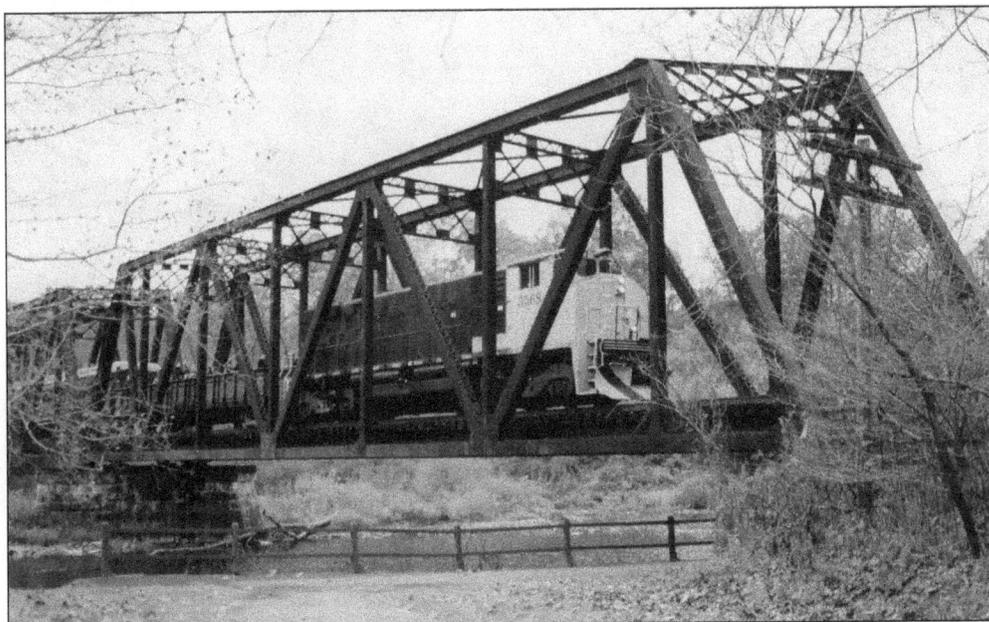

Crossing Oil Creek north of Petroleum Centre is Oil Creek and Titusville Railroad locomotive No. 3568 leading a northbound passenger train on October 21, 2010. American Bridge Company built the Warren truss bridge subdivided with vertical members in 1910. James Warren and Willoughby Monzoni of Great Britain patented the Warren truss bridge design (identified by many equilateral or isosceles triangles) in 1848. (Photograph by Kenneth C. Springirth.)

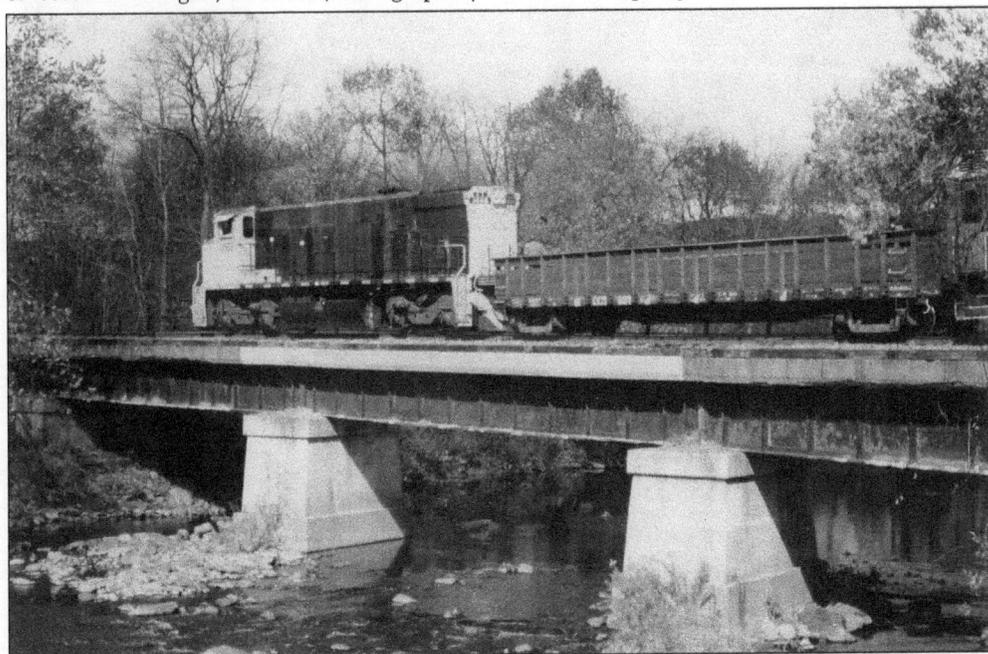

Oil City and Titusville Railroad locomotive No. 3568 with a northbound passenger train is on the Jersey Bridge crossing Oil Creek just north of Drake Well station on October 21, 2010. Received in 1990, the open-air gondola car was built in 1940 for the Great Northern Railway and was later converted from a flatcar into a passenger gondola car. (Photograph by Kenneth C. Springirth.)

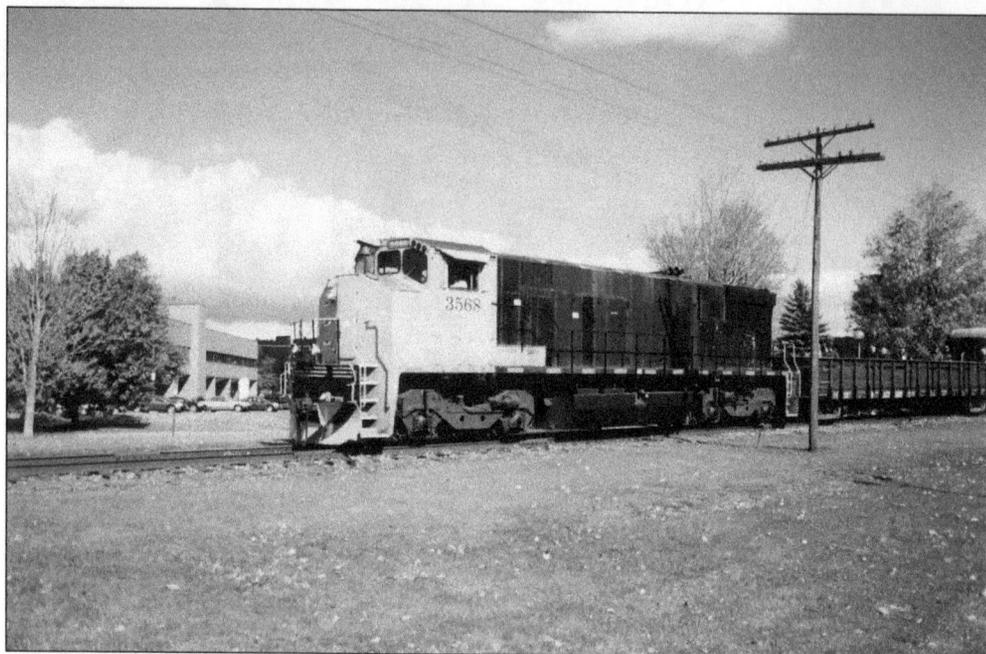

The northbound Oil Creek and Titusville Railroad passenger train powered by locomotive No. 3568 is about to cross Franklin Street in Titusville on October 21, 2010, and will soon be at the Perry Street terminus. Years ago, grocery stores were at this location south of the track, and the Brady House Hotel was north of the track. (Photograph by Kenneth C. Springirth.)

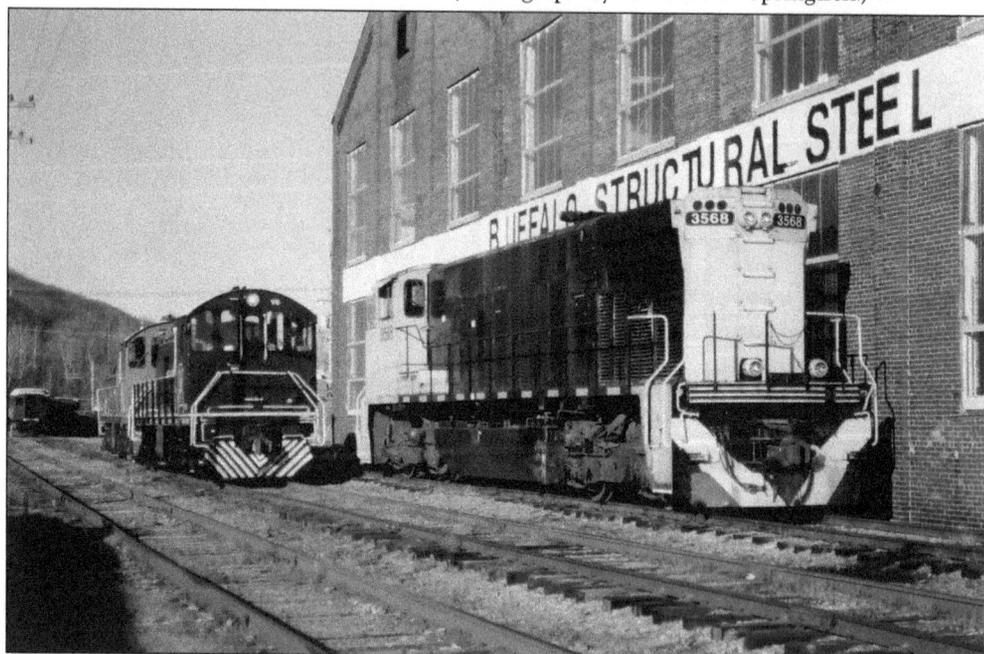

All of the Oil Creek and Titusville Lines locomotives (No. 85 and No. 75 on the center track and No. 3568 on the track adjacent to the Buffalo Structural Steel building) are in view east of Perry Street in Titusville on November 3, 2010. The passenger cars are parked in the distance at the Perry Street station. (Photograph by Kenneth C. Springirth.)

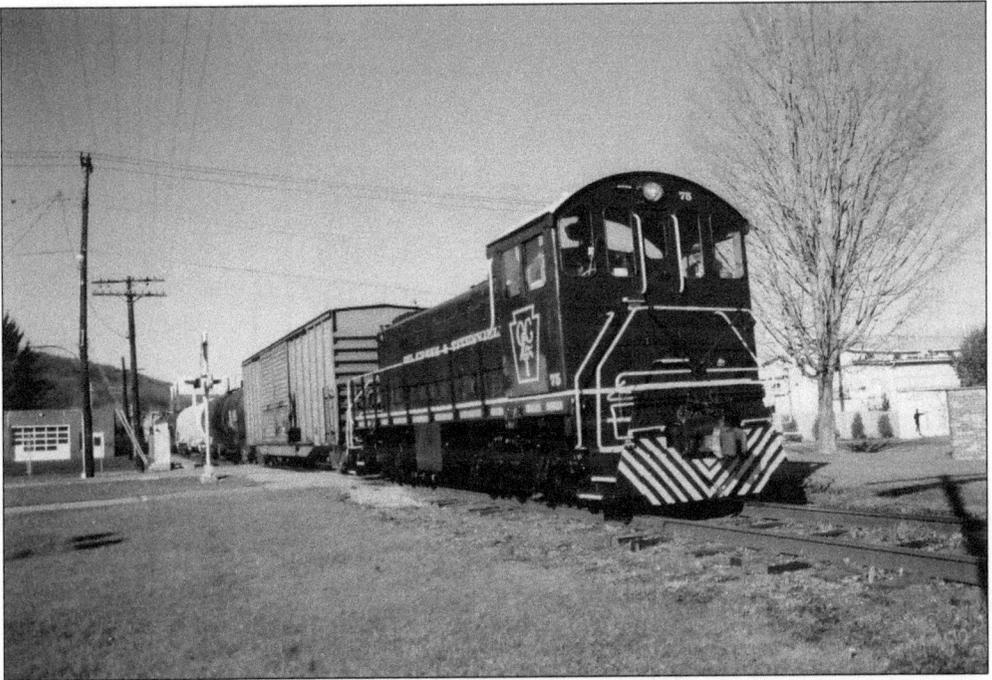

Newly repainted locomotive No. 75 is crossing Franklin Street with an Oil Creek and Titusville Lines freight train bound for the Rynd Farm interchange on November 3, 2010. (Photograph by Kenneth C. Springirth.)

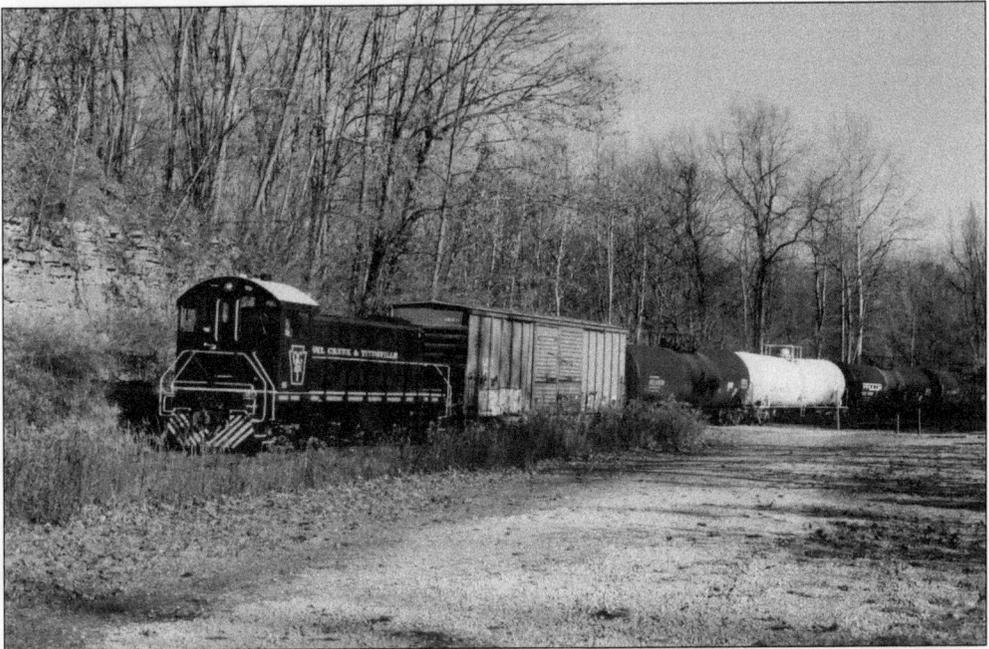

The southbound Oil Creek and Titusville Lines freight train is crossing Stevenson Hill Road at Petroleum Centre with locomotive No. 75 leading the way on November 3, 2010. The first oil well was completed on June 15, 1860, but by the 1880s, the oil industry in the Oil Creek valley declined significantly, and oil workers moved on to new fields. (Photograph by Kenneth C. Springirth.)

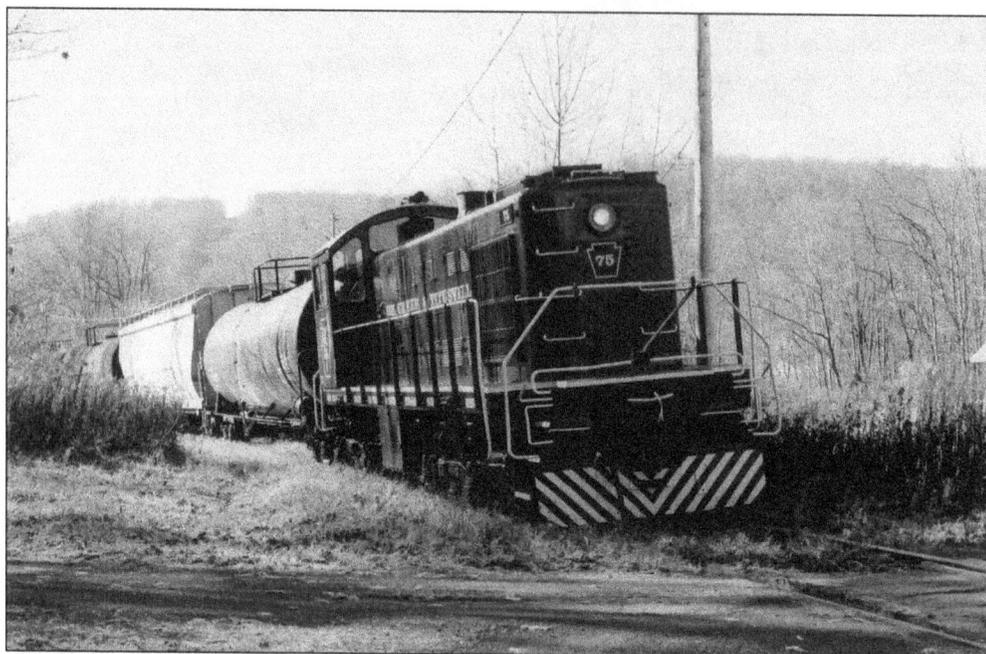

At the Rynd Farm interchange point with the Western New York and Pennsylvania Railroad on November 3, 2010, Oil Creek and Titusville Lines locomotive No. 75 is northbound for Titusville. In 1872, riots started at Rynd Farm when a group of oil producers objected to high freight charges and prevented a train of tank cars from traveling to the Standard Oil Company refinery at Cleveland. (Photograph by Kenneth C. Springirth.)

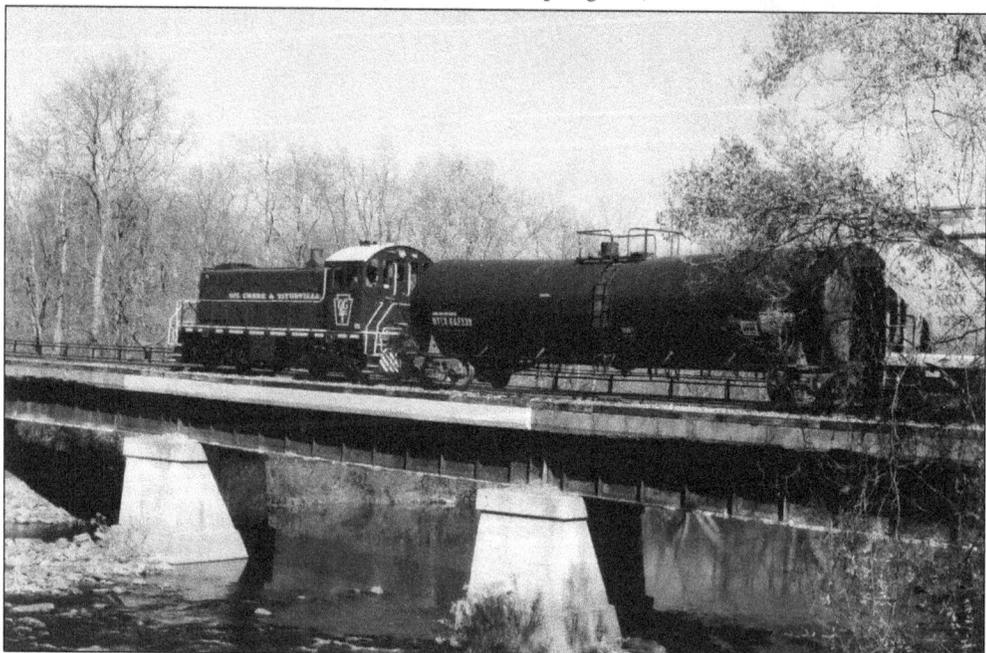

Oil Creek and Titusville Railroad Lines locomotive No. 75 is crossing Oil Creek just north of Drake Well station on November 3, 2010. The discovery of oil near this spot resulted in the birth of the petroleum industry. (Photograph by Kenneth C. Springirth.)

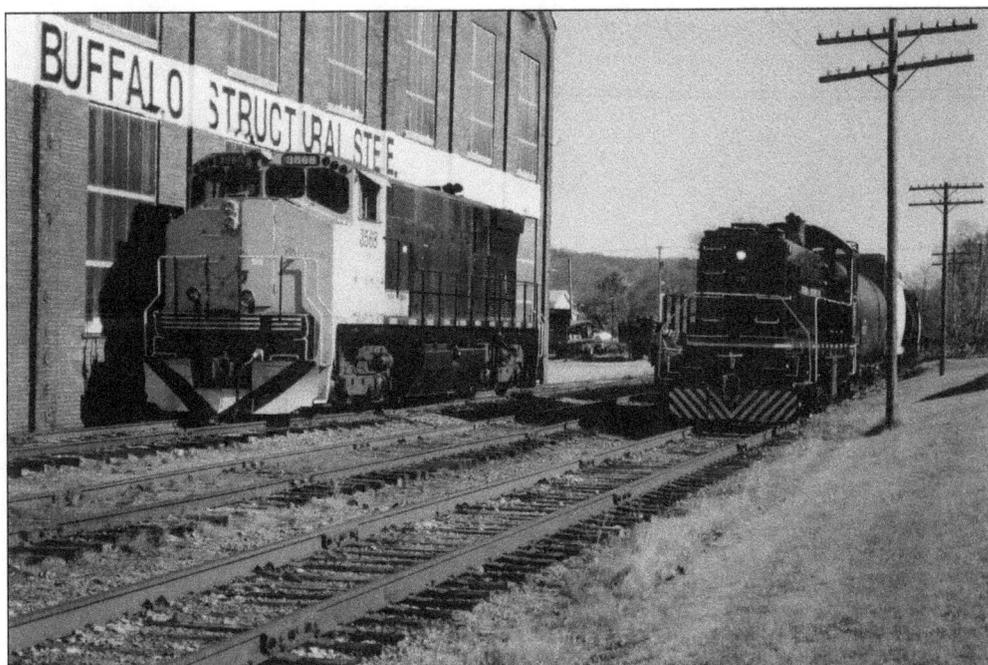

On November 3, 2010, Oil Creek and Titusville Lines locomotive No. 75 is passing locomotive No. 3568 east of Perry Street in Titusville. Buffalo Structural Steel, Inc., now occupies the century-old landmark industrial building that was once part of the Titusville Iron Works welding shop and boiler tube storage area. (Photograph by Kenneth C. Springirth.)

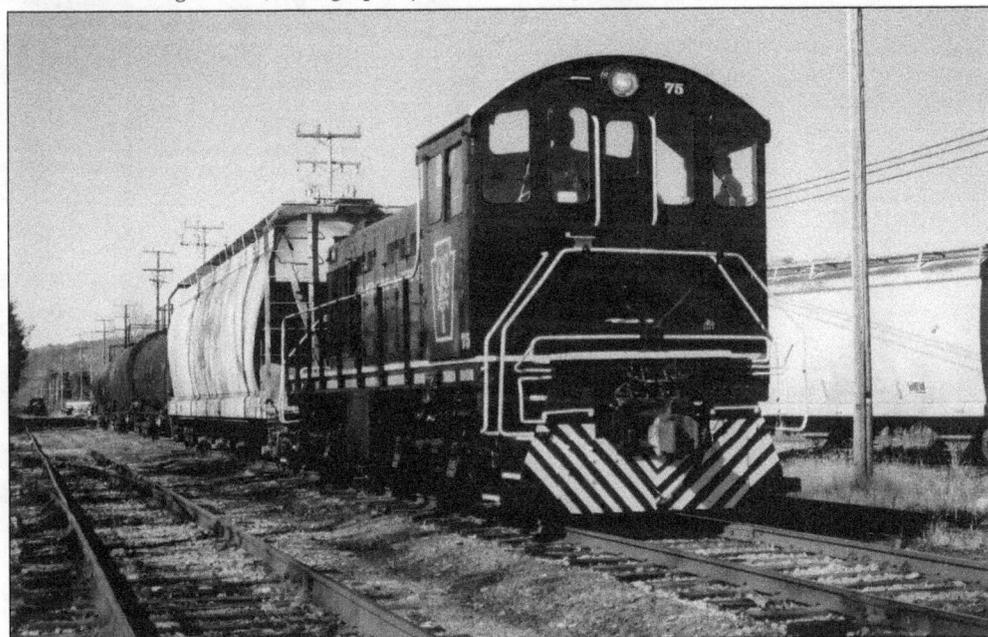

Oil Creek and Titusville Lines locomotive No. 75 switches freight cars at the Titusville yard on November 3, 2010. Titusville's central location was an essential factor in its industrial development. Close proximity to Erie and equidistant between Buffalo and Pittsburgh was (and to a certain extent still is) a benefit for many Titusville industries. (Photograph by Kenneth C. Springirth.)

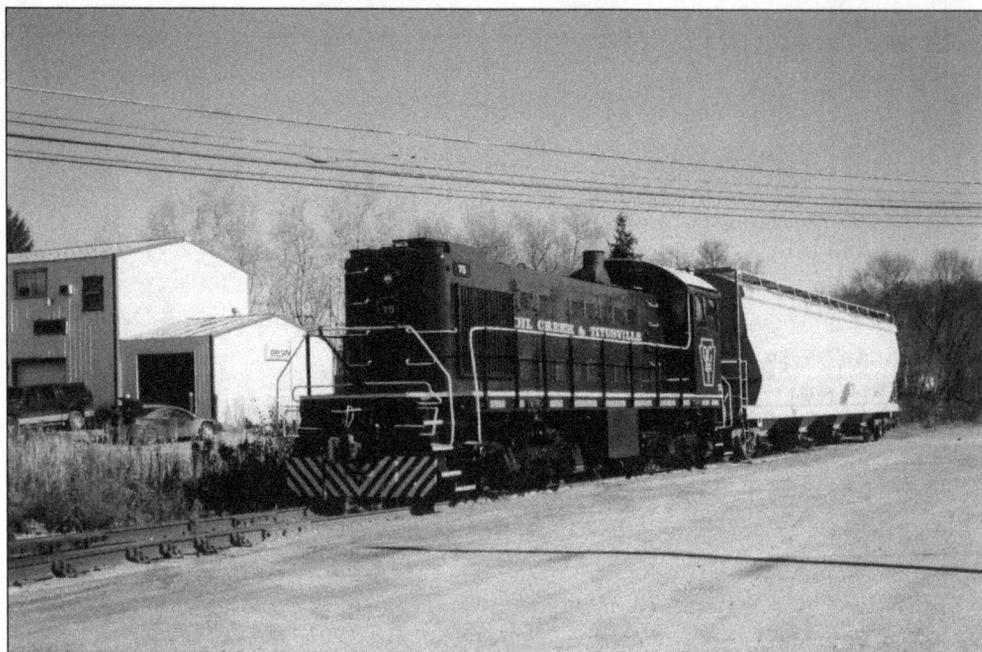

On November 3, 2010, Oil Creek and Titusville Lines locomotive No. 75 has stopped at Oil Creek Plastics, Inc., on the former Fieldmore branch of the New York Central Railroad. (Photograph by Kenneth C. Springirth.)

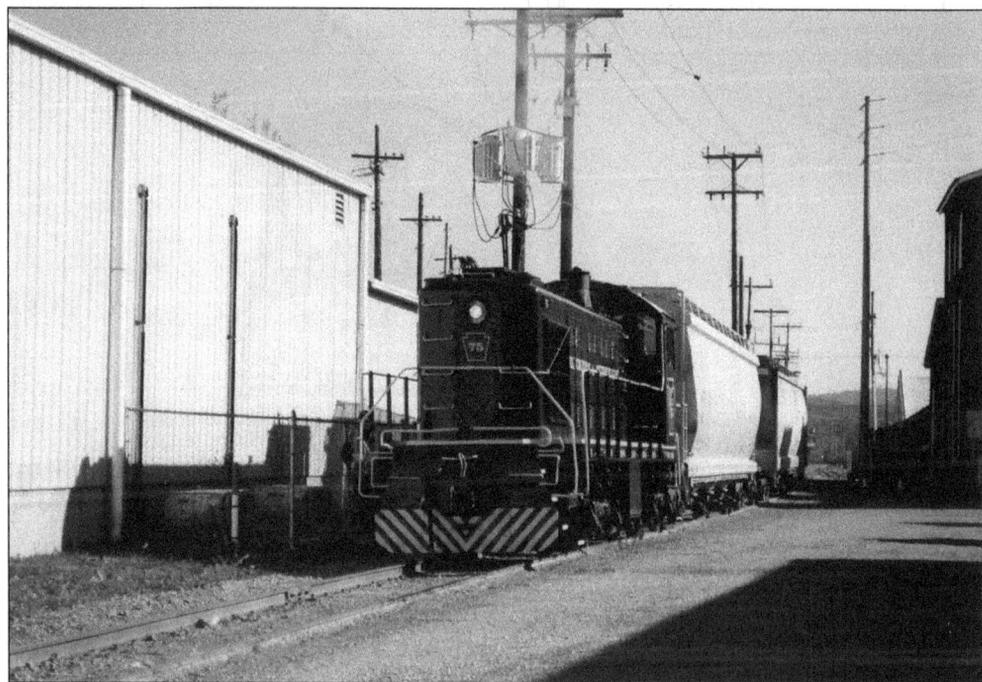

Westbound from Charter Plastics and passing the Titusville Dairy Products Company on the left, Oil Creek and Titusville Lines locomotive No. 75 is just east of Perry Street in Titusville on November 15, 2010. The Titusville region survived the collapse of the oil market and over the years has attracted new industries. (Photograph by Kenneth C. Springirth.)

An Oil Creek and Titusville Lines freight train is crossing Perry Street in Titusville for a trip to the interchange at Rynd Farm on November 15, 2010. Nearly every type of industry has been found in the Titusville region at various times. (Photograph by Kenneth C. Springirth.)

The morning quiet of November 15, 2010, is interrupted as Oil Creek and Titusville Lines locomotive No. 75 leads a southbound freight train over Oil Creek via the Jersey Bridge just north of Drake Well station and just south of the Crawford and Venango County line. (Photograph by Kenneth C. Springirth.)

On November 15, 2010, engineer Chris Dingman (bending over) and conductor Chuck Brown (kneeling) scoop debris out of the grooved portion of the Stevenson Hill Road crossing so that the flanged wheels on the locomotive and freight cars can pass by without derailing. On the Oil Creek and Titusville Lines, the employees serve customers by doing whatever is necessary to keep the trains moving. (Photograph by Kenneth C. Springirth.)

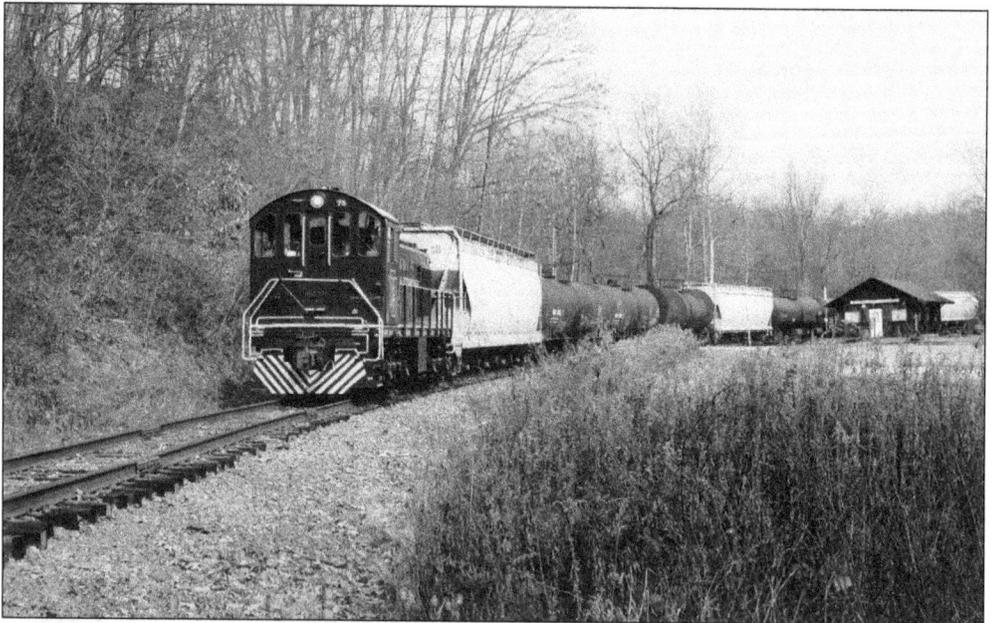

Following the crossing maintenance work on November 15, 2010, the Oil Creek and Titusville Lines southbound freight train powered by locomotive No. 75 is passing by the Petroleum Centre station. Historic displays, a detailed diorama, a walking tour, and information are at the Petroleum Centre station, which serves as a visitor center and train stop. (Photograph by Kenneth C. Springirth.)

On November 15, 2010, a southbound Oil Creek and Titusville Lines freight train powered by locomotive No. 75 is within a mile of its Rynd Farm destination along the east bank of Oil Creek, which is one of the best trout and bass streams in Pennsylvania. On the west side of Oil Creek, Columbia Farm had produced oil for over 100 years until about 1969. (Photograph by Kenneth C. Springirth.)

Oil Creek and Titusville Lines locomotive No. 75 is preparing to cross Stevenson Hill Road at Petroleum Centre on its northbound trip to Titusville on November 15, 2010. During much of Petroleum Centre's most active period, the city had only one policeman. Lacking a jail, prisoners were often handcuffed to telegraph poles or sometimes just given a reprimand. (Photograph by Kenneth C. Springirth.)

In the afternoon of November 15, 2010, Oil Creek and Titusville Lines locomotive No. 75 is crossing Oil Creek north of Drake Well station. On September 1, 1865, Amos and James Densmore placed two wooden tanks on a flatcar, and it successfully carried oil. Hundreds of these tank cars were placed in service. The first iron-boiler-type tank car appeared in February 1869. (Photograph by Kenneth C. Springirth.)

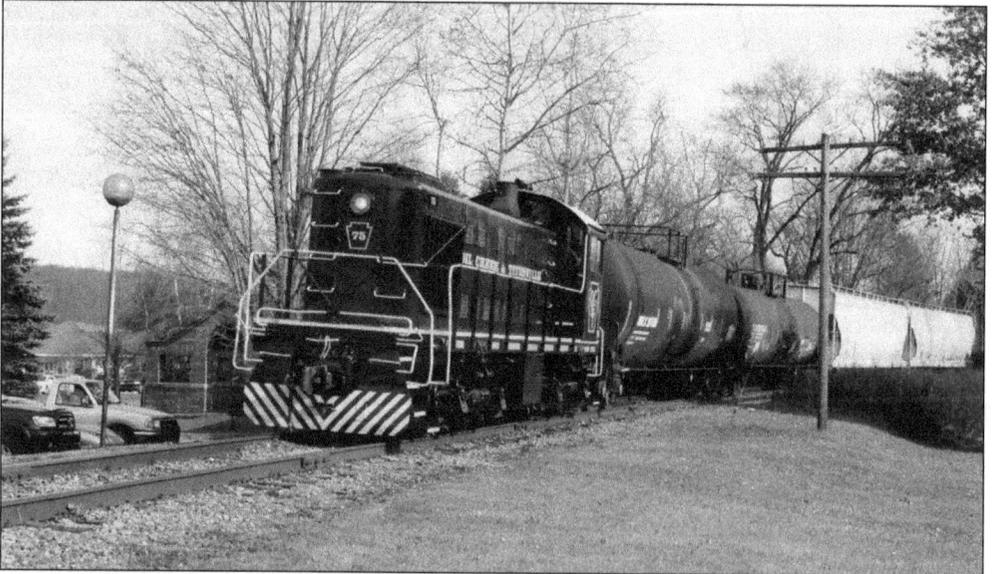

At the foot of South Martin Street and approaching Franklin Street on November 15, 2010, Oil Creek and Titusville Lines locomotive No. 75 will shortly arrive at the Titusville yard. In spite of the many economic challenges over the years, key factors in Titusville's survival were its churches, fraternal lodges, public school system, and diversified industrial base. (Photograph by Kenneth C. Springirth.)

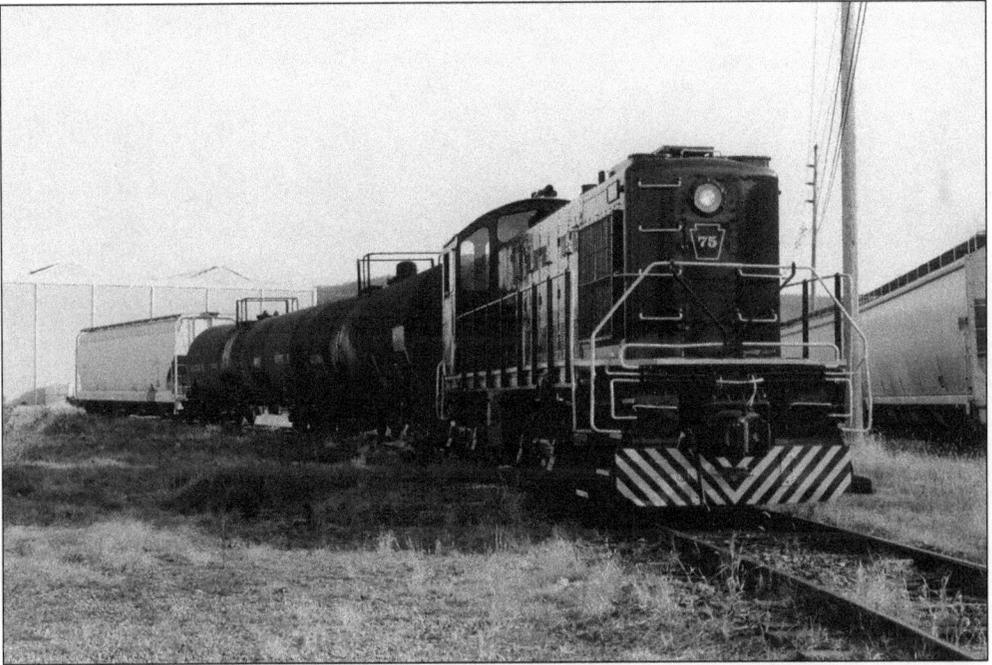

Locomotive No. 75 is at the Oil Creek and Titusville Lines rail yard in Titusville on November 15, 2010. The freight cars received from the Rynd Farm interchange have to be properly positioned for nearby freight customers or delivered to the various industries along the former New York Central Railroad line to East Titusville. (Photograph by Kenneth C. Springirth.)

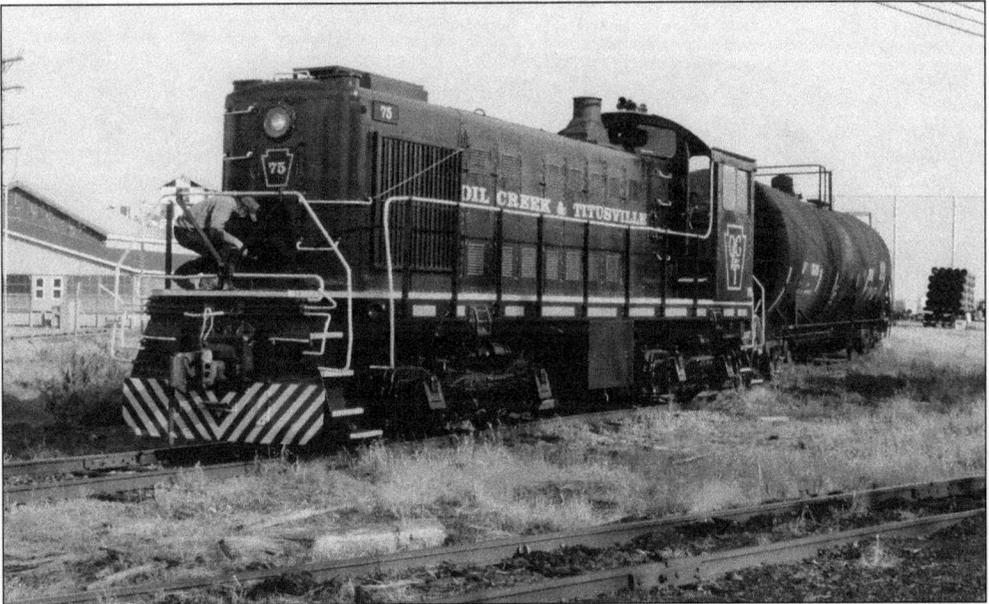

Switching cars is time-consuming work. In addition to the switching activity, Oil Creek and Titusville Lines engineer Chris Dingman is working on Locomotive No. 75 at Titusville yard on November 15, 2010. Queen City Tannery, once the largest independently operated sole leather firm in the United States, was at this site from 1890 to 1915. (Photograph by Kenneth C. Springirth.)

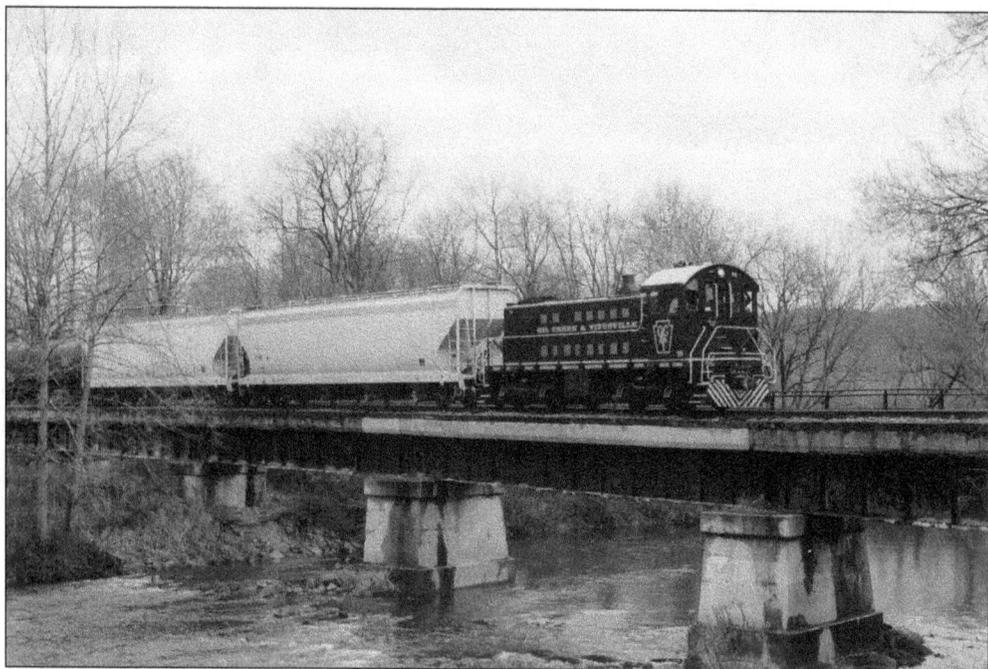

On the cloudy morning of November 19, 2010, Oil Creek and Titusville Lines locomotive No. 75 is crossing Oil Creek and will shortly pass Drake Well station on its southbound run to Rynd Farm. (Photograph by Kenneth C. Springirth.)

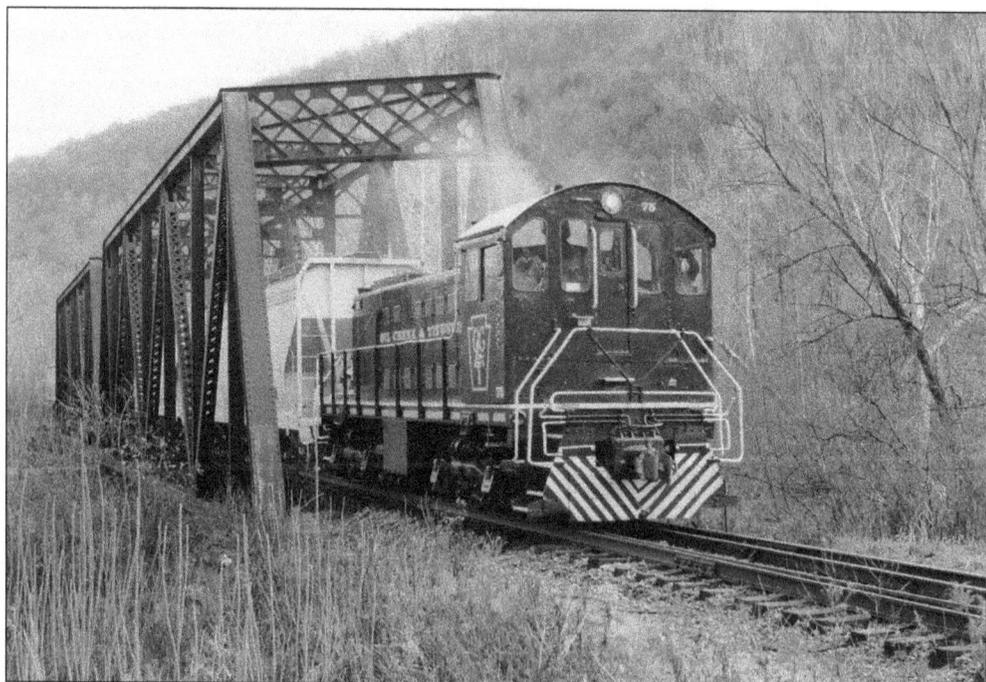

Oil Creek and Titusville Lines locomotive No. 75 is leading a southbound freight train across Oil Creek (over the railroad's only Warren truss bridge) and will shortly pass by Petroleum Centre on its November 19, 2010, run to Rynd Farm. (Photograph by Kenneth C. Springirth.)

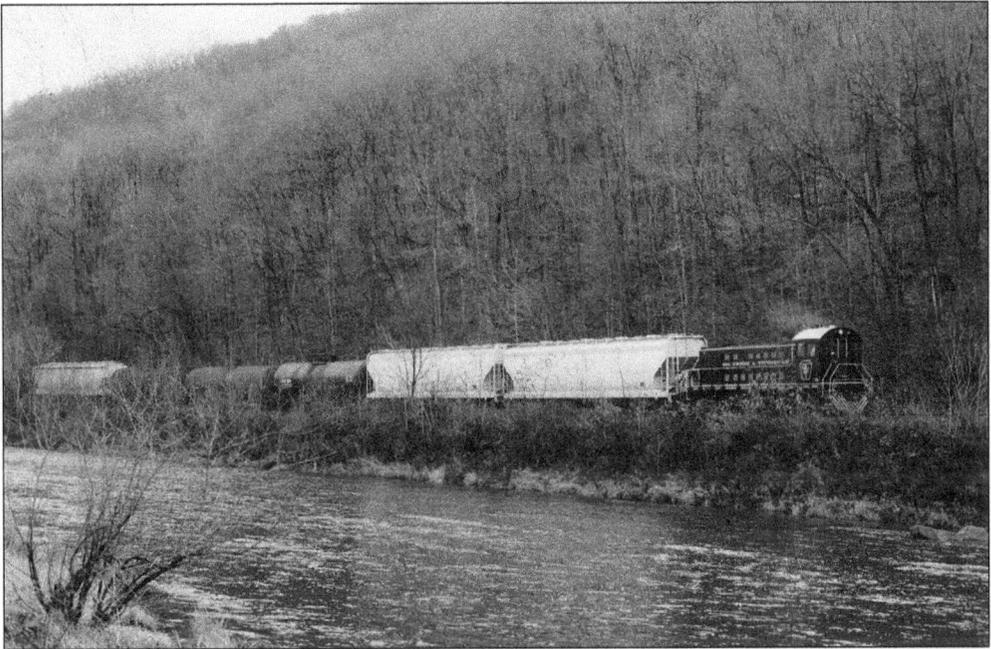

Even after the trees have lost their leaves, Oil Creek State Park is a beautiful setting on the east bank of Oil Creek for this southbound Oil Creek and Titusville Lines freight train headed by locomotive No. 75 on November 19, 2010. It is within a mile of the southern terminus at Rynd Farm. (Photograph by Kenneth C. Springirth.)

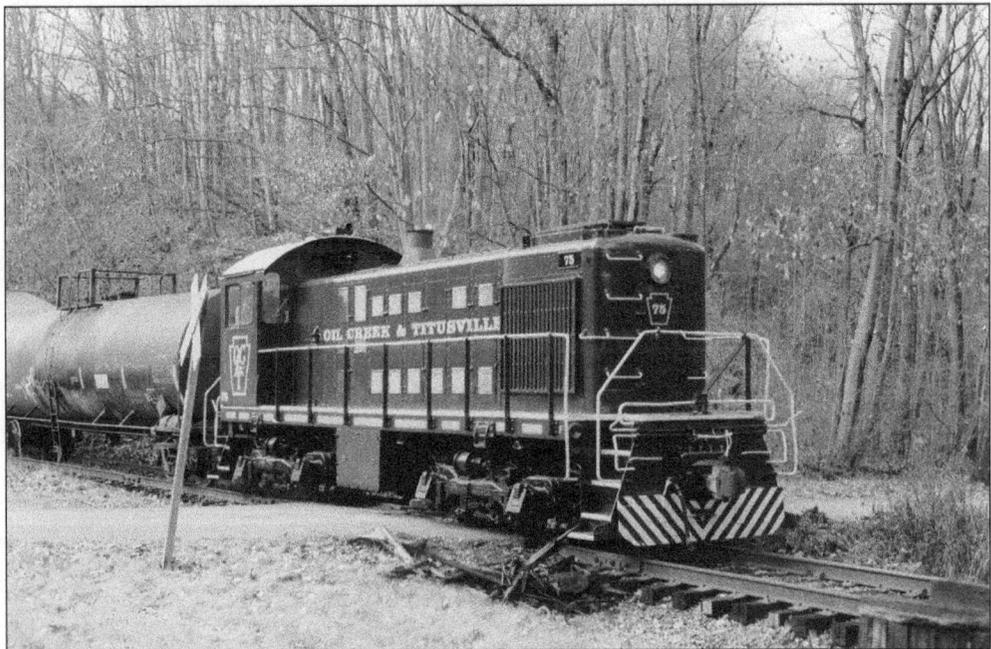

On November 19, 2010, Oil Creek and Titusville Lines locomotive No. 75 is northbound crossing Stevenson Hill Road at Petroleum Centre. The first oil well was completed in Petroleum Centre on June 15, 1860. The town soon had hotels, theaters, business houses, refineries, and machine and blacksmith shops. (Photograph by Kenneth C. Springirth.)

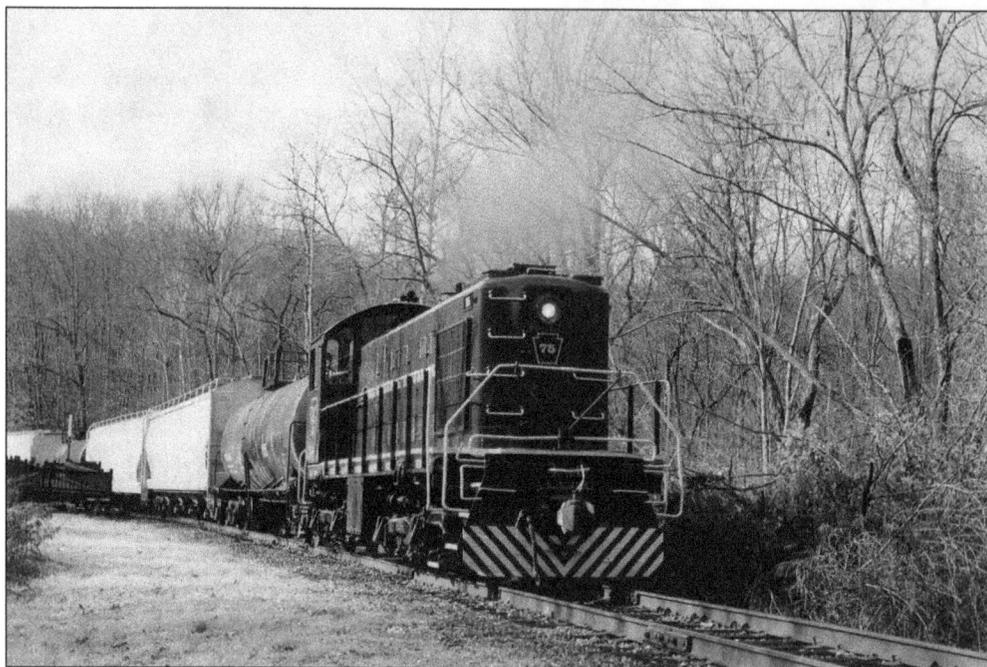

Passing by Petroleum Centre station, Oil Creek and Titusville Lines locomotive No. 75 is northbound on November 19, 2010. After Pres. Ulysses S. Grant spoke at a reception in Titusville on September 14, 1871, he traveled by train to Petroleum Centre, where he spoke at the nearby Central House Hotel. The presidential train stopped at Columbia Farm, where the president was shown the process of oil well drilling and pumping. (Photograph by Kenneth C. Springirth.)

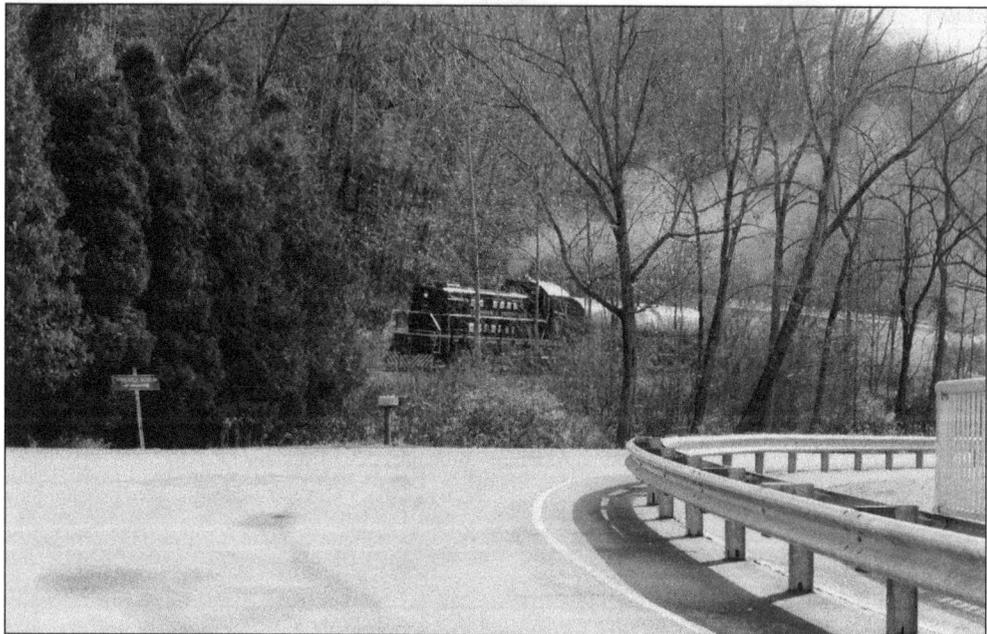

On November 19, 2010, near the Jersey Bridge along the road to Drake Well station, Oil Creek and Titusville Lines northbound freight train powered by locomotive No. 75 is heading to Titusville. (Photograph by Kenneth C. Springirth.)

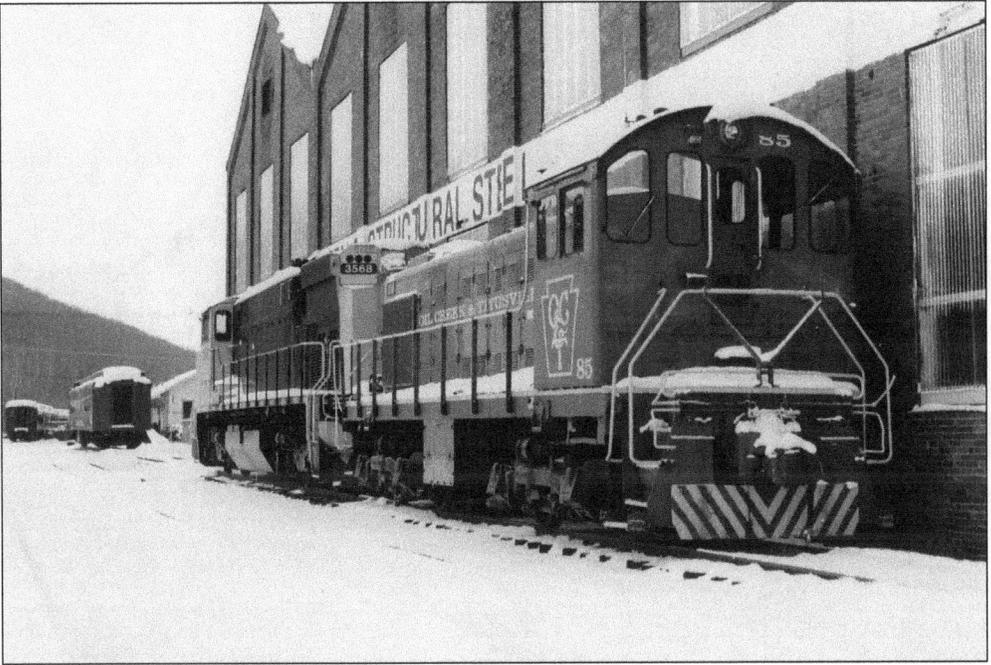

Titusville east of Perry Street is the scene for Oil Creek and Titusville Lines locomotives No. 3568 and No. 85 on December 17, 2010. In the same place on May 20, 1908, there was a property dispute. Pennsylvania Railroad crews threw cinders into a foundation trench for a new Titusville Iron Works building. Titusville Iron Works workers sprayed water on the railroad crews. Following a truce, the building was constructed. (Photograph by Kenneth C. Springirth.)

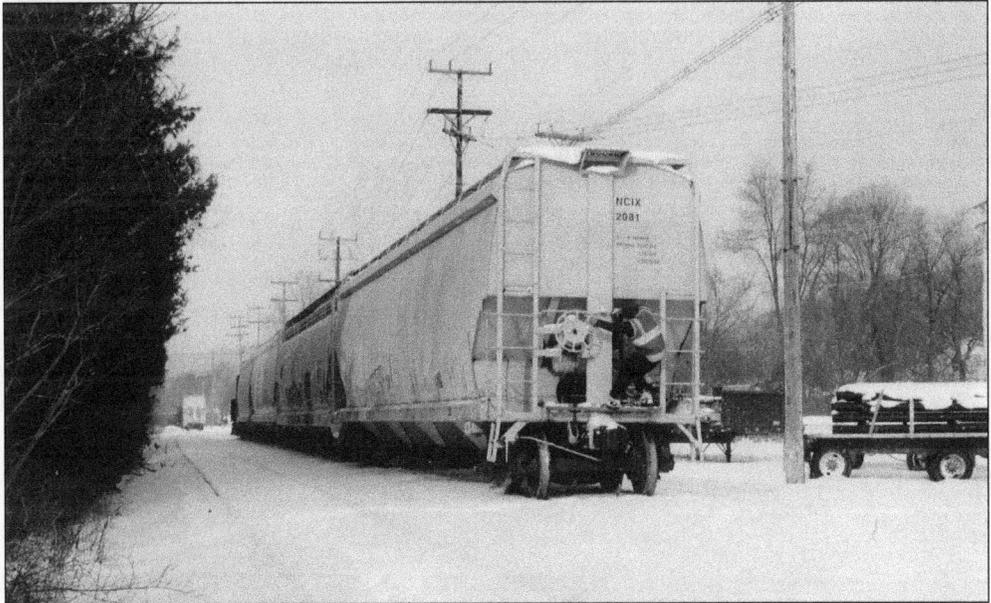

On a cold December 17, 2010, at the Titusville yard, conductor Chuck Brown is setting the handbrake for the freight car parked on the siding. Railroad work is hard in all kinds of weather. Tracks are already snow-covered in this region, even though it is not yet officially wintertime. (Photograph by Kenneth C. Springirth.)

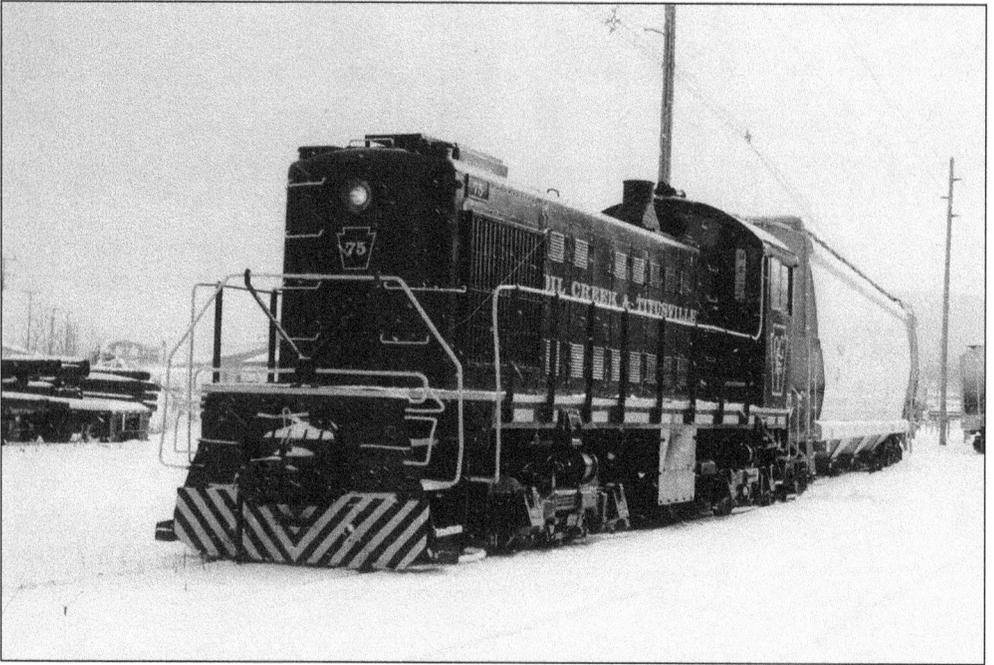

A snowy December 17, 2010, finds Oil Creek and Titusville Lines locomotive No. 75 switching freight cars at the Titusville yard. (Photograph by Kenneth C. Springirth.)

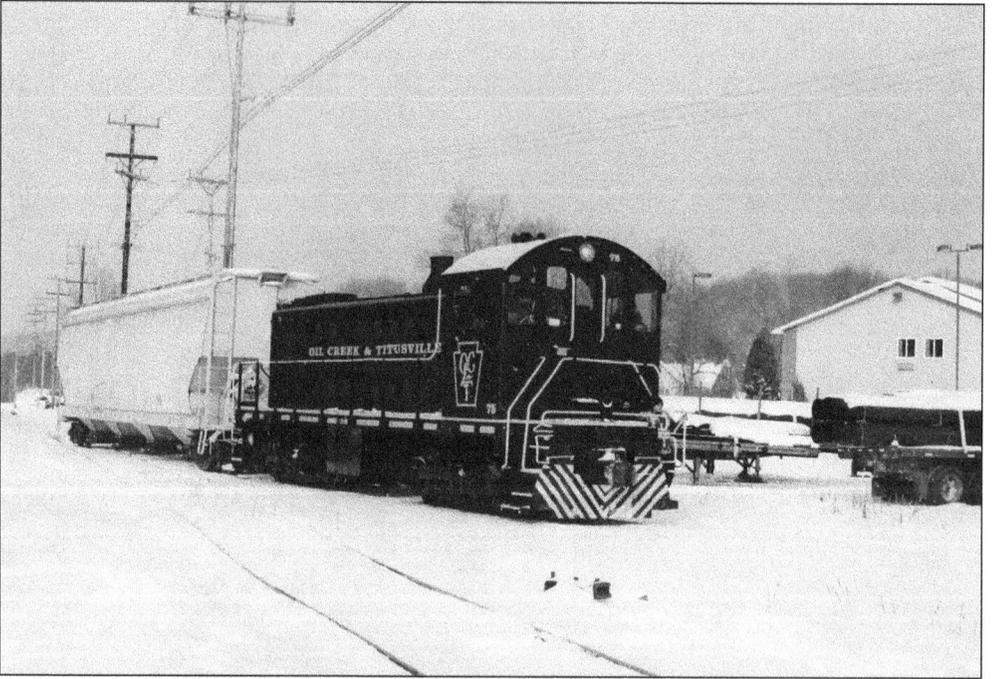

Oil Creek and Titusville Lines conductor Chuck Brown is on the platform of locomotive No. 75 to work with the locomotive engineer in the delivery of the covered hopper car on December 17, 2010. With snow as high as and even above the top of the rail, switching freight cars requires extra care. (Photograph by Kenneth C. Springirth.)

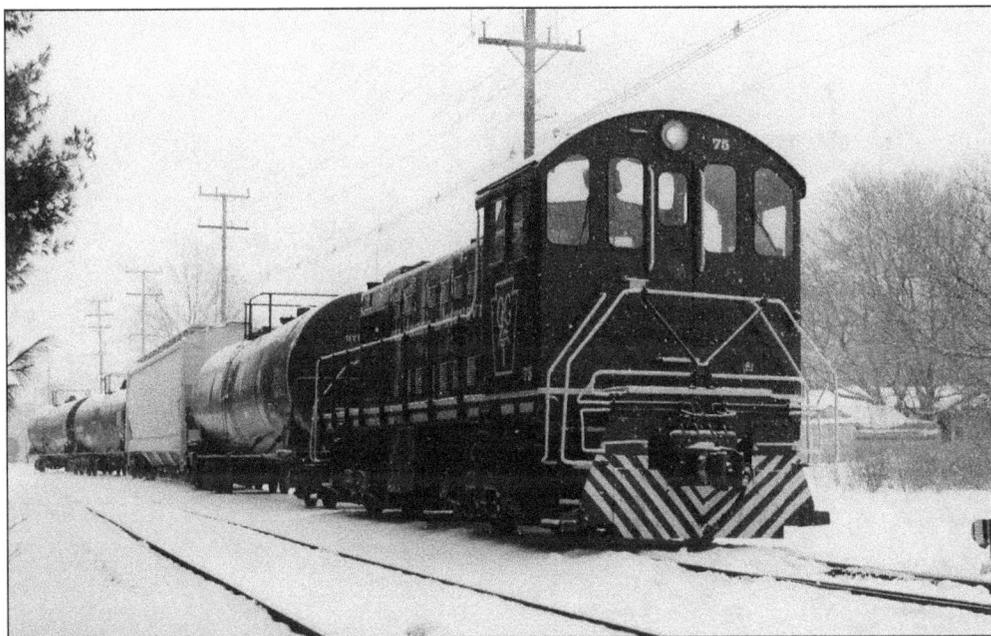

On December 20, 2010, a four-car freight train headed by Oil Creek and Titusville Lines locomotive No. 75 is approaching the switch for the Fieldmore branch of the former New York Central Railroad to deliver cars to the various industries, including Oil Creek Plastics, Inc., Charter Plastics, Inc., Baillie Lumber, Weyerhaeuser, and International Waxes, Ltd., which are on the line to East Titusville. (Photograph by Kenneth C. Springirth.)

An eastbound Oil Creek and Titusville Lines freight train powered by locomotive No. 75 is passing by the Ellwood Titusville Machine Shop (located in part of the former Titusville Iron Works Division of Struthers Wells Corporation complex) on its approach to Franklin Street in Titusville on December 20, 2010. (Photograph by Kenneth C. Springirth.)

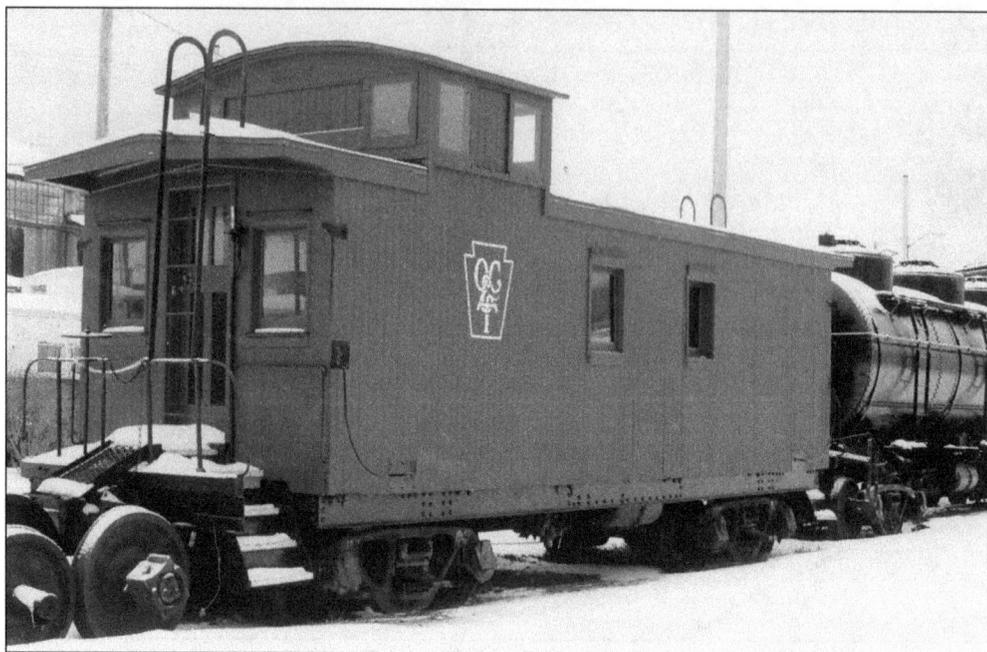

Caboose No. 10 in this December 20, 2010, view is on display at the Perry Street station of the Oil Creek and Titusville Railroad. It was built during 1913 for the Elgin, Joliet, and Eastern Railroad. It later served as an executive car for the Lake Erie, Franklin, and Clarion Railroad, once owned by Gen. Charles Miller of the Galena-Signal Oil Company. (Photograph by Kenneth C. Springirth.)

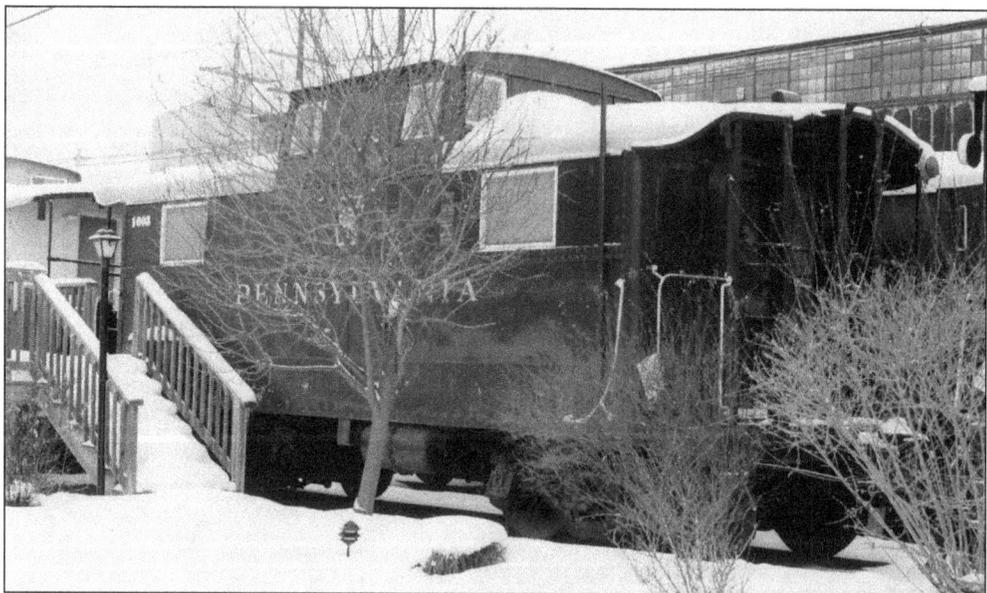

In this December 20, 2010, scene, Pennsylvania Railroad caboose No. 1003 is one of 21 cabooses at the Caboose Motel, Inc., adjacent to the Perry Street station of the Oil Creek and Titusville Railroad in Titusville. The Oil Creek Railway Society, Inc., established the motel with each caboose a self-contained motel room. The telephone number for reservations at the Caboose Motel, Inc., is 800-827-0690. (Photograph by Kenneth C. Springirth.)

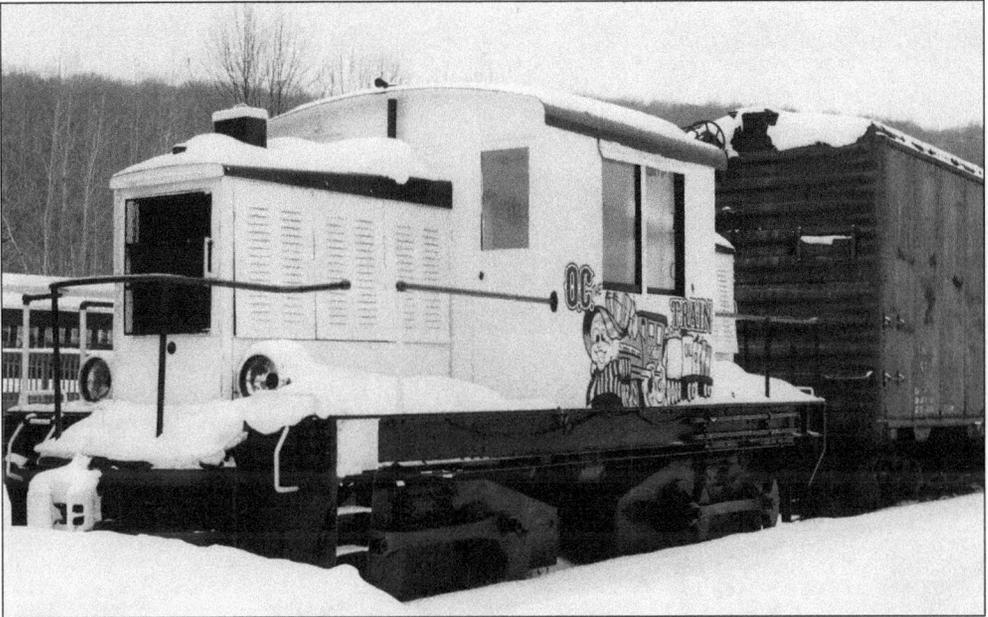

This 50-ton Atlas industrial switcher, originally used at the Universal Rolling Mill Company at Bridgeville near Pittsburgh, is at the Perry Street station in this scene on December 20, 2010. In 1969, the locomotive was moved to Universal-Cyclops Steel Corporation in Titusville to move carloads of scrap and steel ingots between the main part of the plant and the melt shop in Titusville's east end. (Photograph by Kenneth C. Springirth.)

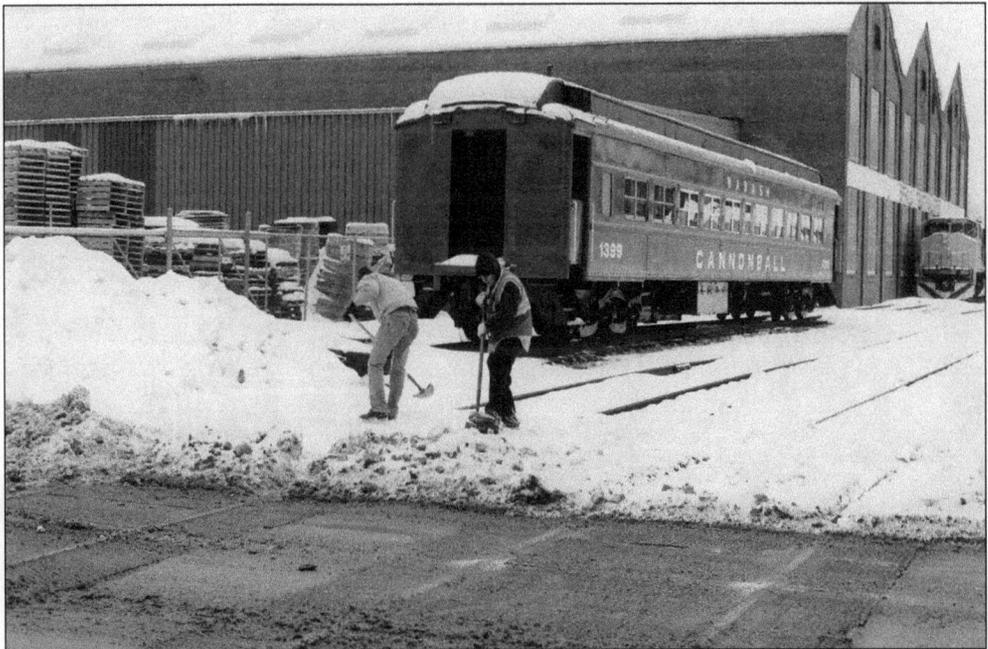

Engineer Chris Dingman (left) and conductor Chuck Brown are shoveling ice and snow off the Oil Creek and Titusville Lines rails at the Perry Street crossing in Titusville on December 20, 2010. On the siding is passenger car No. 1399, built by American Car and Foundry in 1925 for the Wabash Cannonball. (Photograph by Kenneth C. Springirth.)

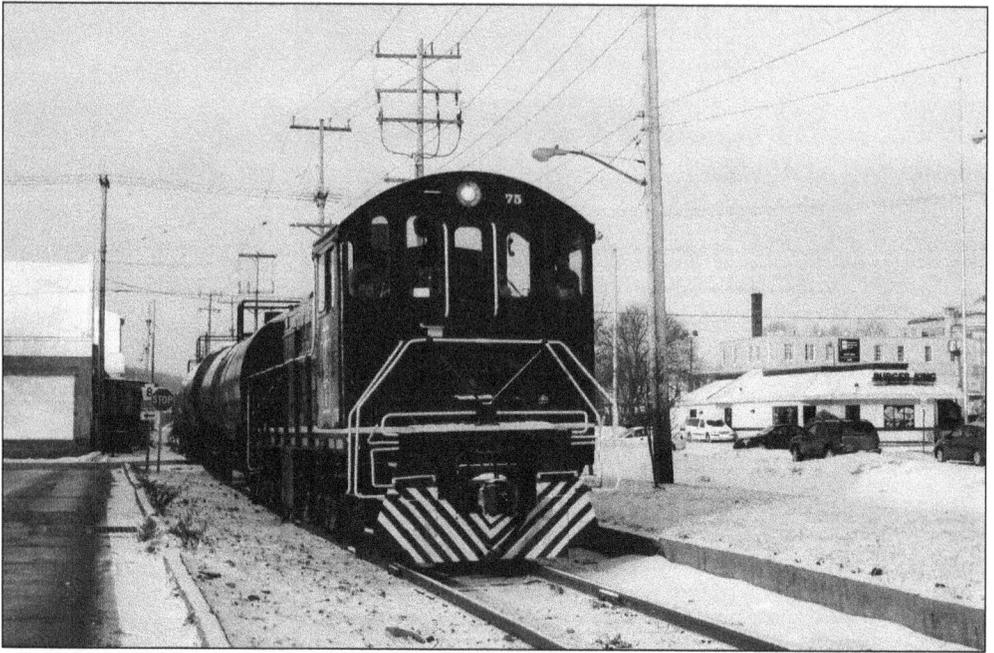

Oil Creek and Titusville Lines locomotive No. 75 is crossing Franklin Street eastbound on the former Fieldmore branch of the New York Central Railroad on January 5, 2011. The northwest corner of this intersection was formerly the location of Titusville City Mills, a water-powered flour and feed mill that operated from 1849 to 1935. (Photograph by Kenneth C. Springirth.)

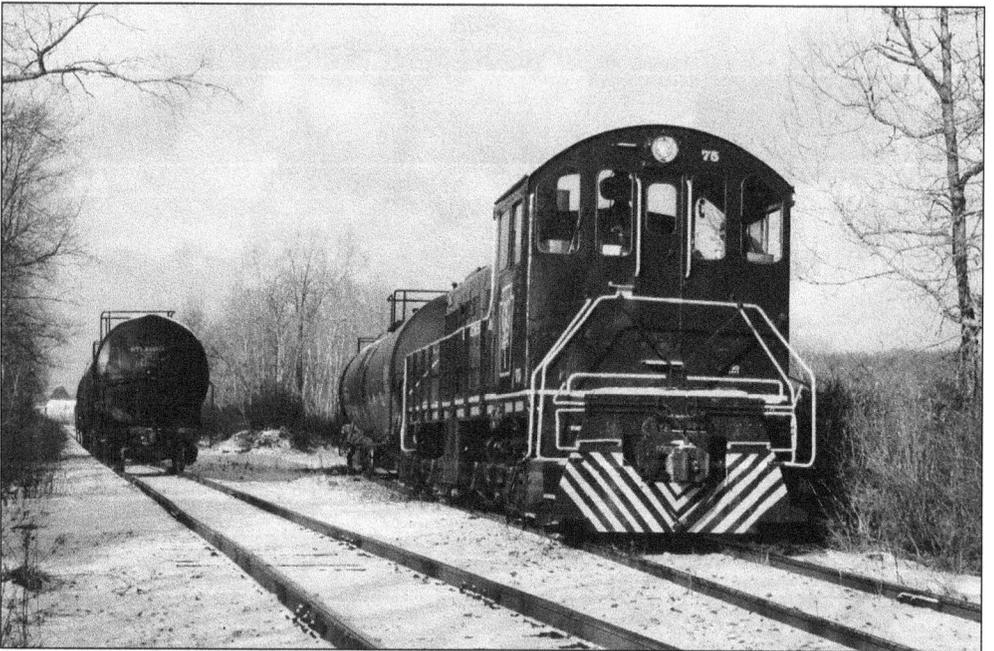

East of the East Industrial Drive crossing in Titusville, Oil Creek and Titusville Lines locomotive No. 75 is switching tank cars for International Waxes, Ltd., on January 5, 2011. International Waxes, Ltd., receives a variety of raw paraffin and microcrystalline waxes and manufactures distilled and blended specialty waxes. (Photograph by Kenneth C. Springirth.)

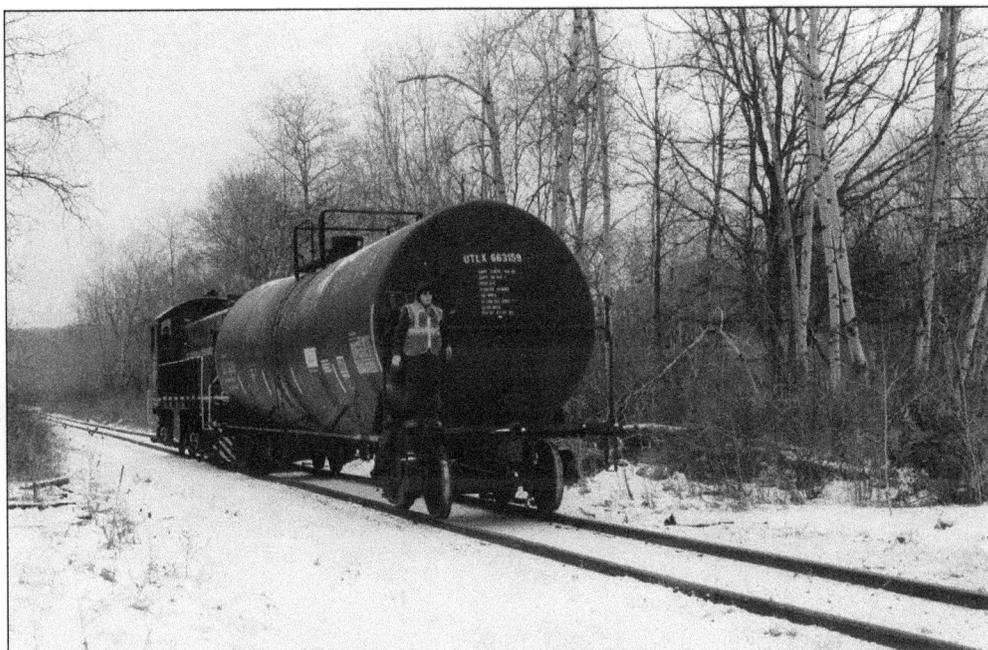

Oil Creek and Titusville Lines locomotive No. 75 is westbound approaching East Industrial Drive with a tank car from International Waxes, Ltd., on January 5, 2011. Conductor Chuck Brown is riding on the front of the tank car to make sure the road crossing is safe to cross. (Photograph by Kenneth C. Springirth.)

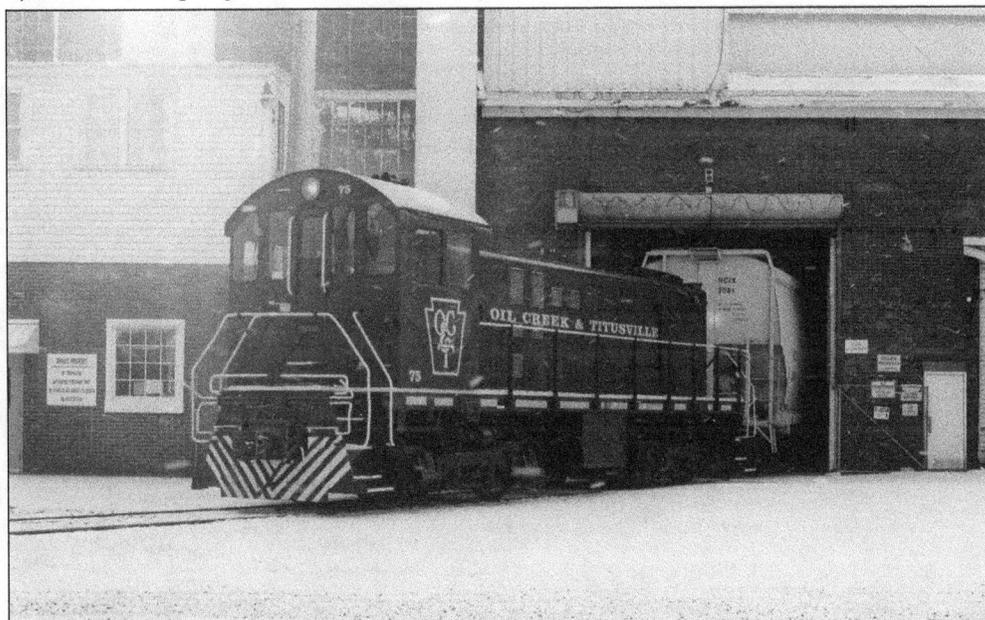

Oil Creek and Titusville Lines locomotive No. 75 is taking a covered hopper car from Charter Plastics, Inc., near South Washington Street on January 5, 2011. The Ellwood Titusville Machine Shop is at left. Titusville's industrial base has been a microcosm of Pennsylvania, because it had a sampling of nearly every type of industry that was ever located in Pennsylvania. (Photograph by Kenneth C. Springirth.)

A covered hopper car from Charter Plastics, Inc., in Titusville is being switched by Oil Creek and Titusville Lines locomotive No. 75 onto the main track near South Washington Street with conductor Chuck Brown on the front to make sure the way is clear. The photograph was taken on January 5, 2011. (Photograph by Kenneth C. Springirth.)

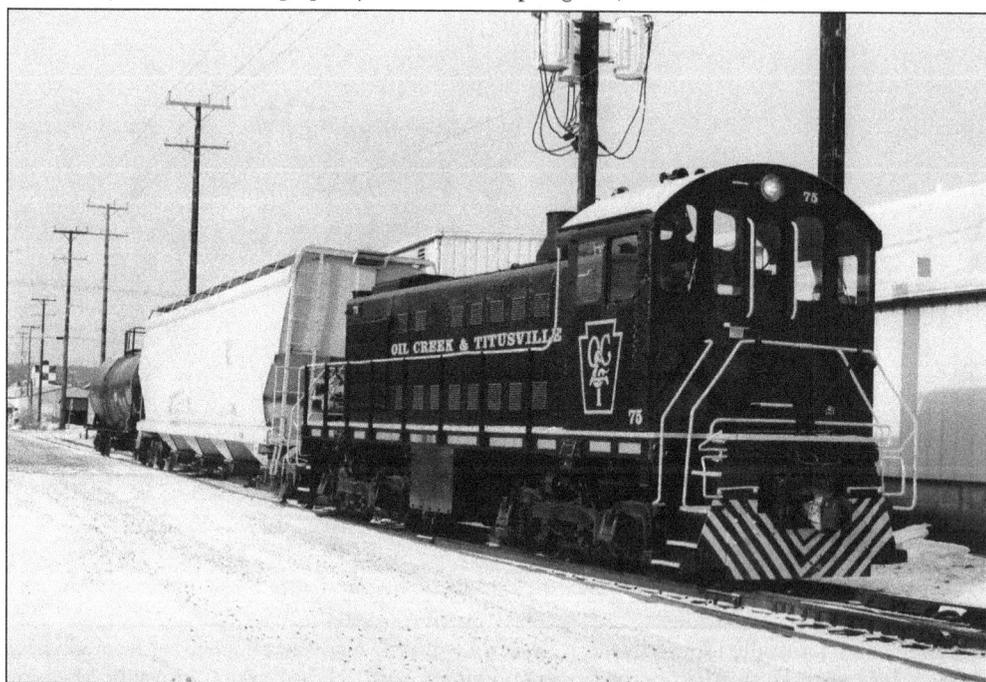

Westbound on January 5, 2011, Oil Creek and Titusville Lines locomotive No. 75 is approaching Perry Street in Titusville. Public and private investment has strengthened the industrial base of Titusville and redeveloped many former industrial sites. (Photograph by Kenneth C. Springirth.)

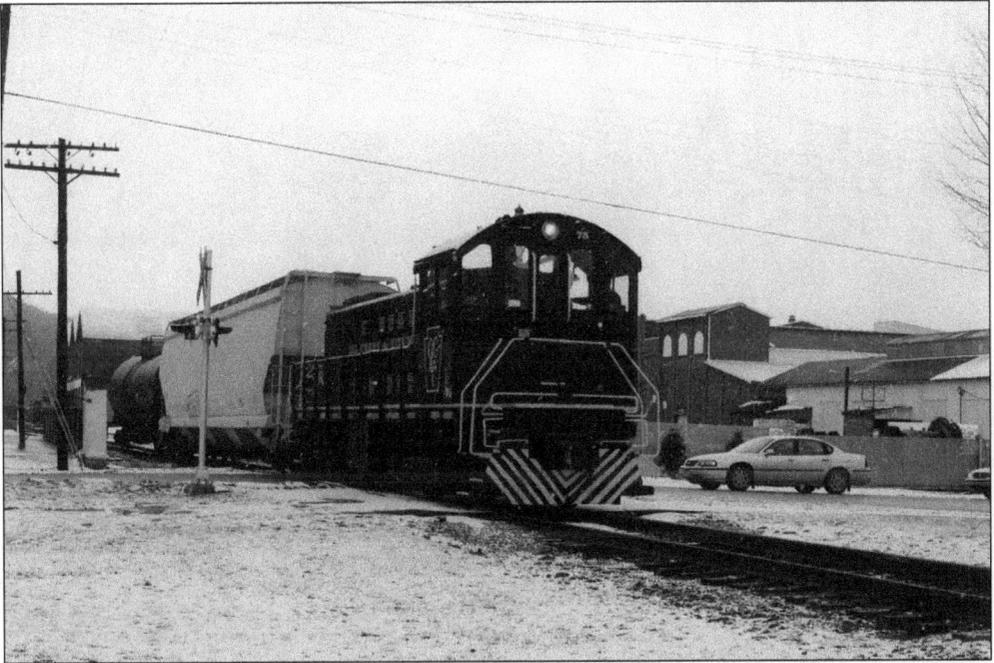

Oil Creek and Titusville Lines locomotive No. 75 is crossing Franklin Street in Titusville on January 5, 2011. The railroad crew makes sure salt has been applied to the rail flangeways at road crossings. Without the salt, gravel deposited in the flangeways by motor vehicles could freeze and cause the wheel flange to ride on top of the hardened material and derail. (Photograph by Kenneth C. Springirth.)

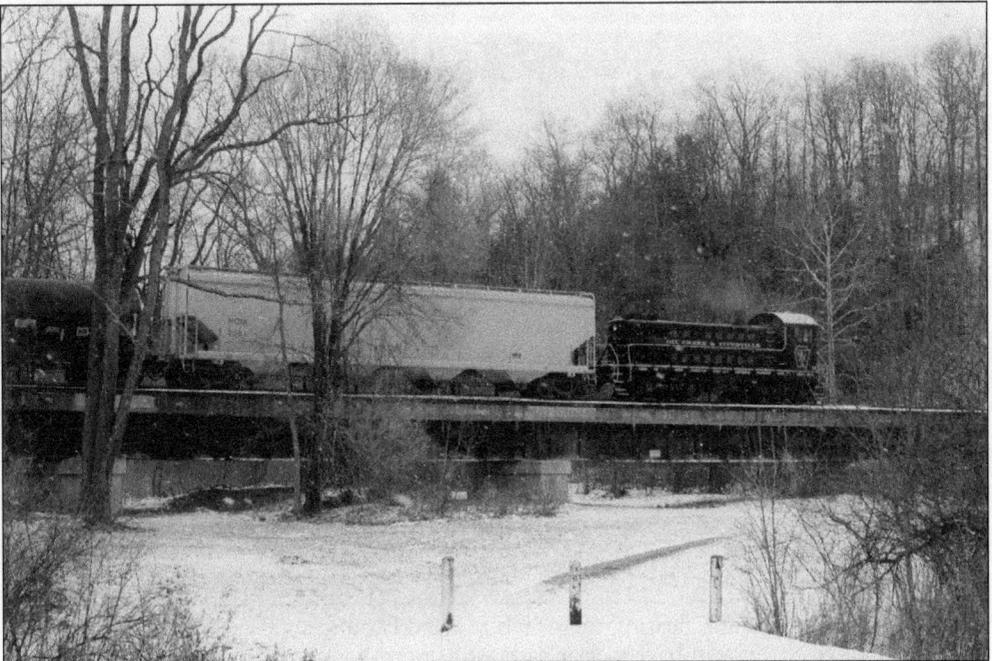

A picturesque winter scene finds Oil Creek and Titusville Lines locomotive No. 75 crossing Oil Creek at the Jersey Bridge on January 5, 2011. (Photograph by Kenneth C. Springirth.)

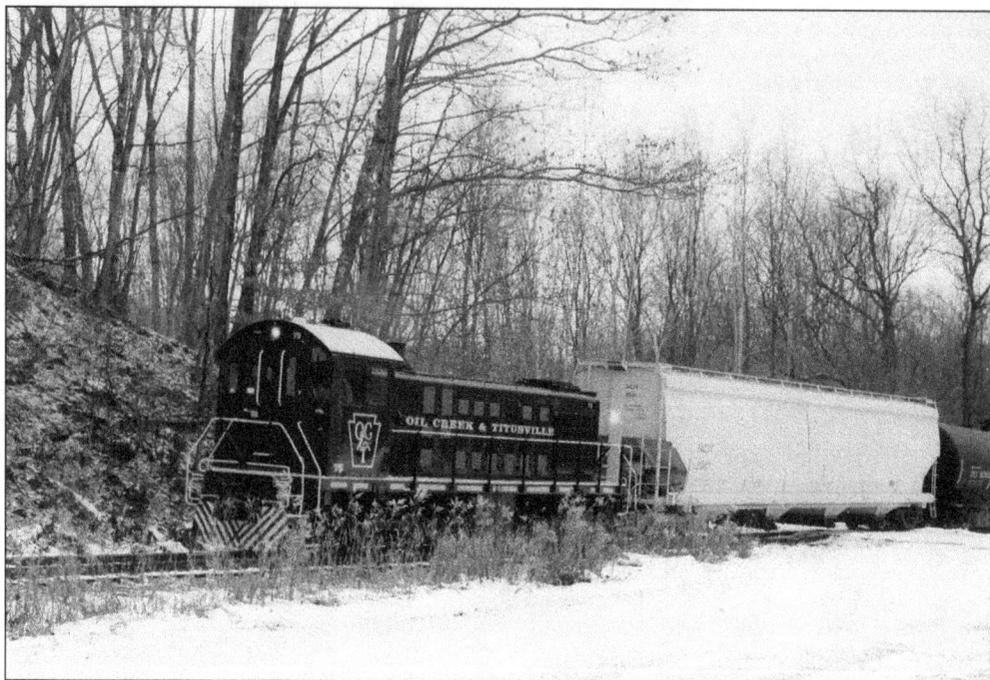

Oil Creek and Titusville Lines locomotive No. 75 is southbound crossing Stevenson Hill Road at Petroleum Centre on January 5, 2011. Once a boom town, the area is now a recreational park operated by the Pennsylvania Department of Conservation and Natural Resources. (Photograph by Kenneth C. Springirth.)

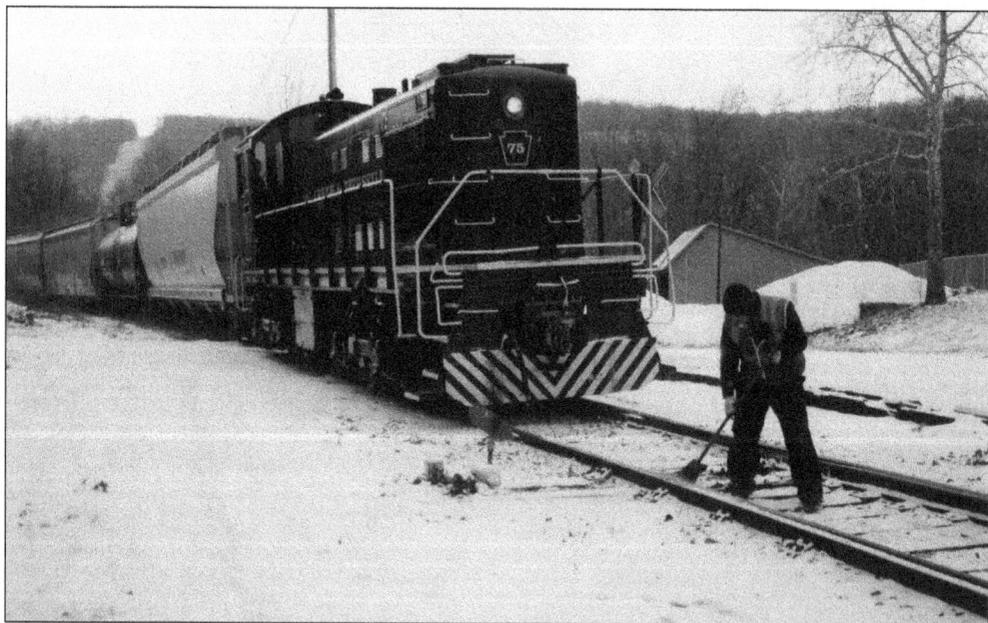

Conductor Chuck Brown is clearing the switch at Rynd Farm so that Oil Creek and Titusville Lines locomotive No. 75 will have a clear path for its northbound trip to Titusville on January 5, 2011. Railroad employees work in all kinds of weather to meet customer needs. (Photograph by Kenneth C. Springirth.)

126

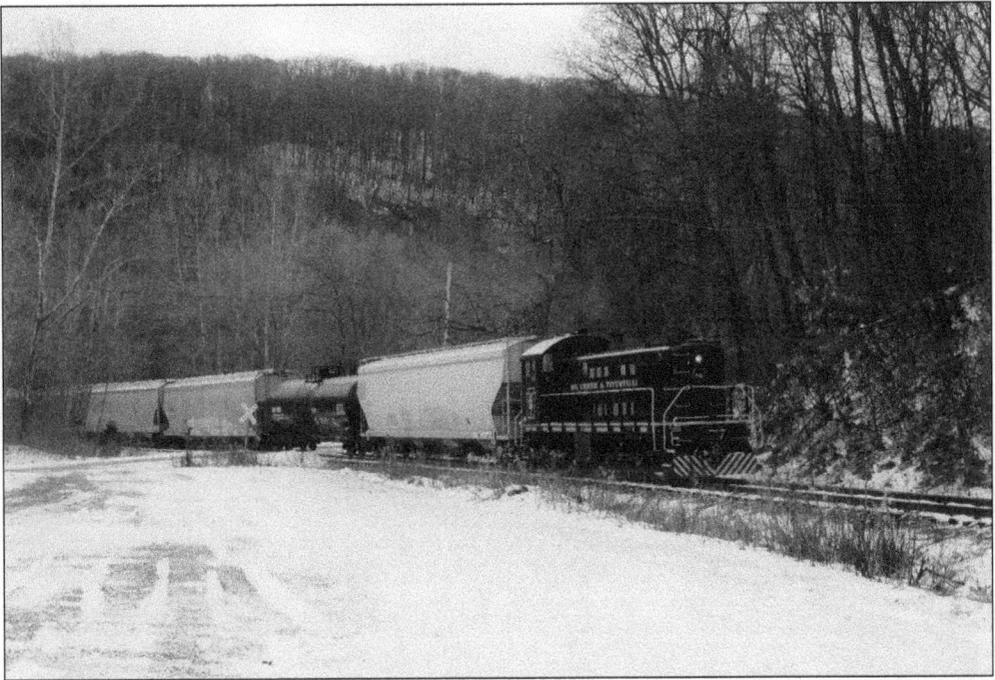

Most of the snow is gone as Oil Creek and Titusville Lines locomotive No. 75 is northbound at Petroleum Centre on January 5, 2011. Oil made the region famous, but over the years, Titusville residents worked hard to establish new industrial opportunities. The railroad has contributed to making the region an attractive location for industry. (Photograph by Kenneth C. Springirth.)

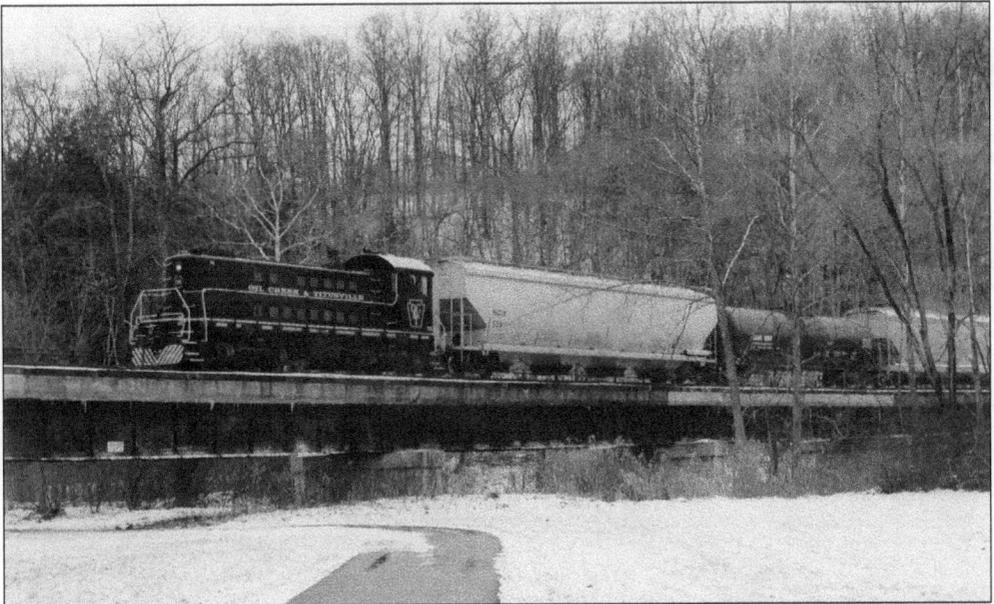

Oil Creek and Titusville Lines locomotive is crossing Oil Creek just north of Drake Well Station on its northbound run to Titusville on January 5, 2011. Oil Creek, a 46-mile tributary of the Allegheny River, was named after oil that was found along the banks of the creek before the drilling of the first successful oil well on August 27, 1859. (Photograph by Kenneth C. Springirth.)

Visit us at
arcadiapublishing.com